# the little book of
# *LAYOUTS*

## GOOD DESIGNS AND WHY THEY WORK

David E. Carter

*An imprint of* HarperCollins*Publishers*

the little book of
*LAYOUTS*

Copyright © 2003 by David E. Carter and HDI, an
imprint of HarperCollins*Publishers*.

First published in 2003 by:
Harper Design International,
An imprint of HarperCollins*Publishers*
10 East 53rd Street
New York, NY 10022

Distributed throughout the world by:
HarperCollins International
10 East 53rd Street
New York, NY 10022
Fax: (212) 207-7654

HarperCollins books may be purchased for educational,
business, or sales promotional use. For information,
please write: Special Markets Department,
HarperCollins Publishers Inc., 10 East 53rd Street, New
York, NY 10022.

Book design and astute observations by
Designs on You!

Library of Congress Control Number: 2003112070

ISBN: 0-06-057025-3

Printed in Hong Kong by Everbest Printing Company
through Four Colour Imports, Louisville, Kentucky.
First Printing, 2003

Every designer has the word "layouts" tattooed on the brain somewhere. (The adventurous may have it tattooed on various body parts.)

Layouts are the fundamental element of ads, publications, brochures, and lots of other work created by graphic designers.

This book is full of layouts! Most of the pieces shown are two-page designs, with each page using a different grid. All those layouts by themselves give you a huge resource for great design. And, this is where the "Little Book" series makes a big leap forward: each layout has commentary to give you some ideas about why and how the designs work.

For all those who use books like this to do what I call "solitary brainstorming," here's a book for your shelf that you'll refer to time and again.

Enjoy.

**NOW Legal Defense and Education Fund**
2001 Annual Report

holding
fast

fast
forward

creative firm
*The Wyant Simboli Group, Inc.*
designers
Julia Wyant, Jennifer Duarte,
Christine Keen
client
NOW Legal Defense and Education Fund

*Text follows
the visual flow of
artwork, reiterating
the symbol of
forward motion*

Paper (dollar) airplane on brochure front mimics the company's logo in bottom left corner

**BAA** USA ◢ ®

creative firm
*Elias/Savion Advertising*
designer
Ronnie Savion
client
BAA USA

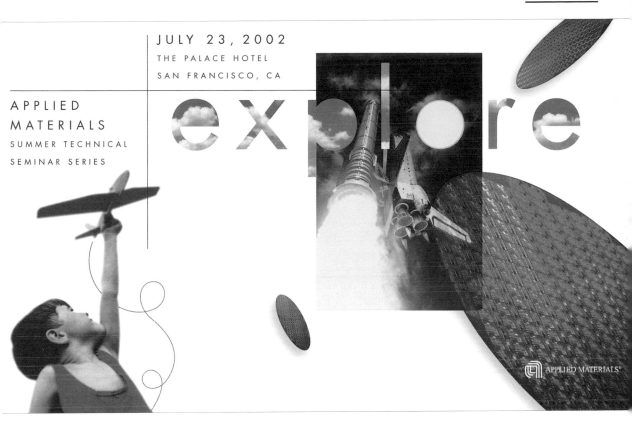

JULY 23, 2002
THE PALACE HOTEL
SAN FRANCISCO, CA

APPLIED
MATERIALS
SUMMER TECHNICAL
SEMINAR SERIES

explore

APPLIED MATERIALS®

creative firm
  *Gee + Chung Design*
designers
  Earl Gee, Fani Chung,
  Kevin Ng
client
  Applied Materials

*This layout is divided into quarters by strong vertical lines; visual excitement is created when design elements break those boundaries*

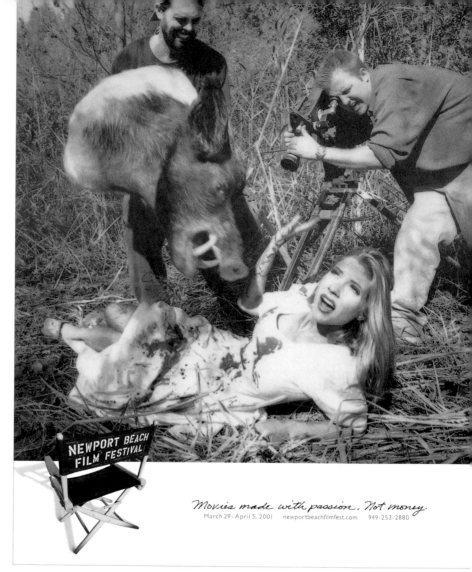

Movies made with passion. Not money.
March 29 - April 5, 2001   newportbeachfilmfest.com   949-253-2880

creative firm
*DGWB*
designers
Jon Gothold,
Dave Swartz,
Enzo Cesario,
Dave Hermanas,
Elliott Allen,
Peter Samuels,
Kara LaRosa
client
Newport Beach Film Festival

Humorous ad uses basic black-and-white photography and exaggerated visuals to suggest that creativity is more important than the budget (or lack of budget)

*For readability, text is specifically separate from medically-dominant photo*

creative firm
**Fry Hammond Barr**
designers
Tim Fisher, Sean Brunson,
Shannon Hallare
client
Florida Hospital

Experience counts

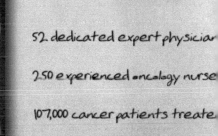

52 dedicated expert physician

250 experienced oncology nurse

107,000 cancer patients treate

1 name

FLORIDA HOSPITAL
CANCER INSTITUTE

creative firm
**The Riordon Design Group Inc.**
designers
Dan Lim, Alan Krpan,
Dan Wheaton, Ric Riordon
client
Oakville-Trafalgar Memorial Hospital

em

our hospital, our future

critical**support**

OAKVILLE-TRAFALGAR MEMORIAL HOSPITAL

01

# acing the    needs of a lifetime

Oakville-Trafalgar Memorial Hospital has it all.

A full service hospital offering a continuum of expert care, from the newborn to the elderly, including core clinical programs such as maternal/child, emergency, medicine, diagnostic imaging, mental health, surgery, rehabilitation and geriatrics.

But we also have much to lose if we don't prepare for a future that's already here. Now more than ever your support is critical because by 2003, OTMH will have run out of beds and facilities for our rapidly growing and ageing community.

This need is the catalyst behind the launch of the $10 million *Critical Support* Campaign.

We refuse to compromise the excellent reputation of Oakville-Trafalgar Memorial Hospital. With a patient satisfaction score of four out of five on the Province's recent report on hospitals, we rated among the highest in the GTA/905 area. We will not settle for anything less than being a hospital given top marks for delivering patient-centred care in a fiscally responsible manner.

We must continue to attract and retain a compassionate, highly dedicated staff which today is comprised of 94 family physicians, 93 specialists and close to 900 full-time employees.

We can't continue having it all by standing still.

Oakville-Trafalgar Memorial Hospital is a first rate community hospital – the heart of our medical system, in the heart of our community. But by 2003, we will have run out of space and beds. This Campaign is one that can't wait.

John Oliver, President & CEO, Halton Healthcare Services

*Employing monochromatic photos, this brochure's copy and art relate well in its strongly-grid-influenced design*

# Vassar

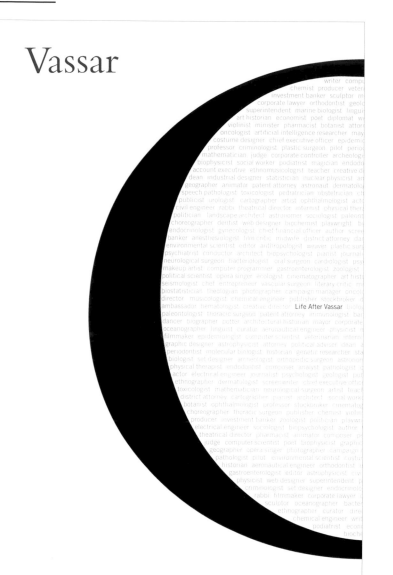

Life After Vassar

*Great typography!
Repeated letter
segment, used in
positive & negative
formats, acts as text
frame*

Interesting use of wraparound type with second column bordering the first

creative firm
**Nesnadny + Schwartz**
designers
Mark Schwartz, Joyce Nesnadny,
Michelle Moehler, Cindy Lowrey,
Stacie Ross, Keith Pishnery
client
Vassar College

# Outcomes

here's no denying it.
Higher education is a
huge investment; you
want to be reasonably
sure of a "good return."
What is a "good re-
turn"? Is it a decent job, right out
of college? Is it a career? Accep-
tance at the nation's top profes-
sional or graduate schools? Vassar
is "blue-chip" on all three counts.
That's what makes it a sound
investment. What makes it an
exciting investment is that it's also
a "growth" stock—your growth.

THE OFFICE OF CAREER DEVELOPMENT
at Vassar conducts an annual survey of the
prior year's graduates to find out what
they're up to. According to Clare Graham,
the office's director, the numbers from the
most recent survey are characteristic: About
70% of the respondents are employed full
time; about 20% are attending graduate or
professional schools. (Within five years
after graduation, 75–80% of Vassar gradu-
ates pursue advanced study.) The other 10%
are either traveling, doing volunteer work,
or looking for full-time jobs.

What are they doing? A few just-out-
of-college examples: Graham Ericksen, English major,
got a job as an analyst at Siegel and Gale (top commu-
nications firm in New York); Nicole DeRosa, chemistry
major, is a researcher at the National Gallery of Art;
Eamon Joyce, sociology major, is at the University of
Pennsylvania Law School; Paul Cardillo, psych major,
is an equity researcher at Lehman Brothers; Heather
Woodward, cognitive science major, is a genetic
researcher at Harvard Medical School; Liz Powers,
biology and Hispanic studies major, is at Stanford

Medical School; Leticia Villarreal, art major, is a systems
engineer for IBM and Lucent Technologies; Shreyank
Purohit, computer science major, is a Web designer at
Teralon Interactive.

A first job, however, is not a career. According to
*Fortune* magazine, the average American changes careers
five times in the course of his or her work life. This
is precisely why a liberal arts education is so valuable.
A liberal arts education is preparation for anything—
because it teaches you how to think, question, explore,
prove, imagine, reason, and create. There are no courses
at Vassar on Web design, for example—and yet there
are Vassar graduates in top-level positions at cutting-
edge Web design firms. There are no business courses
at Vassar—and yet Vassar graduates hold C.E.O. and top-
level management positions at Fortune 500 companies.

Where do Vassar graduates go after that first job?
Anywhere, and everywhere—as the alumnae/i profiles
in this brochure demonstrate.

-1-

creative firm
  *Leo Burnett Company Ltd.*
designers
  Judy John, Kelly Zettel,
  Chris Hall, Matt Syberg-Olsen,
  Anne Peck
client
  J.M. Smucker (Canada) Inc.

WE ADD SOMETHING
TO OUR PEANUT BUTTER
THAT FEW OTHER
COMPANIES DO.

NOTHING.

Simple text treatment and focus on product label highlights the message of "no additives"

Two words, printed black on white, are linked by a large, blind-embossed ampersand

creative firm
*INC Design*
designers
Meera Singh,
Denise Madera,
Rosanna Menza
client
XL Capital Assurance

**NEW**

**IMPROVED**

Black type and large ampersand are repeated from brochure's cover (page 15). Blind embossing is suggested by a gray outline around white ampersand.

10.

FIXI
AD

(continued)
creative firm
*INC Design*
client
XL Capital Assurance

11.

**FIXED**   The financial strength, experience, and long-term strategic commitment of our multiline parent to our monoline business is fixed, absolute, and unconditional. The financial guarantee business is an attractive fit for our parent because it provides earnings stability and risk diversification uncorrelated to its core property and casualty insurance portfolio. That commitment has been demonstrated in a variety of ways – substantial capital investment, significant dedication of human resources, and unconditional and irrevocable guarantees. We're here to stay.

**ADJUSTABLE**   We are constantly redefining, adjusting, and improving what a triple-A rated monoline financial guarantor can and should be. We have built a client service culture that is the gold standard in our industry. We listen. We hear. We speak up. We are up-front, honest, and direct. We make decisions quickly, and we stand by them. And we do everything it takes to close the deal successfully, on time.

16.

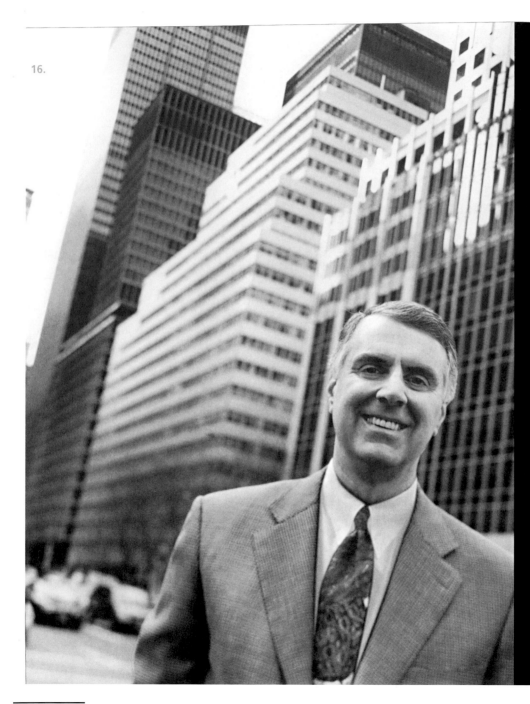

**Frank Constantinople**
Managing Director, Inve

As head of
world with
issuers, inv
we hear the
Immense c
Outstandir

It's a story
industry fo
tization, an
I'll tell you
Smart, acco
record in th
meeting cli
successful

We are bui
It's great to

ns, XLCA                                                    **17.**

## "WORLD-CLASS BUSINESS ON
##  A TERRIFIC PLATFORM"

stor relations, I have been traveling around the
senior management team, telling our story to
s, and investment bankers. Everywhere we go,
he thing: there is a real need for XLCA.
ity. Financial strength. Analytical expertise.
vice.

oy telling. I've been in the financial services
years, in the financial guarantee, asset securi-
estment and commercial banking areas. And
XLCA is truly an extraordinary company.
shed people of vision, with a proven track
ancial guarantee business, dedicated to better
leeds by improving upon the industry's
l.

a world-class business on a terrific platform.
lere.

Continuation of the use of strong black and white contrast (see pages 15 – 17). Notice, though, that reverse type is employed on this spread.

(continued)
creative firm
  *INC Design*
client
  XL Capital Assurance

By Henry Canaday • Illustrations by Malcolm Tarlofsky

# A NEW VISION
# OF CHANGE

How the best sales forces meet the challenge (20% pain and 80% gain)

's mind stretched to a new idea never
>es back to its original dimensions.
OLIVER WENDELL HOLMES

SELLING POWER  JULY/AUGUST 2001  **61**

Large negative space on title page is colored with a subtle gradient; these colors are repeated in the artwork on following page

creative firm
*Selling Power*
designers
  Colleen McCudden,
  Malcolm Tarlofsky
client
  Selling Power Magazine

COMMUNITY BANKING

GLOBAL VISION

*P*romistar Bank helps make your vision a reality, whether it's planning for retirement, education, a new home, or growing your business. At Promistar Bank, we deliver promises that help you build a bright financial future.

What's your vision?
Let Promistar lead you there.

PROMISTAR
BANK

Member FDIC
Equal Opportunity Lender

1-888-440-4011
WWW.PROMISTAR.COM

*Taken from the company's logo, curve of the photo edge creates body copy's alignment*

creative firm
**Adam Filippo & Associates**
designers
Martin Perez, Larry Geiger,
Ralph James Russini,
Robert Adam
client
Promistar Financial

creative firm
**Savage Design Group**
designers
Paula Savage,
Doug Hebert,
Matthew Ryf,
Jonathan Jackson,
Donny Jansen,
Champagne Fine Printing
client
Anadarko
Petroleum Corporation

Focus on human figure is emphasized by placing it on an expanse of solid yellow

*Dominant colors are defined on brochure's cover (page 23). Inside, they are used in initial caps, headlines, and boxes which add visual weight to bands of information*

GO!

A Day Of Real Life At Anadarko

24

**Sommer Mason**
Senior Human Resources Representative

*Bachelor of Science in MIS
Louisiana Tech University*

"I decided to join Anadarko after my site visit. It's hard to explain, but it was just a feeling I got about the people and the environment. Everyone works together and respects each other. You're not expected to know it all — everyone brings something to the team."

— Sommer

## GROWTH

Opportunity is what defines Anadarko today as a super independent - a responsible company pursuing profitable growth.

**9**¹⁰
→ A M
P M

Anadarko is one of the very
growth. No company of any size
what we're doing. Don't just take
best performing company in th
Houston's Top Performing Compa

We've got the people and the pro
it happen.

To Do List

☐ Team meeting moved to 10 a.m.   ☐ Run ideas by supervisor about project

04   ANADARKO   A DAY OF REAL LIFE

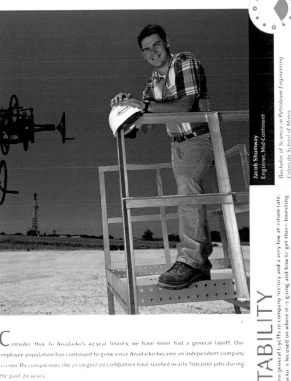

"I grew up in the oil industry and had been affected by the booms and busts in oil. That's why I was so impressed that Anadarko had never had a general lay-off. This company has a wealth of projects that can be pursued at any time — this kind of growth is exciting to be a part of."

— Jacob

Jacob Shumway
Engineer, Mid-Continent

*Bachelor of Science in Petroleum Engineering*
*Colorado School of Mines*

## STABILITY

With no general layoffs in company history and a very low attrition rate, Anadarko is focused on where it's going, and how to get there. Investing in our people has made all the difference at Anadarko.

1 25
A M
→ P M

gas companies today that is achieving volume
predict "double-digit" growth. But that's exactly
at *Business Week* named Anadarko the second-
year, and the *Houston Chronicle* named us
ar.

tinue growing, and we need new talent to make

Consider this. In Anadarko's 42-year history, we have never had a general layoff. Our employee population has continued to grow since Anadarko became an independent company in 1986. By comparison, the 25 largest oil companies have slashed nearly 700,000 jobs during the past 20 years.

Energy, indeed, is a cyclical business. But, although Anadarko is subject to the same commodity price dynamics as our competitors, we have continued to invest in our people and build our inventory of prospects. We stand ready with the people and projects in place to accelerate our growth and build value for our shareholders.

To Do List:

Go to Goldsmith Field      Meet chemical company rep for lunch      Present stimulation proposal to operations manager      Make 5:30 p.m. tee time

ANADARKO    A DAY OF REAL LIFE    05

(continued)
creative firm
### Savage Design Group
client
Anadarko
Petroleum Corporation

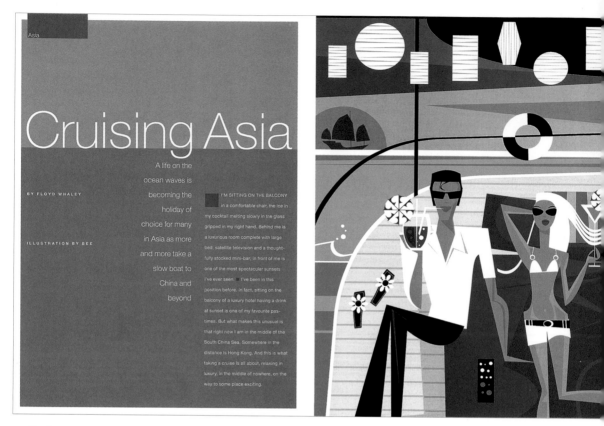

Asia

# Cruising Asia

A life on the
ocean waves is
becoming the
holiday of
choice for many
in Asia as more
and more take a
slow boat to
China and
beyond

BY FLOYD WHALEY

ILLUSTRATION BY BEE

I'M SITTING ON THE BALCONY in a comfortable chair, the ice in my cocktail melting slowly in the glass gripped in my right hand. Behind me is a luxurious room complete with large bed, satellite television and a thoughtfully stocked mini-bar; in front of me is one of the most spectacular sunsets I've ever seen. I've been in this position before. In fact, sitting on the balcony of a luxury hotel having a drink at sunset is one of my favourite pastimes. But what makes this unusual is that right now I am in the middle of the South China Sea. Somewhere in the distance is Hong Kong. And this is what taking a cruise is all about, relaxing in luxury, in the middle of nowhere, on the way to some place exciting.

creative firm
**Emphasis Media Limited**
designer
Percy Chung
client
Cathay Pacific Airways

An almost-primary color
scheme gives this layout an
upbeat image; text is very
comfortable floating in lots
of negative space

*Filled with art images from the opening spread, evenly-spaced medallions run parallel to horizontal lines at top of design*

"Our ships can change course as opportunities present themselves, perhaps for an impromptu stroll among brightly coloured flora, to watch a whale, or for a moment of silence as we contemplate an age-old glacier."

"Our ships not only can go where large ships cannot, they can also stop at smaller ports, hidden fiords or uninhabited islands, and take passengers ashore in our fleet of motorised landing craft," says a Clipper press release.

"We can change course as opportunities present themselves, perhaps for an impromptu stroll among brightly coloured flora, to watch a whale, or for a moment of silence as we contemplate an age-old glacier."

Cruise-ship visits to Asia trigger fierce competition among major destination cities in the region to attract port calls. Cruise passengers are among the most sought-after tourists in the world. They step onto land ready to shop for souvenirs, eat at local restaurants and check into hotels on their way to and from their cruise ships.

"The cruise market is an important growth segment of Hong Kong's tourism business," says Hong Kong Tourism Board executive director Clara Chong. "Hong Kong's strategic location provides cruise passengers with a unique Chinese cultural voyage to the north to major Chinese ports such as Xiamen, Shanghai and Beijing.

The cruise lines are well aware of Hong Kong's attributes. The well-appointed Ocean Terminal is located in the heart of the Tsim Sha Tsui tourist area. The city also provides global air links that make it a convenient place to start or finish a cruise.

"There is nowhere else in the world where you can arrive at port right in the city centre and have such a beautiful skyline as the backdrop," says Aris Zarpanely, a senior vice-president with Silversea Cruise Lines. "The city's excellent infrastructure, top-class hotels, and variety of sightseeing, dining and shopping

make it the perfect place to begin or end a cruise holiday."

Singapore has no plans to allow Hong Kong to hog the cruise-ship limelight. In 1998, it refurbished the US$50 million Singapore Cruise Centre and the following year received more than its million-strong local and international passengers. Between 1991 and 1999, cruise-passenger traffic grew more than 400 percent, according to officials. But Singapore's sights are not just set on local competition for cruise passengers. The city-state's tourism officials call the Asia-Pacific region "a vast cruise playground". Says a press release from the cruise centre, "There are more than 50 exotic ports close to Singapore. The cruise passenger will find more tropical islands and beaches here than the Caribbean."

Thailand is also in the running with its Star Cruises Terminal Bangkok that operates from Laem Chabang, near the southern resort town of Pattaya. The terminal is designed to accommodate up to 2,000 passengers at a time, and the elevated highway between the terminal area, Bangkok and the airport, has slashed the amount of time it takes to get from the terminal to the city.

Making clear that it is not just a bit-part player in the region, the Thailand terminal hosted the world's largest cruise ship, P&O Princess Cruises, *Star Princess* in February this year. The mammoth vessel can accommodate 2,600 passengers in luxury with four swimming pools, nine spas, and even self-service laundry rooms.

The Philippines is also trying to get back on the map as an international cruise ship destination. Few big ships call in at Manila due to its lack of infrastructure to support them, but

Subic Bay, north of the capital, is now wooing the big operators. The area was a former US Navy base that once accommodated giant aircraft carriers. It is perfectly suited to handle big cruise ships, say officials.

We intend to promote Subic as the next premier cruise stop," says Subic Bay Metropolitan Authority chairman Felicito C. Payumo, who attended the Sea Cruise Trade Convention in Miami, Florida in March 2002. "It has all the elements that make it a winner: a safe and secure environment, a wide array of choices in hotels and restaurants, and other tourist spots."

One city that is already well on its way to giving Hong Kong and Singapore a run for their money in terms of cruise passengers is Shanghai. The host of world leaders during the recent Asia Pacific Economic Conference forum, the historic city sits where the Yangtze River washes into the sea. New York-based Regal China Cruises runs three luxury vessels along the part of the Yangtze near the Three Gorges Dam area. Each ship accommodates 258 passengers in luxurious rooms with picture windows offering panoramic views of the river. In Shanghai, luxury cruise ships ply the historic Huangpu River that divides the city's historic section and its booming business district.

"Cruise passengers are always welcome to stay with us, and they always have a lot to see and do in Shanghai," says Michelle Wan, spokeswoman for The Portman Ritz-Carlton, Shanghai. "We treat them like honoured guests."

It seems many more guests will be taking the slow boat around China's coast in future. ■

**For the latest cruise information, visit www.cruise.com**

Dark negative space contrasts strongly with the white boxes presenting this article's text

If you could name the most significant recent change in your company's sales force, what would it be?

  a. technology
  b. new ways to sell
  c. different company culture that fosters the sales process
  d. outsourcing
  e. different relationships with reps
  f. all of the above.

If you answered "f," congratulations. You're on top of the most recent developments in sales force management. If you didn't, listen up. The sales field is changing. How? In every way conceivable, including the way companies hire, train and use salespeople. To discover how companies are reinventing their sales forces, *Selling Power* spoke with executives at four major sales organizations.

### SAS INSTITUTE, INDEPENDENCE, OH
Focus on solution selling

Recently named by *Fortune* magazine the number two company in America to work for, 25-year-old SAS Institute serves more than 35,000 business, government and university sites, including 90 percent of the Fortune 500. With revenues averaging double-digit annual growth since the company's founding, SAS leads its market segment – business intelligence.

In any other market, that would be stunning success. In the tough, high-tech field where SAS plays, however, it was not good enough. "They had a great corporate culture, but the sales force was not very aggressive," recalls Brad Lawson, who joined SAS as a district sales manager for the Cleveland–Pittsburgh District of the Ohio Valley Region in late 2000. SAS is the largest privately held software firm in the United States, with about $1.1 billion in revenue in 2000.

Fortunately, the corporate culture provided several assets for the turnaround of the sales effort. In keeping with its traditional approach to business, SAS did not look for a quick fix in sales by just installing some new managers and compensation plans. "They knew they had to change other parts of the organization to align them with the new sales culture," Lawson says. "That meant changing pricing and contracts as well as legal and support functions – even research and development."

Lawson saw another thing that impressed him about SAS's commitment to selling better: The firm was moving toward solution selling for its high-tech products. "A lot of companies just send the reps away for training in solution selling," Lawson notes. "But the managers and the other execs still think the old way. So the reps come back and the solution-selling approach falls apart."

It was not going to be that way at SAS. "The reps and everybody involved with sales, all the way up to the president of SAS, learned solution selling," says Lawson.

In addition, SAS had already revamped its sales compensation plan to motivate sales. The old system paid a straight salary plus bonuses that were subjectively determined by managers.

"The new plan was highly leveraged," Lawson says. "The minimum payment was reduced, but the upside potential substantially increased." Territory quotas now average about $1.3 million per year. Under the new comp plan, a successful rep should be able to earn "in the high hundred thousands up to mid-two hundred thousands," Lawson estimates – but only if the rep performs.

Although the corporate commitment and strong incentives were there, Lawson still had his work cut out for him. He joined SAS in mid-October 2000, about 45 days short of the end of its fiscal year, which then ran until November 30. The new manager spent his first 45 days mostly gaining credibility with his district team.

Lawson had always been a high-performance rep and sometimes a mentor to younger reps. Suddenly, he was a 30-year-old manager of some veteran high-tech reps, most of whom had at least 10 years on him. These reps were smart and worked for one of the most praised companies in America. Yet the Cleveland–Pittsburgh district had sold less than half – 48 percent – of its assigned quota in fiscal 2000. Of SAS's 33 sales districts in the United States, Lawson's bunch was at the bottom.

But poor performance was only the symptom of a deeper issue. "They were apathetic when I came on board," remembers Lawson. "And I had zero credibility," he says. Gaining the team's trust fast and then managing a successful sales effort was to become "the hardest thing I ever did."

Lawson set out to gain credibility first by going on sales calls with his reps and doing presale planning with them. He also let them know he would fight for the team with upper management. That was important because better selling required many kinds of support from the other units of SAS – the better 'alignment' the company had promised.

But Lawson did not have much time to make friends. By December 2000 he had to set strategy and plans for 2001. He first asked his reps for their own plans and, used to being a top performer himself, he let them know that he wanted aggressive plans for a top team. "I wasn't responsible for the poor results of the previous year," Lawson says. "Yet I felt embarrassed for the team. I wanted to transfer some of that shame to them." He also wanted to transfer a little aggressiveness. "I told them up-front my goals were very high," Lawson says. "That meant going from worst to first." At least the reps would know what they were dealing with. "Some people dropped out, saying, 'This guy is too aggressive.'"

Lawson was willing to work with reps who understood and accepted the new goals. "I wanted to show them how they could be successful, how much they could make with a successful year, and how that could change their lives," he says. The emphasis is always on what the sales force can control, not what is outside of anyone's control. "I told them, 'Sorry, we can't move the Fortune 500 to Cleveland.' We had to sell to the firms that were already there."

So some reps moved on, while others were moved out. The rest "stepped up to the plate," Lawson says. Altogether, about half of the fiscal 2000 district team was retained for the 2001 effort. Lawson now had a half-dozen reps to cover the district, two each in Cleveland and Pittsburgh, and one apiece in Dayton and Columbus.

Lawson had his team in place, his expectations laid out and a highly motivating comp plan. He still had to manage the sales effort and he had the key: solution selling.

SAS makes highly sophisticated computer programs, which are termed decision-support tools. However, with a price tag ranging from $100,000 to $250,000 on up to a

*Change is the law of life. And those who look only to the past or present are certain to miss the future.*

JOHN FITZGERALD KENNEDY

creative firm
*Selling Power*
designer
  Colleen McCudden
client
  Selling Power Magazine

*The slightly-muted colors chosen for this magazine layout offer a calming effect, but in conjunction with so much dark gray, hint at something mysterious*

creative firm
*Scanad*
designers
Lars Holmelund,
Henry Rasmussen
client
TeleEurope Xformation

| | | | | |
|---|---|---|---|---|
| "Non, merci"! | "Please don`t call again"! | "No, no,no"! | "Prøv igen næste år"! | "Sie stehen als nummer 4 in der Reihe"! |
| "Je n'ai pas du temps maintenant"! | "Ingen interesse"! | "Nej tak"! | "Je ne sais pas"! | "Øøøøøøhh"! |
| "Rufen Sie bitte nicht wieder"! | "Ich verbinde"! | "Non,non - finalement non"! | "Hvem siger du, det er"? | "Unfortunately, he is not in at the moment"! |
| "Avez vous le temps d'attendre"? | "Han har dårlig tid nu"! | "Kein Interesse"! | "yes, yes"! | "Wen meinen Sie es ist"? |
| "No thanks"! | "Do you speak French"? | "Nej, nej og atter nej"! | "Peut-être"! | "Har du tid at vente"? |
| "Nein, nein und nochmals nein"! | "Not interested"! | "Kein Interesse"! | "Måske"! | "Ich habe kaum Zeit jetzt"! |

## Language of results

Time is best used for hot leads.

But most sales resources are swallowed by contacts without results. Eliminate them and save a lot. And use your powers were they matter.

It's the art of cutting to the bone. Removing irrelevant information. This is called xformation and that is what TeleEurope produces.

By phone and Internet we identify your gold through rational, effective, compentent market intelligence.

The final product is relevant information. Leads, open doors and positive response. This is the foundation for profitable costumer relations.

Start by calling +45 8730 7744.

TeleEurope ®
XFORMATION

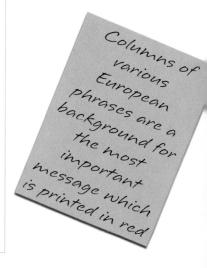

Columns of various European phrases are a background for the most important message which is printed in red

SEXY MEN 2001

# John
# Stamos

**sexiest comeback**

Among his many gifts, John Stamos has one that comes in particularly handy at home. The 38-year-old actor, who's married to supermodel-actress Rebecca Romijn-Stamos and stars as a master criminal turned FBI crime fighter in ABC's new *Thieves*, is an accomplished cook—shrimp scampi over pasta is a specialty. "I do it basically out of necessity," he says. "Rebecca can't even boil water." She doesn't have to. During their 1998 wedding, "he vowed he would always cook for me," says Romijn-Stamos, 29. "He's kept his promise. I'm very happy about that."

Lately, though, it's been strictly room service for the couple. They're staying in a hotel while overseeing construction of a home and two guest houses on a ranch outside L.A., not far from where Stamos grew up. The former teen idol, who played Blackie Parrish on ABC's *General Hospital* from 1982 to 1984, and Uncle Jesse on ABC's *Full House* from 1987 to 1995, looks forward to the project's completion so he and his wife can resume entertaining, a favorite activity. Meanwhile, they've been thinking about what would make their new place inviting to guests. They've already purchased an entrance sign to Disneyland, one of the couple's favorite places and the site of their first date. But apart from the decor, "Rebecca wants a llama," says the 6-ft. Stamos. "And I want a shrimp farm. We'll have people over and I'll say, 'Want some shrimp?' Then I'll ride the llama over to the shrimp tank, and everything will be right there."

Photograph by Lance Staedler

PEOPLE 11/26/01 **85**

creative firm
*People Special Issues*
designers
Gregory Monfries,
Ronnie Brandwein-Keats
client
People Magazine

*Title, beginning in the portrait and ending in the color block for text, links the image and written word*

Red, white, and blue letters in the first name are juxtaposed with black and gray letters to suggest two sides of the man

creative firm
*American Airlines Publishing*
designers
Gilberto Mejia,
Justin Case
client
American Way Magazine

CELEBRATED WEEK

GEORGE

STEPHANOPOULOS

D.C.

The former Clinton administration wunderkind, who now appears on ABC's *This Week* each Sunday, takes us on a tour of the nation's capital. **BY MARK SEAL** PHOTOGRAPH BY JUSTIN CASE

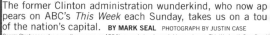

George Stephanopoulos currently serves as an ABC News analyst and roundtable member on *This Week with Sam Donaldson & Cokie Roberts*, where each Sunday he discusses current affairs with fellow pundits Sam Donaldson, Cokie Roberts and George Will. Which is a long way from that July Fourth in 1981, when Stephanopoulos took his very first trip to Washington, D.C., from his home in Cleveland, carrying with him what most people carry to Washington: a sense of awe. A Rhodes scholar and son of a Greek Orthodox priest, Stephanopoulos' first Washington job was as a congressional intern. That position launched him on a journey that would eventually take him all the way to the White House, where as key strategist in both Clinton presidential campaigns, he became the young face — and most eligible bachelor — of the Clinton administration, eventually serving as senior advisor to the President for Policy and Strategy. Although the 41-year-old now lives in New York with his new wife, actress Alexandra Wentworth, a piece of Stephanopoulos' soul remains in the nation's capital. Here is a weekend with George in Washington, D.C.

22 | AMERICAN WAY | 02.15.02 | © JUSTIN CASE/CORBIS OUTLINE

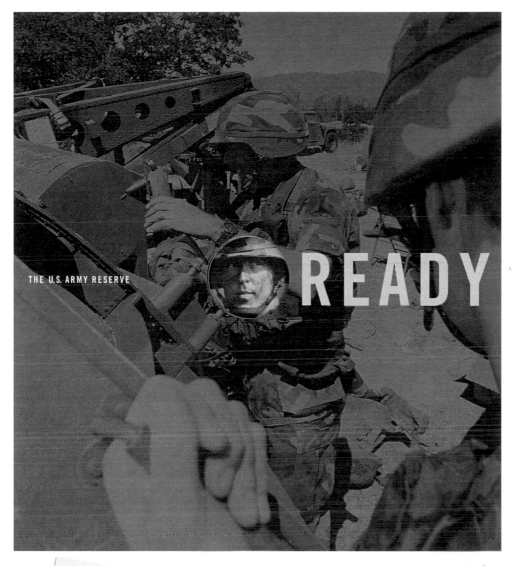

THE U.S. ARMY RESERVE

READY

creative firm
*Pressley Jacobs*
designers
William Lee Johnson
client
The U.S. Army Reserve

Gold words and figure emerge powerfully from gray background

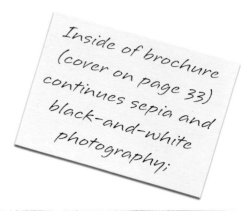

Inside of brochure (cover on page 33) continues sepia and black-and-white photography;

GO

Die cut circle keeps printed face (from inside back cover) in the center of all photographic action

THE U.S. ARMY RESERVE
IS AN INTEGRAL PART OF
THE U.S. ARMY'S FIGHTING
FORCES. JOB ONE FOR
THE ARMY RESERVE IS
TO PROVIDE THE
SPECIALIZED MANPOWER,
BRAINPOWER AND
SKILLS THE ARMY NEEDS
WHEN IT NEEDS IT.

(continued)
creative firm
*Pressley Jacobs*
client
The U.S. Army Reserve

Hot pink is used at the top of this ad to get the viewer's attention, and again at the bottom to move the eye downward

creative firm
**Bergsoe 2**
designers
Carsten Loland,
Henry Rasmussen
client
Organon

White text reversed out of bright red is a powerful aesthetic

creative firm
**Kiku Obata + Company**
designer
Joe Floresca
client
Patrick Davis Communications

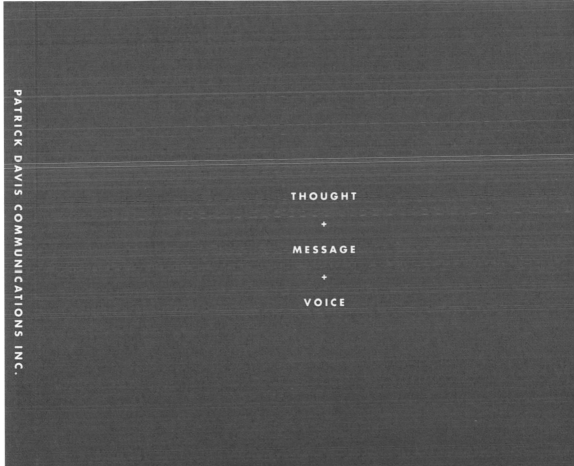

PATRICK DAVIS COMMUNICATIONS INC.

THOUGHT

+

MESSAGE

+

VOICE

(continued)
creative firm
  *Kiku Obata + Company*
client
  Patrick Davis Communications

# PATRI©KDAVIS

We would be honored to learn about your
needs, goals and priorities.

314.436.9333

The last page of
this brochure
(cover on page 37)
has angled slits to
hold a business
card

creative firm
**Leo Burnett Company Ltd**
designers
Judy John, Sean Barlow,
Paul Giannetta, Kim Burchiel
client
Kellogg Canada

Not a lot of words— strong photographic images with a brief line of text complete the message

SNACK ON THEM.

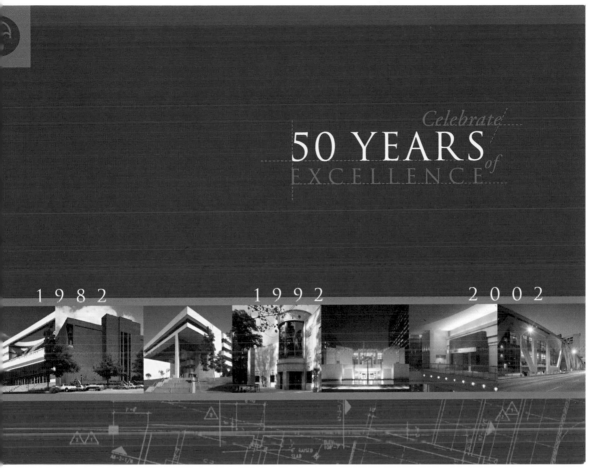

Celebrate

# 50 YEARS
of
EXCELLENCE

1982    1992    2002

creative firm
*Jones Worley Design Inc.*
designer
Cynthia Jones Parks
client
H.J. Russell and Company

Architectural elements are found not only in the art of this brochure cover, but in the headline presentation as well

(continued)
creative firm
*Jones Worley Design Inc.*
client
H.J. Russell and Company

# 1950s

## AGAINST ALL ODDS

. Russell was a child during the Depression. Although times were tough, his role model was his
no owned his own plastering business. "As much as I wanted to work, I remember when there were no
t's one of the reasons my desire was so great to be my own boss." Out of that challenge of no
work was born an entrepreneurial spirit. At the age of eight, H.J. did chores in his neighborhood; at
t a paper route. A couple of years later, he opened a shoeshine parlor in a vacant lot in front of his
ouse in Summerhill. Always enterprising, Herman got someone to help him and began selling soft
d ice cream to his clients.

T. Howard High School, Herman was campaign manager for the Progressive Party. His slogan was
od, more reasonable prices." His party won, even though he admits he had no idea how he could
that promise. During the summers as a young teen, he worked with his father as sub-contractor and
master tradesman and mechanic. He saved his money and at age 16 bought a vacant lot from the city
, building his first rental property, a duplex.

Photos left to right:

David T. Howard's industrial art class, 1949, with H.J.
in the front left

H.J. and Edward Johnson enjoy a cool drink at H.J.'s
first home on South Avenue in Summerhill in 1956

H.J. graduates from Tuskegee in 1953

Later, Herman Russell attended Tuskegee Institute in
Alabama and worked as a subcontractor, with his brother
Rogers assisting. "We got so much work, the sheriff told
Rogers to leave town, we were taking work away from
locals," recalls Herman with a laugh. He graduated in
1953 with a degree in building construction.

9

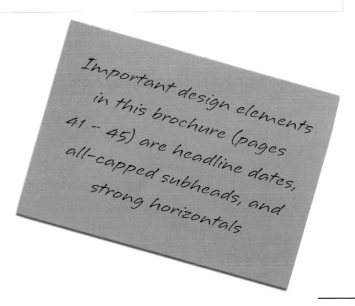

Important design elements in this brochure (pages 41 – 45) are headline dates, all-capped subheads, and strong horizontals

(continued)
creative firm
*Jones Worley Design Inc.*
client
H.J. Russell and Company

*Inside layouts of brochure (pages 41 – 45) are related through full-page pictures on the left, text and photos on the right*

# 1960s

## OPENING
## DOORS

of the 1960s was important for both the United States and H.J. Russell & Company. While erican leaders were waging a war for Civil Rights throughout the South, Herman began his first ect, a development of 12 units on South Avenue in Atlanta. Two years later in 1962, H.J. Russell on Company was born. The following year, the 33-year old developer had a coveted assignment: he Atlanta Fulton County Stadium. That same year, Herman Russell became the first African-member of Atlanta's Chamber of Commerce.

-profile commercial projects were quickly added during this turbulent decade, including the uilding (1968); and the Citizens Trust Bank building (1969). In 1968, HUD began its building d H.J. Russell & Company quickly became one of the largest constructors of HUD housing heast. That same year, the H.J. Russell Plastering Company was awarded the fireproofing and contract for the Equitable building, the largest contract of its type ever for an African-American npany.

During the civil rights movement, Herman Russell was just as active. Dr. Martin Luther King, Jr., whom he met in 1964, was an inspiration. "Dr. King was a part of my generation; I admired him." He cites civil rights attorneys Donald Hollowell and A.T. Walden, along with Bishop W. R. Wilkes of the Allen Temple AME Church, as part of a circle of influence on local, regional and national issues.

13

### Living the brand

A brand must live to survive. And progress is the only proof of life.
That is why we see the strong brand as a story that never ends.
As a perpetual process always to be renewed, always demanding
attention and commitment. It's hard work. But it adds life to your
brand.

Bold bar of color balances the larger black-and-white portrait

creative firm
*Scanad, Odense/Aarhus*
designers
Ole Kirkeby, Alan V. Hansen,
Henry Rasmussen, Lasse Jensen
client
Scanad

A box of lighter
tones makes for
easier readability
when text is placed
on a photograph

creative firm
**Tilka Design**
client
Ford Consulting Group

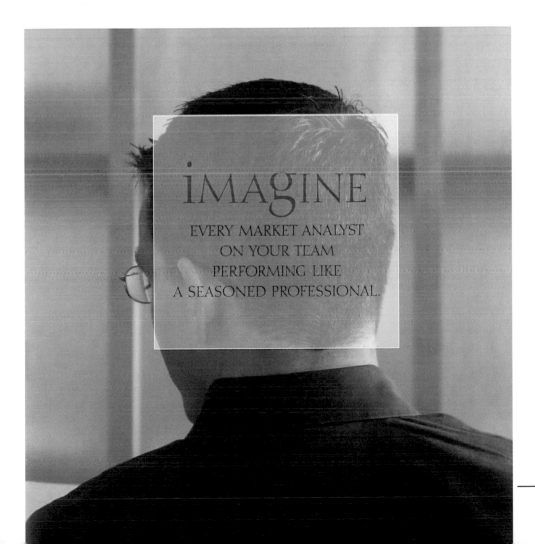

Cohesive elements of this brochure (pages 47 – 49):

Tonal boxes, similar photo colors, and the repeated use of a white bar (with logo) at the top of each layout

fORD
CONSULTING
GROUP

eMPOWER

YOUR BUSINESS ANALYST TO
CONTRIBUTE INDISPENSABLE
RECOMMENDATIONS
WITH MINIMAL COACHING
AND SUPERVISION.

(continued)
creative firm
   *Tilka Design*
client
   Ford Consulting Group

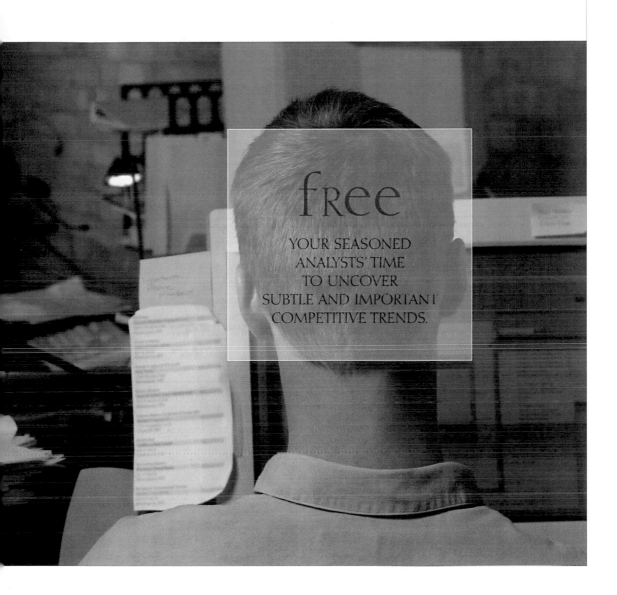

free

YOUR SEASONED
ANALYSTS' TIME
TO UNCOVER
SUBTLE AND IMPORTANT
COMPETITIVE TRENDS.

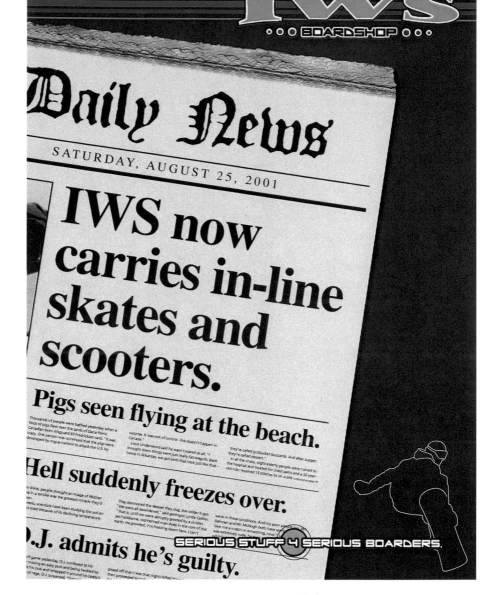

Bright colors contrast strongly with a black-and-white image, giving both extra emphasis

creative firm
 *Lawrence & Ponder Ideaworks*
designers
 Lynda Lawrence, Matt McNelis,
 Gary Frederickson
client
 IWS Boardshop

Lots of white space encourages the eye to focus on darker-colored text and logo

FORGING RELATIONSHIPS, BUILDING BUSINESSES
*Since 1974*

EXECUTIVE SEARCH SERVICES ◆ TEMPORARY/QUICK-RESPONSE STAFFING ◆ BUSINESS CONSULTING

creative firm
**Phoenix Creative Group**
designer
Angela Buchanico
client
MBA Management

PUT A RELATIONSHIP WITH US TO WORK FOR YOU.

Regardless of your employment needs, MBA Management can help your business tap into the best available resources the industry has to offer. Put a quarter century of knowledge, commitment, and yes, *relationships* to work for you tomorrow. Start a relationship with us today.

### Corporate Retainer Program

The most comprehensive way to put MBA Management's resources on your side is through our Corporate Retainer Program. This arrangement keeps us working on your behalf every day, and enables you to:

- Spread out costs
- Add a proactive resource to your team
- Get access to top candidates as soon as they become available
- Reduce in-house time spent recruiting and hiring
- Deliver ongoing feedback and communication

*MBA Managemen*
*business tap into t*
*resources the indu*

START A RELATIONSHIP WITH US TODAY.

TELECOMMUNICATIONS

*The same neutral colors are used throughout this brochure (pages 51 – 53)*

*Back inside cover incorporates a flap to hold informational sheets and business cards*

*p your*
*ailable*
*o offer.*

VISIT US AT WWW.MBAMGMT.COM

(continued)
creative firm
   *Phoenix Creative Group*
client
   MBA Management

*Geometrics with gradient fills show space and dimensionality*

Unlocking
Exceptional
Performance

TOTAL: Impact

A Total Solution
Approach to the
Challenges of
Human Services.

creative firm
**Desbrow & Associates**
designer
Brian Lee Campbell
client
ESTEAM

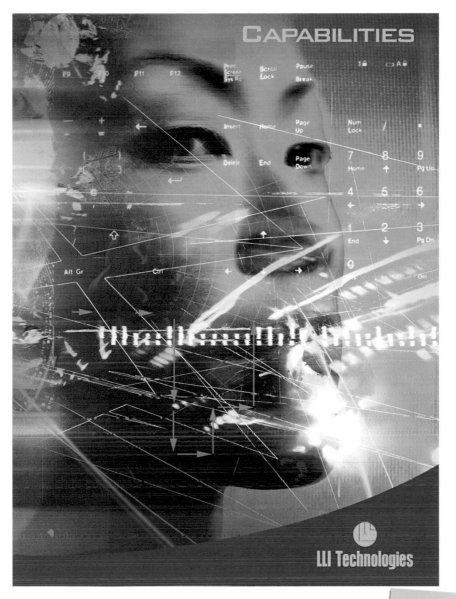

creative firm
**Adam, Filippo & Associates**
designers
Adam, Filippo & Associates,
Martin Perez,
Ralph James Russini
client
LLI Technologies

Energy is indicated through bright colors and layers of images (mathematical, human, textural)

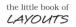

# ENGINEERING
# DESIGN

INTEGRATING COMPLEX

ENGINEERING AND TECHNOLOGY

TO PROVIDE COMPLIANT,

RESPONSIBLE BUILDING SOLUTIONS.

LLI Technologies

LLI'S ENGINEERING DESIGN

PRACTICE IS BUILT AROUND THE PLANNING, DEVELOPMENT, CONSTRUCTION

ION OF BUILDING SYSTEMS. IT INCLUDES OUR BASIC BUILDING TECHNOLOGIES

PECIALIZED CONSULTING SERVICES SUCH AS ENERGY MANAGEMENT, FACILITIES

MANAGEMENT, COMMISSIONING AND START-UP.

All caps or small caps are used in this brochure's headlines (pages 55 – 57)

a curved border filled with solid blue echoes the shape, and complements the color, of the company's logo.

(continued)
creative firm
*Adam, Filippo & Associates*
client
LLI Technologics

Excellent photography is the medium used to make this company's fashion statement; the only text used is the business name

MaxMara

creative firm
*Dente Cristina*
designer
Barbara Dente
client
MaxMara

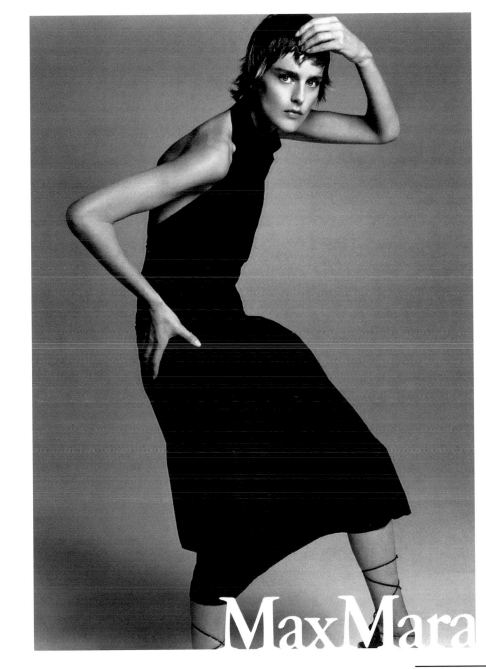

MaxMara

Large copy, even though somewhat obscured by foreground figure, is easy-to-read; importance among words is indicated through usage of percentages of black

creative firm
**American Airlines Publishing**
designers
Korena Bolding,
Michael O'Neill
client
American Way Magazine

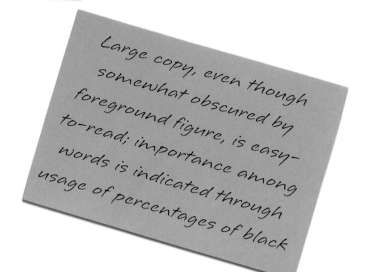

**CELEBRATED WEEKEND**

# LOPE

**Movie star, recording artist, and fashion icon J.Lo gives us the lowdown on her happening hometown.** *Growing up in the Bronx, Jennifer Lopez learned how to dream big. And while she is an undeniable star today, she hasn't forgotten where she came from. Her first album, On the 6, was inspired by the #6 train that took her from her family's Castle Hill neighborhood in Manhattan for dance lessons. The daughter of a kindergarten teacher and a computer specialist, Lopez literally rode the #6 train to stardom, as her lessons began paying off. She first landed a spot as one of the Fly Girls, who shimmied into commercial breaks on the TV series In Living Color. Lopez then danced her way into Hollywood. First, she landed a role in the short-lived series South Central, before moving on to movies with Mi Familia. But it was the much-coveted lead in 1997's Selena, the story of the slain Hispanic singer, that made Lopez a star. She was named one of People's Most Beautiful People of 1997, then went on to appear with Jack Nicholson in Blood & Wine, with Sean Penn in U Turn, and with George Clooney in Out of Sight. With her most recent film, The Wedding Planner, Lopez became the first person to have both the nation's number-one movie and number-one album (her second) simultaneously. This month, she's back on-screen in the romantic drama Angel Eyes. But a piece of her soul is still riding the #6 train into Manhattan. Here's where you'll find Jennifer Lopez in her hip hometown.* **BY MARK SEAL** ▶

05.15.01 | **AMERICAN WAY** | 25

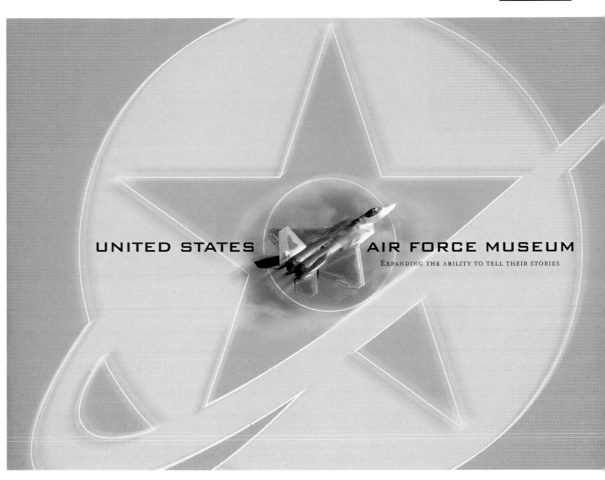

UNITED STATES AIR FORCE MUSEUM
EXPANDING THE ABILITY TO TELL THEIR STORIES

creative firm
**VMA, Inc.**
designers
Rob Anspach, Kenneth Botts,
Joel Warneke
client
Air Force Museum Foundation

Not too shiny, silver metallic ink offers an added brilliance to color printing

## ELEMENTS OF THE "NEW" MUSEUM

### The Hall of Missiles

The Cold War forever changed the course of American history. Protected by two oceans, Americans had always felt safe from aggression, but the advent of nuclear weapons and the threat to the free world presented by the Soviet Union eroded that security after World War II. This erosion of security manifested itself as American families constructed personal bomb shelters and children learned to "duck and cover." In those dark days, the newly created United States Air Force shone brightly as a crucial element to deterring communist aggression.

Together with American industry, the Air Force built two of the three strategic elements of deterrence: long-range bombers and intercontinental ballistic missiles. In addition, space-based reconnaissance played an equally important, if less well known, part in the successful outcome of the Cold War. The Hall of Missiles will eliminate the difficulty of displaying the Museum's historic ICBMs and satellite launch systems, which range from the Redstone II to the mighty Minuteman III. Not only will they be placed in a protected environment, but visitors will be able to view them from several levels. Furthermore, the Hall of Missiles will provide for meaningful exhibits to tell this wonderful story to future generations.

### The Eugene W. Kettering Gallery

Exhibit space remains the Museum's most basic need, and the new Kettering Gallery will partially fill that need. While providing room to tell the Cold War story, it will be the scene of numerous changes and many temporary displays over the next five years. Arranging the aircraft into that enormous floor space will be a challenge—some of the aircraft are very large and difficult to move on the ground, but visitors will be able to observe the proceedings from a safe distance. Often times, aircraft that have not been moved for decades will be moved into the new building, and aviation enthusiasts will have a unique opportunity to see these aircraft in the open air for the first time.

The United States Air Force Museum, the Air Force Museum Foundation, and the American people cannot begin to repay their debt of gratitude to the Kettering family. From Mr. Kettering's "jumpstarting" the Museum in the 1960s to their $3 million pledge to the current campaign, the Ketterings have provided financial leadership whenever needed.

8

(continued)
creative firm
**VMA, Inc.**
client
**Air Force Museum Foundation**

### The Space Gallery

Immediately after World War II, the Air Force Scientific Advisory Board reported the possibility of "rocket navigation" beyond the stratosphere. Furthermore, it deemed the placement of a satellite into space as "a definite possibility." From that time forward, the Air Force, working in conjunction with the American aerospace industry, has fulfilled those possibilities, and the United States Air Force Museum is constructing a Space Gallery to present this largely unrecognized history.

The formerly classified history of the Air Force in space has been overshadowed by the National Aeronautics and Space Administration's (NASA) highly publicized exploration of space. The Air Force, as envisioned by the Scientific Advisory Board, has in fact been involved in every aspect of space from the beginning. With high-altitude balloons and rocket-propelled aircraft, the Air Force explored the outer reaches of our atmosphere, and from its earliest experiments with captured German V-2 rockets the Air Force developed many of the launch vehicles used by NASA. Mercury and Gemini spacecraft were launched on missiles originally built by the Air Force as part of the Cold War strategic deterrence. Air Force development of modern telecommunications and reconnaissance satellites has fostered space-based systems the world now takes for granted.

Along with the Hall of Missiles, the Space Gallery will tell this remarkable story of Air Force activities in space during and after the Cold War and the continuing move into space. Together, these two facilities will provide the right environment to display the Air Force's sophisticated space systems and to give the public a greater appreciation of why these systems are critically important.

Metallic ink isn't used inside this brochure (pages 61 – 63), but silver objects give the same feel

a consistent graphed background reinforces a technological image

creative firm
**Keller Crescent Advertising**
designers
Randall Rohn,
Gerry Ulrich
client
BVD

*Dotted line guides the viewer's eye from headline to art to product, at the same time framing all ad components*

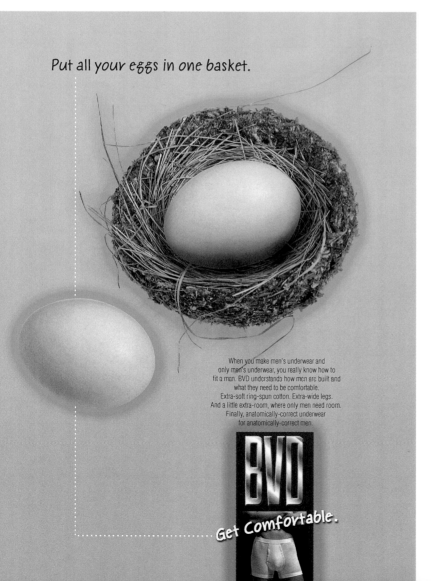

Put all your eggs in one basket.

When you make men's underwear and only men's underwear, you really know how to fit a man. BVD understands how men are built and what they need to be comfortable. Extra-soft ring-spun cotton. Extra-wide legs. And a little extra-room, where only men need room. Finally, anatomically-correct underwear for anatomically-correct men.

BVD

Get Comfortable.

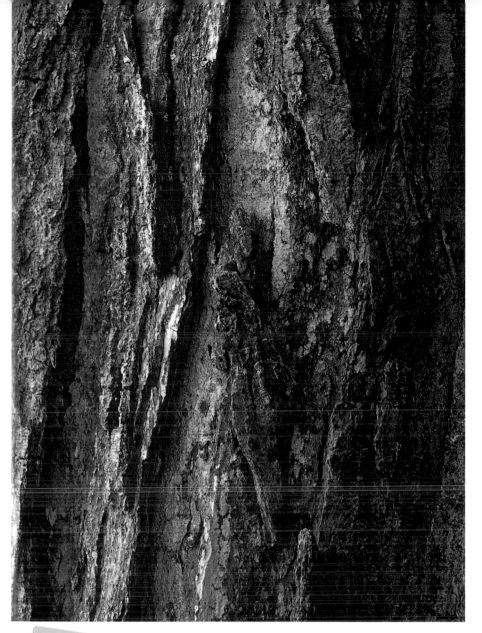

Great cover! Detail and texture of tree bark is enhanced by silver metallic ink and matte varnish

creative firm
  *Keiler & Company*
designers
  James Pettus,
  Sean Kernan,
  Allied Printing Services, Inc.
client
  Sean Kernan

### RHYTHM AND THE FOREST

The woods are music ma

Trunks and branches dr
and air into cycles and r
so complex that reason c
scheme for comprehensi
lets us enter this vast, cc
awareness, not to thougl

Physicists, peering over
of ten dimensions, even
different matter by assur
of one not obliged to pr
that all creation might b
model that gets me towa
into one another.

Art can mirror the worl
parts of ît. Its imprecise
hear two notes played to
one note changes. It cau
color and silence to reso
can feel but not explain.

Making the work on thes

**SEAN KERNAN**

Monochromatic photographs of trees dominate brochure (pages 65 – 67); text on this spread is printed in silver metallic ink on white

ɔle.

that divide great reaches of light
, matter and void alternating in ways
e nothing of them. Only some other
e musical, the artistic, the poetic —
pace. It yields its secrets to unifying
take it apart.

e of the known, suggest a universe
made of forces that manifest into
fferent rhythms. With the abandon
t he says, I jump right to the notion
. It's bad science, but it gives me a
lace where art and reality flow

ly that lets us understand
tify feeling a little sad when we
ust so, then a bit happier when
of light, words, sounds, darkness,
something powerful that we

has been a search for this music.

creative firm
**Keiler & Company**
designers
James Pettus,
Sean Kernan,
Allied Printing Services, Inc.
client
Sean Kernan

Effective insect control
in two easy steps.

creative firm
*OrangeSeed Design*
designers
Damien Wolf, Dale Mustful,
Phil Hoch, Rebecca Miles,
Kevin Caskey, April Umaña
client
McLaughlin Gormley King

This series of brochures (pages 68 – 71) employ reversed type from a green background

Kill crop damaging insects
dead in their tracks.

Insects are plotting
to destroy your
certified organic crops.

(continued)
creative firm
  *OrangeSeed Design*
client
  McLaughlin Gormley King

Note the
subtle
darkening
gradient
around each
green edge

PyGanic deliv

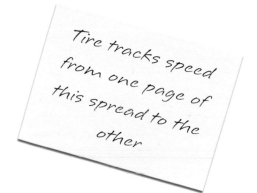

Tire tracks speed from one page of this spread to the other

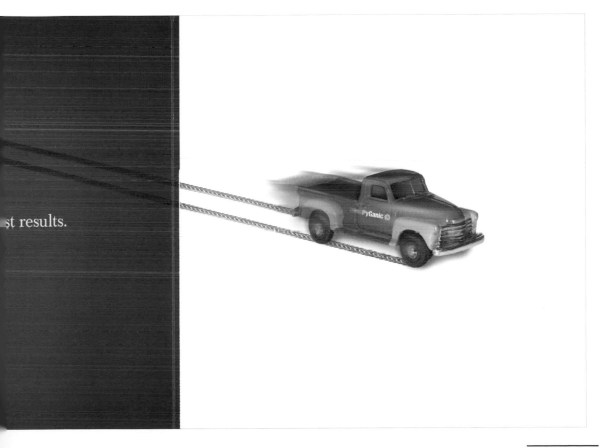

...st results.

# THE ●RACLE SPEAKS

CEO LARRY ELLISON says new software gave Oracle the tools — and the inspiration — to integrate, COMMUNICATE, and save A BILLION every year. And now he wants to do the same for YOUR COMPANY.

BY SCOTT S. SMITH  PHOTOGRAPH BY MATT BRASIER

Executives at Oracle Corporation were shocked when chairman and CEO Larry Ellison decided to manage the nitty-gritty details of the business a few years ago. The second-largest software maker in the world, founded by Ellison and two partners in 1977, was more accustomed to its colorful leader making headlines in yacht racing.

What was most surprising, reports Florence Stone in her new Ellison biography, *The Oracle of Oracle*, is that "time and experience — good and bad — have erased managerial flaws, as happens with many of our best business leaders … and he has developed into a great manager."

One of the things Ellison discovered as day-to-day CEO was that he had little control over his far-flung empire, because Oracle ran

05.01.02  AMERICAN WAY  57

*Decreasingly smaller type, from headline to body copy, guides the viewer into reading text*

*Staggered, hairline circles all orbit the "o" in "oracle", producing an interesting vortex effect*

creative firm
**American Airlines Publishing**
designers
Gilberto Mejia,
Betsy Semple,
Matt Braser
client
American Way Magazine

Though on an angle, this layout still makes use of a grid, strongly-indicated by the color block's edges

creative firm
*Jill Tanenbaum Graphic Design*
designers
Jill Tanenbaum, Sue Sprinkle
client
Johns Hopkins University/PTE

HEADSUP
Enter the world
of engineering
now.

Summer Introductory
Engineering College
Credit Courses
and Internship
Opportunities

Johns Hopkins University
Whiting School of Engineering

HEADSUP
Hopkins Engineering ADvanced Summer University
For Pre- and Early College Students

# Enter the world of engineering **now.**

## Johns Hopkins Engineering

*Summer Introductory Engineering College Credit Courses and Internship Opportunities*

For high school juniors and seniors, and early college students

**Good in math and science? Engineering – and HEADSUP – could be for you.** Bridges and biotech. Robots and rockets. Computers and clean-air engines. Engineers have developed them all. Engineers use math and science to solve problems and create possibilities, shaping every aspect of the world in which we live. Right now, young engineers are working on incredible innovations that will change the world of tomorrow. With HEADSUP, you can prepare yourself now to join them.

**The highest quality, college-credit courses.**
Get ready for a challenge. The HEADSUP summer offers seven weeks of college-credit engineering courses, taught by faculty that meet Johns Hopkins' high academic standards, and conducted at Johns Hopkins' own Montgomery County campus. If you're smart and ambitious, there's no need to wait — you can get excellent, college-level learning underway. Courses will be offered from among:

HEADSUP
For Pre- and Early College Students
Hopkins Engineering ADvanced Summer University Program

Discover HEA
and you'll dis
engineering –
the field that
shapes the w

### Engineering:
- Introduction to Programming in Java
- Digital Systems Fundamentals
- Introduction to Electrical and Computer Engineering
- What is Engineering?
- Models For Life (Biomedical Engineering)
- Introduction to Environmental Engineering

### Arts and Sciences:
- Biotechnology
- Bioinformatics
- Bioethics
- Biological molecules
- Science writing
- Film and media special effects technology
- History of science

## HEADSUF
- 7 week su
- College-cr
- Located o
  Montgom
- Includes
- Engineer
- Admissic

creative firm
*Jill Tanenbaum Graphic Design*
client
Johns Hopkins University/PTE

Chesapeake Bay Bridge photo taken by Scott M. Kozel

**A chance to work at leading high-tech companies.**
HEADSUP is able to arrange a limited number of internships for students
at Washington Metropolitan area companies. Here's your opportunity to
learn what it's really like to be an engineer, and get practical experience
you'll benefit from throughout your career.

**An easy way to learn more.** To learn more about HEADSUP
admissions and our application process, visit our website at
www.headsup.jhu.edu, call 301-294-7172, or email us at headsup@jhu.edu.
Or join us at our next *What Is Engineering? Fair* (check our website for
date and time) to enroll in person for next summer.

301-294-7172    headsup@jhu.edu    www.headsup.jhu.edu

glance

ram

es

s Hopkins University

y Campus

m a range of engineering disciplines

hip opportunities

all qualified high school juniors and seniors and early college students

*The grid of this brochure (pages 73 – 75) is broken by circles, adding both visual interest and theme*

# The Evolution of the Ojai Valley Youth Foundation — It Started with a Vision... then a Plan

"We, the citizens of the Ojai Valley, create this Youth Master Plan to ensure that our community is a safe and nurturing one for our young people to grow and reach their full potential."
Youth Master Plan, 1996

**Steve Olsen**
member. Sur
become a cha
in local goverr

Oak Tree

Ojai City Hall

In 1996 Ojai Valley residents set out on a journey...
The Ojai Valley Youth Master Plan outlines a bold vision for our entire community to support our children, youth and families. It includes the input of more than 1,000 residents, more than 2/3 of them youth.

**with 6 lofty goals...**
- To work together
- To support a safe, healthy and r for families and the community
- To increase valley-wide enrichm
- To prepare youth for the future opportunities
  - To foster respect and c and backgrounds
    - To locate and cr

**Some Ojai Valley Teen Statistics**
- The Ojai Valley is home to a higher percentage of single family households than the county as a whole (2000 census)
- 75% of Ojai Valley workers commute out of the Valley for employment (Chamber of Commerce)... leaving many teens without an adult nearby after school
- Ojai Valley public school 11th graders report a higher than state average use of alcohol (2001 California Healthy Kids Survey)
- Gang activity continues to exist in hot spots in the Valley (Ventura County Sheriff's Department)
- Involved teens don't have time to say "there's nothing to do!"

many o
In just fi
in 199
invo

**Jim Barrett** - Former Police Chief, Current Cowboy. His youth violence prevention efforts grew into the Youth Master Plan.

creative firm
*Generation Communications*
designers
Bobbi Balderman, Kate Engol,
Damian Reyes, Brian Shay
client
Ojai Valley Youth Foundation

The Ojai Valley Youth Master Plan, jointly sponsored by the City of Ojai, the Ojai Unified School District, and the Ventura County Sheriffs Department, quickly became a model for many other communities. According to the librarian of the League of California Cities, Ojai's plan has been in constant use by municipalities across the state.

rez. City Council
incipal. Has
ilt partnership

Ojai Police Department

Ojai School District

**Joi James-Müller, Melissa Ireta, Tammy Ireta, Kate Horwick** – *The Four Musketeers.*
Four of the instigators of the Ojai Valley Youth Foundation, as leaders, spokespeople, writers, graphic artists and videographers.

ent

al and employment

ong people of all ages, races

o achieve these goals

e meeting...
unity is reaching 90% of the Plan's specific objectives.
outh Foundation (OVYF) was formed, with youth actively
d leaders.

may continues...
hares some of what has developed in our community since the
the Youth Master Plan and the inception of the Ojai Valley Youth Foundation.

**OVYF's role is to activate the community for – and with – youth. Through building youth and adult partnerships, sharing ideas and resources, and forging new connections, we are together creating a stronger community for everyone.**

*A freeform mosaic is made with photos, color blocks, original artwork, and text used as the tiles*

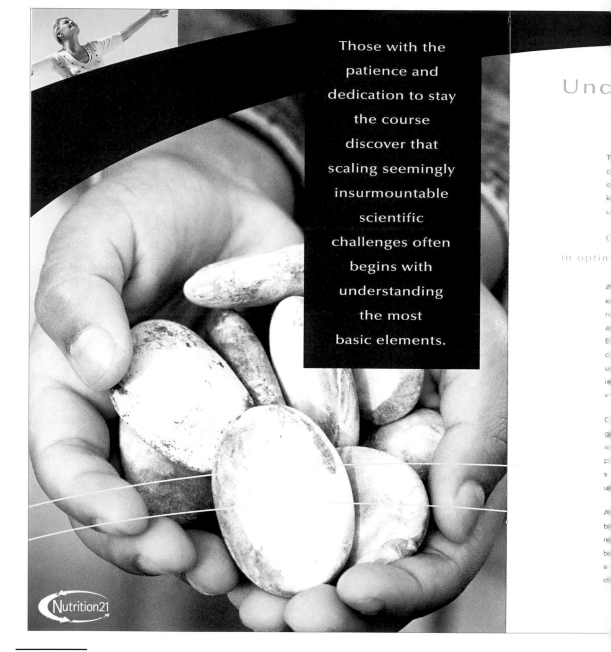

Those with the patience and dedication to stay the course discover that scaling seemingly insurmountable scientific challenges often begins with understanding the most basic elements.

Unc

in optim

Nutrition21

A navy blue arc, repeated in outline at the bottom, unites these two pages into a spread; wide margins and lots of leading between the lines of a sans serif font gives a clean look

tanding the
elemental science

orld is faced with a complex mystery to untangle. The twin epidemics of
obesity threaten to overwhelm our healthcare system and rob their victims
the enjoyment of life. Only recently have we recognized that one of the
aining good health and managing these diseases is to develop a better
g of how to restore impaired insulin function.

um picolinate plays an essential role
nsulin function.

f Nutrition 21's science portfolio lies chromium, a trace mineral deemed
ts critical role as a co-factor of insulin. From the beginning, chromium
uspected that Nutrition 21's form of chromium might hold great promise
tic supplement capable of helping people with insulin resistant diabetes
indicated that chromium picolinate increased insulin sensitivity, but this
otential was obscured by the proliferation of supplements making
ed claims. Many of these supplements contain ineffective forms or
oses of chromium, creating further confusion regarding the
oduct claims.

two years, Nutrition 21 has laid the scientific and business
eeded to address these concerns. Our persistent focus on
d optimizing commercial opportunities associated with our
hromium technology has brought our company to a new
tier—one that foreshadows a paradigm shift in our
g of chromium and its ability to reverse insulin resistance.

his knowledge, Nutrition 21 has pioneered an effort to
ceutical quality research to the development and
therapeutic supplements. We believe we are now on the
ling scientific breakthroughs that will recast the scientific
of chromium and its relevance to obesity, diabetes,
nd other insulin-dependent health conditions.

creative firm
**Planit**
designers
Molly Stevenson,
Kristen Steindl
client
Nutrition 21

creative firm
   *viadesign*
designers
   Scott Pacheco,
   Stephan Donche
client
   Jack in the Box

"BOB NUGENT"        screenprint on lenox museum board, 43 x 32 inches

*White space
emphasizes the
Warholesque artwork
even beyond its vivid
hues*

*a message from the curator*

**DEAR SHAREHOLDERS:**

The business climate of the late 1990s was one of high energy, excitement, and a sense of discovery and opportunity. It would be overly simplistic to characterize all that's happened in the world of business since then as a return to basics. The technological advances that fueled the speculative atmosphere of the '90s boom are still advancing, and even if back-to-basics is a guiding philosophy in business these days, leaders in traditional industries such as ours learned valuable lessons from the era of great expectations and valuations.

We at Jack in the Box Inc. emerged from the late '90s with a renewed appreciation of the role of innovation and the importance of adjusting to shifting market conditions and evolving consumer preferences. At the same time, we have been heartened to find that, in the past two years, many of the values we've believed in for decades found favor in the new-economy sector: a bottom-line orientation, strict attention to product quality and customer service, the importance of building a strong brand, and a refusal to cut corners for short term gains. Taken together, these learnings shaped our response to a number of developments that made 2001 challenging, but ultimately rewarding for the company as well as those with a vested interest in its long-term success.

For fiscal year 2001, sales at Jack in the Box company restaurants increased 12.1 percent to $1.71 billion, with revenues growing 12.3 percent to $1.83 billion. Same-store sales, a key indicator of vitality in our industry, improved 4.1 percent over the 3.3 percent increase we notched in fiscal 2000. Our earnings for the fiscal year, before an accounting change adopted in the fourth quarter, grew 8.7 percent to $84.1 million, or $2.11 per diluted share, from last year's $77.4 million, or $1.97 per diluted share before an unusual income tax item that added $22.9 million, or 58 cents per diluted share. A total of 126 new company restaurants opened for business in 2001, a 9.2 percent increase in total company restaurants compared with the previous year.

19

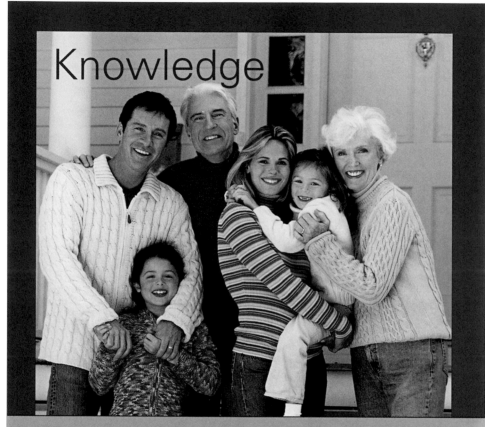

# Knowledge

## Just the Right Size

Every day we pro
Henderson Broth
resources to des
and service prog
major corporatio
every day we pro
smaller business
organizations, as
individuals with a
of personal need
we're big enough
insurance require
all types, yet sm
to respond prom
personally to you

Henderson Brothers services a broad range of commercial, personal and estate insurance clients, but we never forget it's all about people.

"

*Henderson Bro*
*provides world-*
*with local acco*
*They worked h*
*understand our*
*they share sim*
*with us and ha*
*a great advoca*
*extremely pleas*
*our relationshi,*
CEO / Community Ban

## A Unique Organization

Henderson Brothers is not structured like most insurance agencies. Other agencies have three times as many people selling you insurance as helping you deal with claims. We have three times as many claims and service people as sales people. We don't mind being different because we believe we're right. And so do our customers. Ask anyone who has needed help with an insurance matter and they'll vouch for our superior claims service.

## For the Historic Record

In the insurance business, the proof is in the service you provide your customers over time. That's how we've built the outstanding endorsements we have from our customers. At Henderson Brothers, we have many business customers who have been continually insured with us for decades, and many personal insurance customers whom we've insured across three generations and more. Our record says it all.

**What sets us apart**

*Any time there's a problem, one call does it all. Henderson Brothers provides all our insurance coverage, so there's a lot of volume, but I don't have to worry about it – they take care of everything.*

Officer / Paper Company

*We had to move some of our insurance coverage to another company for a short time. What an eye-opening experience! It made us realize what a great partner Henderson Brothers was – and we switched back!*

CFO / Construction Company

*Primary color scheme is orchestrated through several shades of yellow, red, and blue*

*Columns are given additional emphasis with red divider lines and borders*

creative firm
*Desbrow & Associates*
designer
Brian Lee Campbell
client
Henderson Brothers

creative firm
**Futurebrand**
designers
Greg Silveria,
Mark Landry
client
General Motor

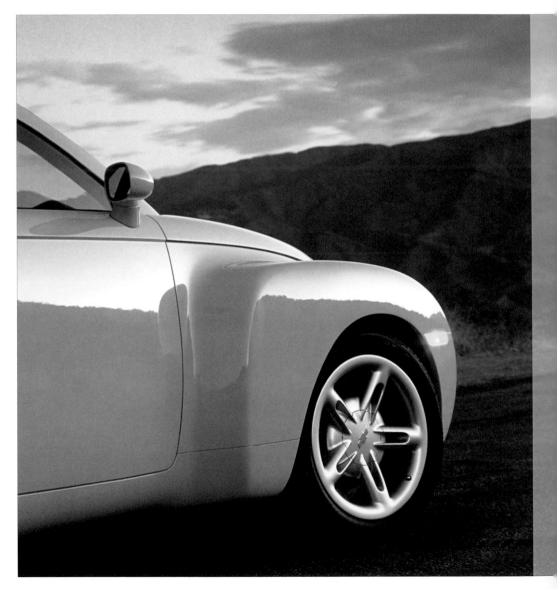

Gray, vertical band on photograph edge smoothly leads the eye to the next page's silver box with reversed type

Our brand is the face, personality and promise of our company. It symbolizes our culture, values and goals. It derives from elements such as our name and identity – and from experiences with our people, products and services.

Our challenge is to tell the GM brand story effectively. We need to manage the corporate brand and express its unequalled strength and heritage. We can not leave it to be defined by others such as the media, our customers or even our competitors.

We now have a unique opportunity to build the GM brand. We have the chance to leverage our achievements of the past and innovations of today to create something special. GM is asserting its leadership in the automotive business. Customers are being emotionally drawn to our "must have" cars and trucks. Let's capitalize on this winning spirit to build a brand that reflects who we are – and who we want to be.

# Defining
## the GM
## corporate brand

*Our brand is the face, personality and promise of our company.*

*Though similar colors and consistent use of fonts relates these two pages,*

*extreme tonal differences in overall values maintains their individuality*

creative firm
**Pricewaterhouse Coopers
Design Department**
designer
Raquella Kagan
client
CEO's & CFO's of Major Corp. Worldwide

# Documentation an
# Disclosure Issues
# Derivatives and H

SFAS

Deri

Activ

all fi

ning

1, 2(

*SFAS 133 is a comprehensive standard and there may*

*companies in understanding whether an instrument is*

*beneficial to companies to discuss SFAS 133 with their*

*believe they do not have any derivatives.*

## Derivatives represent assets and l

SFAS 133 establishes accounting and reporting standards for deriv
derivative instruments embedded in other contracts, (collectively r
activities. It requires that an entity recognize all derivatives as eith
financial position and measure those instruments at fair value. If c
may be specifically designated as:

    (a) a hedge of the exposure to changes in the fair value of a re
       or an unrecognized firm commitment;

    (b) a hedge of the exposure to variable cash flows of a forecas

10   ENTERING THE UNITED STATES SECURITIES MARKETS ◼ Current Accountin

ated to

ing

*ccounting for*

*uments and Hedging*

*5 133") is effective for*

*of fiscal years begin-*

*5, 2000 (i.e., January*

*ndar-year entities).*

*ities involved for*

*It may therefore be*

*en if they initially*

*s*

ts, including certain
erivatives) and for hedging
bilities in the statement of
s are met, a derivative

or liability

; or

ics

(c) a hedge of the foreign currency exposure of a net investment in a foreign operation, an unrecognized firm commitment, an available-for-sale security, or a foreign-currency-denominated forecasted transaction.

## Accounting for derivatives

The accounting for changes in the fair value of a derivative (that is, gains and losses) depends on the intended use of the derivative and the resulting designation.

■ For a derivative designated as hedging the exposure to changes in the fair value of a recognized asset or liability or a firm commitment (referred to as a fair value hedge), the gain or loss is recognized in earnings in the period of change together with the offsetting loss or gain on the hedged item attributable to the risk being hedged. The effect of that accounting is to reflect in earnings the extent to which the hedge is not effective in achieving offsetting changes in fair value.

■ For a derivative designated as hedging the exposure to variable cash flows of a forecasted transaction (referred to as a cash flow hedge), the effective portion of the derivative's gain or loss is initially reported as a component of other comprehensive income (outside earnings) and subsequently reclassified into earnings when the forecasted transaction affects earnings. The ineffective portion of the gain or loss is reported in earnings immediately.

Printed in three languages, the globe theme is perfectly appropriate

Interesting two-part brochure pivots on a rivet allowing information or globe to be fully visible or hidden

creative firm
*Hamagami/Carroll*
designers
Jane Kim, Mark Orton
client
Earth Tech

A Global Infrastructure Services Company

Earth Tech has increased its global presence and capabilities with the acquisition of two business units of Waterlink, Inc.– Waterlink GmbH in Germany and Waterlink AB in Sweden.

With these acquisitions, Earth Tech has not only expanded its global presence in the global water market. It also has expanded its service line to include water and wastewater systems and equipment with names you know and trust: MEVA, Zickert and Nordic Water Products (Dynasand™, Lamella™, Dynadisc™).

With Waterlink GmbH and Waterlink AB now a part of the Earth Tech family, we look forward to providing our complete suite of services and products to all of our clients worldwide.

Ett globalt företag för infrastrukturtjänster

Earth Tech har utökat sin globala närvaro affärsenheter av Waterlink, Inc.: Waterli AB i Sverige.

Med dessa förvärv har Earth Tech in den globala vattenmarknaden. Det servicelinje så att den omfattar sy och avloppsvatten med namn s på: MEVA, Zickert och Nordic Lamella™, Dynadisc™)

Nu när Waterlink GmbH en del av Earth Tech-fa att förse alla våra klie med vår kompletta och produkter.

www.earthtech.com

*Black & white against color is not only a visual contrast, but indicative of the passage of time*

creative firm
*The Golf Digest Companies*
designer
Debbie Chute
client
Augusta National Golf Club

MASTERS TOURNAMENT
$7.00 U.S.

# MASTERS
## JOURNAL 2002

Robert Tyre Jones Jr.
Centennial Celebration

Augusta National Golf Club
Augusta, Georgia
April 8-14, 2002
www.masters.org

Continued from the cover (page 89), black and white photos are used throughout;

taupe, used with percentages of black, adds sophistication to this otherwise single-color spread

## T H E   N I N E T I E S   T O   P R E S E

# Mast

**1990**
**NICK FALDO**
Down by four with six holes to play, Nick Faldo reeled off birdies on Nos. 13, 15 and 16 and caught Raymond Floyd at the end of 72 holes. Faldo, as he had done the year before, topped his rival at the 11th hole, this time with a par.

**1991**
**IAN WOOSNAM**
Ian Woosman came up big with a six-foot putt for par on the final hole to edge Jose Maria Olazabal by a stroke. Woosnam's final-round 72 was the highest fourth-round score by a champion since Craig Stadler's 73 in 1982.

**10 YEARS AGO**
**FRED COUPLES**

Fred Couples finished his third round morning by playing four holes in two to close within a stroke of the lead. B and-down par on No. 12 after his ba stayed on the bank instead of rolling i Creek that allowed him to post a fina It was good enough for a two-stroke v Raymond Floyd.

**The Champion's Performance i**

|  | Score | Eagles | Birdies | Pars | Bogeys |
|---|---|---|---|---|---|
| Final Round | 70 | 0 | 4 | 12 | 2 |
| All Rounds | 275 | 0 | 21 | 44 | 8 |

**1993**
**BERNHARD LANGER**
After making 10 consecutive pars (Nos. 3 through 12) in the fourth round, an eagle at No. 13 catapulted Bernhard Langer to his second Masters title. One stroke ahead of Dan Forsman and two ahead of Chip Beck through 10 holes, he cruised to a four-stroke win over Beck.

**1995**
**BEN CRENSHAW**
Ben Crenshaw suffered his only bogey on the second nine through the Tournament on the 72nd hole, but it didn't matter. He tapped in for a bogey 5 on 18, a 274 total and a one-stroke win over Davis Love III. When the putt dropped, Crenshaw bent over and covered his face with his hands. "I just let all the emotion go," he said.

19
NI
Six
Ne
ro
ha
He
bi
fo
da
th
wa
an
sai
do

**1994**
**JOSE MARIA OLAZABAL**
Two over par through 23 holes, Jose Maria Olazabal played the final 49 holes in 11 under par to win his first major championship. Closing with a pair of 69s on the weekend, the Spaniard won by two over Tom Lehman.

28

(continued)
creative firm
*The Golf Digest Companies*
client
Augusta National Golf Club

ersChampions

**1998**
**MARK O'MEARA**
Mark O'Meara became the first player since Arnold Palmer in 1960 to finish birdie-birdie to win the Masters. O'Meara was confident he could pull off the feat. Before teeing off on No. 17, his caddie told him that David Duval had finished eight under par. "He's going to be one short," O'Meara replied.

**1999**
**JOSE MARIA OLAZABAL**
A second-round 66 put Jose Maria Olazabal in the lead, a position he held right through Sunday to become the 14th player to win multiple Masters titles. "When I won the first one, you might say it might have been a lucky week," Olazabal said. "When you win two, especially the way I did today, it means a lot more."

**2000**
**VIJAY SINGH**
A then-record 35 International players were in the starting field of 93 at the 2000 Masters, including Fiji's Vijay Singh. Once he took the lead on the 12th hole Saturday, he never let go. Singh's 278 total was good for a three-stroke win over another International star, South African Ernie Els.

d Greg
fourth-
Faldo
error.
th six
e bogey
67 (the
nd his
et. "I just
nsibly
nistake,"
naged to

**1997**
**TIGER WOODS**
With a record-shattering performance in his first Masters as a professional, Tiger Woods left the field in his wake with a 12-stroke win. His 270 total remains a scoring record. The victory made the 21-year-old Woods the youngest champion in Masters history.

**2001**
**TIGER WOODS**
Tiger Woods used a dazzling tee-to-green game to win his second Masters and fourth straight professional major. In fashioning a 16-under-par total of 272, Woods led the field in driving distance (305 yards), while hitting an amazing 59 greens in regulation. ❖

## AUGUSTA NATIONAL BENCHMARK

By launching its Internet site (www.masters.org) in 1996, Augusta National Golf Club brought the excitement of Masters week and the beauty of the Club to golf enthusiasts via the Web. The 2001 Web site was visited by more than one million people during Tournament week. This year it includes live practice-round coverage on Nos. 12 and 18, plus live driving range video all week. Also available: exclusive real-time scoring and leader boards, CourseCam images, streaming audio and video of player interviews, and live Masters radio coverage.

29

Cut narrower than its brochure, cover opens to reveal text printed on a solid color beside a power-filled painting

**TRC offers your company a unique solution to relieve its environmental liabilities—forever. We call it the Exit Strategy® program. By transferring your liability for a contaminated site to TRC, we reduce your corporate costs and expedite site restoration.**

When TRC created the Exit Strategy program several years ago, the *Wall Street Journal* praised it as a "radical experiment" to end the "tangle of litigation around U.S. Superfund law." Today, it is a proven success. With several major projects completed and over forty others under way, TRC is leading the industry with financial solutions that turn environmental liabilities into corporate and community opportunities.

TRC has more than thirty years of experience in restoring contaminated sites. We combine risk management, engineering, and financial expertise to provide cost-effective ways to eliminate your liability.

TRC accepts total and perpetual
liability for site cleanups.

creative firm
**Sightline Marketing**
designers
Robert McVearry,
Samantha Guerry,
Lucinda Kennedy
client
TRC Companies

## Exit Strategy solves a range of environmental challenges.

### Acquisitions, Divestitures, and Mergers

Exit Strategy liberates transactions stymied by uncertain environmental liabilities. TRC can make your deal a success by assigning a fixed value to the environmental uncertainty and accepting full liability. With Exit Strategy, the buyer gains cost certainty by eliminating the risk of future liability, while the seller secures a fair market price for the land and relinquishes the site free and clear. Both parties get an independent assessment of the costs, a framework for structuring a successful transaction, and the ability to optimize the tax implications associated with the liability. The Exit Strategy solution also ensures that neither party is dependent on the financial condition of the other when it comes to managing the long-term environmental liability.

"I don't believe this transaction could have been completed without the Exit Strategy contract. It's a creative way to solve what before would have been considered an impossible problem."

—President of a Public Energy Authority

### TRC Solution

A major utility planned to acquire 18 plants from the oil and gas division of a major U.S. corporation. With a $1.4 billion deal on the table, the acquisition came down to a disagreement on the value of the future costs of the existing environmental liability at those operating facilities. The deal came together when TRC was able to resolve that issue by conducting a site analysis and taking on the liability and cleanup for a fixed price of $47 million.

(continued)
creative firm
*Sightline Marketing*
client
TRC Companies

## Discontinued Operations

Exit Strategy relieves companies of the burden of maintaining environmental compliance support to closed or sold facilities.

### TRC Solution

As part of a restructuring, a major aerospace corporation closed facilities in New Jersey, Massachusetts, and California. With no personnel on-site to manage the cleanup, the company needed a way to manage their liability more efficiently—so they outsourced the projects to TRC. TRC assumed the environmental remediation liability associated with the regulatory closure for each of the three sites. Since the project was initiated, TRC has developed the remediation action plans, removed contaminated soil, designed and installed groundwater treatment systems, and worked with the community to build awareness and support for the process. All three projects are on schedule and within budget.

Spreads inside this brochure (pages 92 – 95) reimpose selected images from the artwork on its first two pages;

staggered paragraphs of type leave much white space; crossing dotted lines "point" to text of importance

*Divided into three boxes, picture, headline, and copy have similar weights*

creative firm
**Computer Associates International, Inc.
In-House Creative Development Dept.**
designers
Loren Moss Meyer,
Tom White
client
Computer Associates

I help the
CA team
achieve
our goals.

**TEAMWORK WITH FOCUS**

CA's success depends on my ability to work closely with my colleagues and partners. My role is to enable CA to deliver on our commitments and focus resources on doing what it takes to get the job done right. I am dedicated to selling new products and identifying new customers. Market leadership is my goal.

I AM CA.

Solid colors have shapes and text reversed out of them; white has words printed in the afore-mentioned hues

creative firm
**Greenfield/Belser Ltd**
designers
Burkey Belser, Tom Cameron,
George Kell
client
Dyer, Ellis & Joseph

DYER
ELLIS &
JOSEPH

LAW OF THE SEA

Left page is mainly art; right page is text and shapes repeated from the cover (page 97);

horizontal black and reversed line connects both

We know a seaworthy venture when we see one. Several of our lawyers are former officer the U.S. Coast Guard and Navy who recognize risks and identify opportunities others may

*SHIP TO SHORE*
Our clients include:
   cruise lines
   financing institutions
   heavy lift operators
   liner companies
   marine insurers
   offshore oil/gas service companies
   oil, chemical and LNG tanker operators
   ports and terminals
   salvage and dredging companies
   shipbuilders

FLE
To he
expa
a fiv
and
gene
thro

creative firm
   *Greenfield/Belser Ltd*
designers
   Burkey Belser, Tom Cameron,
   George Kell
client
   Dyer, Ellis & Joseph

AT HOME AT SEA. Dyer Ellis & Joseph lawyers have been guiding the
fortunes of leading maritime companies for more than 30 years. Our Washington,
D.C. location affords us an uncommon perspective on the changing regulatory
and legislative climate and enables us to chart legal, legislative and business
solutions to achieve your goals.

# WALL STRAIT

DYER
ELLIS &
JOSEPH

*NEW LAUNCH*
*When a growing diversified offshore*
*services company needed financing,*
*we helped launch their IPO and*
*follow-on public equity and debt*
*offerings of more than $600 million*

operator
otiated
financing
t that
savings

FULL SPEED AHEAD. Every sector of the maritime industry is changing

to meet the pressures of increased global trade. While some competitors

have consolidated to maintain market position, others are innovating

equipment and operations to remain independent. We help both with

strategies that cut through traditional barriers to create real change—

raising capital for vessel operators, helping ports expand operations,

securing grants from DOT for high-speed ferries and negotiating

joint ventures for a three-continent common carrier service.

35
34
33
32
31
30
29
28
27
26
25

# show

Geographics was a
highest possible h
Printing Industry A
Georgia (PIAG) at t
Excellence Awards. T
Award is bestowe
company that takes h
Best of Category
Awards of Exceller
(57 in all to be exact).
companies win award
shines as Top Notch
has now firmly estab
the top printing comp

GEOGRAPHICS 10-COLOR PRESS

Ten-color printing shows off with CMYK + metallic + four spot colors + varnish (wow!)

ı're the cat's meow

creative firm
*Jones Design Group*
designers
Vicky Jones, Caroline McAlpine
client
Geographics

Clean-looking cover nods at a grid through horizontal alignments of letters, and vertical alignment of green hairline and box edge

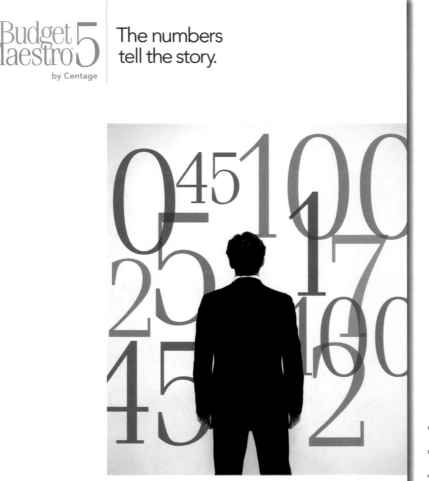

Budget Maestro 5
by Centage

The numbers
tell the story.

creative firm
*Lee Busch Design Inc.*
designer
Lee Busch
client
Centage Corporation

creative firm
**Toolbox Studios, Inc.**
designers
Paul Soupiset,
Steve Vance,
Allie Vallery
client
USAA

Superhero cover unfolds to a life-size version, ready for the viewer to insert head and click the camera

This three-page spread folds out from inside the brochure;

letter segments, snapshots, and more formal photography comprise a montage.

*statistics*
*are*
*smattered*
*throughout*

creative firm
**Nesnadny + Schwartz**
designers
Mark Schwartz, Joyce Nesnadny,
Michelle Moehler, Cindy Lowrey,
Stacie Ross, Keith Pishnery
client
Vassar College

Full-page copper metallic provides the background for photographs in this brochure (pages 106 – 109); copper recurs in headline and iconography on facing page

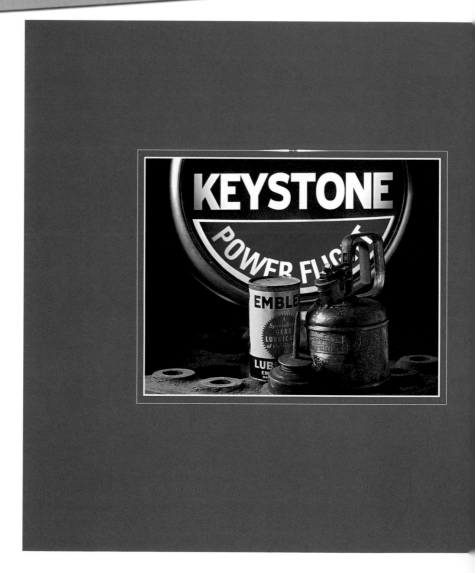

creative firm
**Adam, Filippo & Associates**
designers
Robert Adam,
Lawrence Geiger
client
United Refining Company

IT'S THE DAWN OF A **NEW CENTURY.**

TEDDY ROOSEVELT is in the White House. Confidence
is in abundant supply as a young country begins to
flex its mighty industrial muscles. And a small group
of entrepreneurs from Warren, Pennsylvania decide
the best way to ensure their companies a steady
supply of lubricating oils is to start their own firm.

On June 23, the Commonwealth of Pennsylvania
grants them a charter and 20 workers at the brand-
new United Refining Company begin processing
semi-finished lubricating stocks from nearby
refineries.

A hundred years later, United Refining has grown in
both capability and capacity, adapted to market
trends and world events, and emerged as a dynamic,
diverse regional player in the petroleum industry
while remaining a major employer in the local area.
Our commitment to the community remains as
strong as our determination to succeed in our
industry. And we plan to continue growth in both
areas for the next 100 years.

United Refining Company

Light on body copy, this brochure has a timeline across the bottom, spanning both pages, which helps move the viewer through the publication

FROM THE GROUND UP.

A COMPANY BORN OF NECESSITY.

United Refining
1929

**AT THE BEGINNING OF THE** 20th century, with America in the midst of the machine age, industry was booming everywhere. Including Warren County. And to keep the parts of that machine moving smoothly, they needed to be lubricated. So, to a group of local businessmen, it seemed like good business to own your own supply of lubricants. These captains of local industry decided rather than depend on other suppliers, they'd start their own refinery. And a dynamic, diverse company that would become an industry leader and a vital part of the local economy was born.

**1859**
Drake Oil Well is drilled.

**1902**
United Refining is begun by a small group of local businessmen who want to assure themselves an independent source of lubricating oils. Granted a charter by Commonwealth of PA on June 23.

**1903**
First auto license in Warren County issued. The first class graduates from Warren Emergency Hospital. The Wright Brothers take flight at Kitty Hawk. The first World Series is played.

**1904**
New York City subway opens.

**1905**
Oil is discovered along the Allegheny River near the eastern edge of Warren. The "Oil Boom" lasts two months as the shallow wells are quickly depleted. Einstein proposes his Theory of Relativity.

(continued)
creative firm
*Adam, Filippo & Associates*
client
United Refining Company

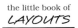

**1911**
Standard Oil
Company is
broken up.

**1913**
Henry Ford
creates the
assembly line.

**1914**
World War I
begins in Europe

**1915**
Electricity lights the
streets and homes of
Warren.

**1916**
The first self-
service grocery
store opens in the
U.S.

**1919**
World War I ends.
Prohibition begins.
Warren Chamber of
Commerce organized.

**1921**
First land purchase
authorized for Allegheny
National Forest on
October 21.

**1923**
The Pennsylvania Grade Crude Oil Association is organized to
promote and market the state's crude and refined oils. United
Refining begins gathering PA crude oil from nearby Bradford
field, acquiring pipeline system linking Bradford to Warren
refinery. Also begins exporting lubricants to European markets.

**1924**
More additions to the
company's refining capacity,
including installation of a new
vacuum unit.

# ON THE WATERFRONT

Waterwork has traditionally been the backbone of the company's business, exemplified in the construction of new piers, bulkheads, cells, fender systems, wharves, dolphins, and marinas. Repairs to marine structures are handled with the same attention to detail and technique as new construction. We employ innovative design techniques such as monopiles with floating fenders to bring our customers the most cost effective and durable result.

15.

Simpson and Brown is proud to be considered among the top six firms in the New York metropolitan area in marine construction. We have worked on such notable projects as:

◆ Pier Construction on Liberty Island (on cover)

◆ Port Authority Pier & Wharf Construction

◆ Renovation of Ellis Island Vehicular Bridge (above)

◆ Renovation of Pier A at the Battery (on cover)

◆ Staten Island Ferry Racks

◆ Governor's Island Ferry Racks

13.

14.

Photo 13. 3rd Avenue Bridge Fender
Photo 14. & 18. Hutchinson River Parkway
Bridge Fender
**Client: New York City Department of
Transportation, Bureau of Bridges**

Photo 17. New Pier Con
**Client: International Ma**

creative firm
*Ted DeCagna Graphic Design*
designer
Ted DeCagna
client
Simpson & Brown Construction

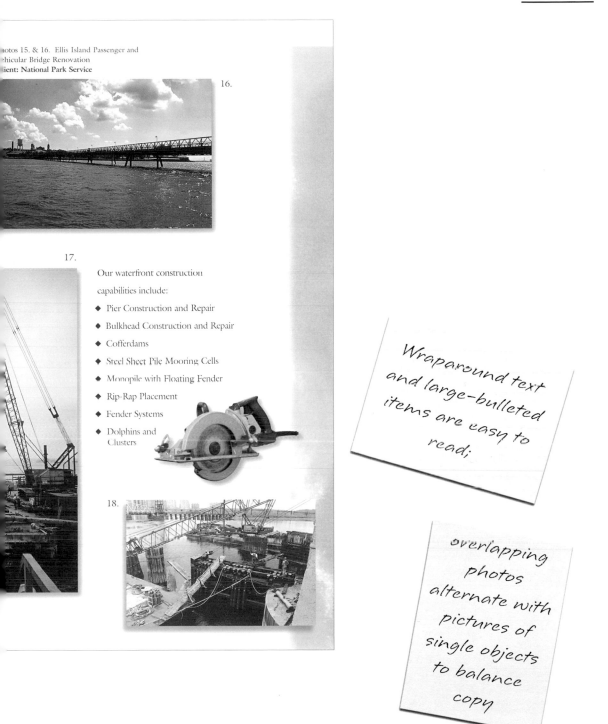

Photos 15. & 16.  Ellis Island Passenger and
Vehicular Bridge Renovation
Client: **National Park Service**

16.

17.

Our waterfront construction

capabilities include:

◆  Pier Construction and Repair

◆  Bulkhead Construction and Repair

◆  Cofferdams

◆  Steel Sheet Pile Mooring Cells

◆  Monopile with Floating Fender

◆  Rip-Rap Placement

◆  Fender Systems

◆  Dolphins and
    Clusters

18.

*Wraparound text and large-bulleted items are easy to read;*

*overlapping photos alternate with pictures of single objects to balance copy*

creative firm
**PriceWeber**
designers
Marta Garcia, Jenise Carolan,
Laura McDonald, Paul Schlesinger,
Jerry Duval
client
Brown-Forman Wines

Folder, made to hold loose cards (pages 113 & 114), is tone-on-tone debossed with logo in black foil

One of the
folder inserts is
a classic still
life featuring
the product

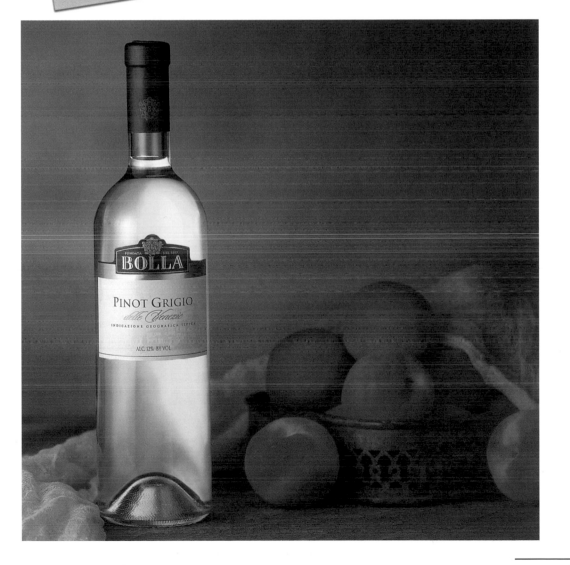

## THE BOLLA FAMILY OF WINES

BOLLA PRODUCES ITALIAN WINES OF UNCOMPROMISING QUALITY FOR EVERY TASTE AND EVERY OCCASION, FROM AN EXCEPTIONAL LINE OF SPECIAL RESERVES TO THE EVER-POPULAR VARIETALS TO TRADITIONAL VENETO CLASSICS. EACH AND EVERY BOTTLE OF BOLLA IS CRAFTED TO COMPLEMENT THE WORLD'S FAVORITE CUISINES OR SIMPLY TO OPEN UP ANYTIME FOR A WONDERFULLY AUTHENTIC TASTE OF ITALY.

SPECIAL RESERVES. RECOGNIZING THE NEED OF RESTAURATEURS TO OFFER A CHOICE OF ITALIAN WINE STYLES, THE BOLLA WINERY HAS PRODUCED A LINE OF SUPER- AND ULTRA-PREMIUM RESERVE WINES. REPRESENTING THE BEST OF BOLLA'S WINE-MAKING EXPERTISE AND COMMITMENT TO QUALITY, EACH WINE IS A UNIQUE EXPRESSION OF BOLLA'S VARIETAL OR CLASSIC MAINLINE WINES.

(continued)
creative firm
*PriceWeber*
client
Brown-Forman Wines

Simple, but tasteful, layout unobtrusively incorporates both serif and sans serif fonts: centered, justified, and in wraparound fashion

An expanse of
negative space
draws attention to
the title/statement

creative firm
**Cahan & Associates**
designers
Bill Cahan, Sharrie Brooks
client
McKesson

McKesson is everywhere.

Red on black, blue on white…copy is easy-to-read;

color choices and unusual numeric characters prevent a boring text-only layout

Everywhere in healthcare.

(continued)
creative firm
**Cahan & Associates**
client
McKesson

One company touching the lives of
100 million patients every day.
While we may be 170 years old, what
we do has never seemed
more relevant. As the population ages,
as new challenges arise, we continue
to find ways to connect and improve
the business of healthcare.
To reduce costs. To improve efficiency.
And, of course, to help save lives.
McKesson is everywhere.
Perhaps most important, we're
right at the center of
a healthcare evolution that has only
begun to show its promise.

Gestalt: an entity
greater than the
sum of its parts
OR
letter fragments
forming a legible
word

creative firm
**Nesnadny + Schwartz**
designers
Mark Schwartz, Joyce Nesnadny,
Michelle Moehler, Cindy Lowrey,
Stacie Ross, Keith Pishnery
client
Vassar College

Vassar

CommuNitY

of color

**WHAT ABOUT POUGHKEEPSIE?**

**NII MOI** I get out into the town a bit. There are some pretty good restaurants nearby — a nice Mexican restaurant, a Japanese restaurant. I've been out to some of the clubs, and they're pretty nice. And there are a bunch of festivals that are always interesting. A couple of weeks ago they had a Greek festival — Greek food, Greek music, Greek dances, Greek everything. So yeah, there's stuff to do in Poughkeepsie.

**KRYSTAL** It's an OK town. It does have its share of quaint little restaurants and cafes and shops. Cobablu (bakery and coffee shop) is probably one of my favorites.

**LIZ** Sometimes my friends and I will wander around, go shopping, go to a movie. We went to a drive-in in Hyde Park When my mom came to visit, we went to Rhinebeck and Red Hook, and it was just so much fun to walk around those quaint little towns.

**AND NEW YORK CITY?**

**GELEEN** Freshman year, I went down every weekend. And the next year when my brother passed away, I wanted to be with my family as much as I could. Now, I go when there's a special occasion. It's so near, and it's so easy to hop on a train and go home.

At some schools, the top profs just supervise graduate students and conduct their own research — they don't do much actual teaching. At Vassar, the entire faculty is committed to teaching. They love it. We asked Lizabeth Paravisini-Gebert, professor of Hispanic studies, one of the foremost scholars of Caribbean literature, author and editor of a shelf-full of books, why she teaches. "Teaching is a blast! I ask myself, can I be the one who lights the fire? I want to be the one who helps someone discover what they want to do with their lives, the one who sparks a passion…"

In many courses, particularly upper level courses, you have the sense that professors and students are co-discoverers. It isn't that the professor is simply passing on something already known. It's more that, together, they are investigating a particular problem, asking questions that have yet to be answered, engaging in true inquiry.

The student-faculty ratio is 9 to 1; average class size is 16. You *will* get to know your professors.

# f

## Faculty

a course on the international history of film, focusing in a given semester on a specific national cinema or region — Latin America, for example, where the class watched and analyzed films from Cuba, Argentina, and Brazil.

Mask, who got her doctorate in cinema studies at NYU, freelances as a film critic for a number of publications — *Cineaste, Indiewire.com,* and *Time Out,* among others. " I he benefit for me as a teacher is that I'm constantly aware of what's coming out, both from young, new filmmakers and older, more well-established directors as well."

-11-

*Nice type treatments— segment of a lowercase "f" is just too large to not be addressed as a capital; curve is accentuated by wraparound text*

**WHAT DO YOU LIKE BEST ABOUT BEING AT VASSAR?**

NII MOI  What I like best is that Vassar encourages students to believe that they can do whatever they choose to do, not just academically, but with their lives — the power and the freedom to construct your life.

GELEEN  I think the campus is beautiful — it truly is. Where do you find a college that has a lake? Academically, I like the flexibility of the curriculum, and I like the fact that the professors are so accessible. It says that in all the brochures, and I've really found that to be true.

ALEX  I hate to sound cheesy, but there are so many things to like. I love the aesthetics of the campus, the landscaping and everything. And the dorm rooms. Of all the colleges that I've been to visit, Vassar has the best dorms. And I also like the size of the school and the fact that I know my professors. I've been over to numerous professors' houses to have pizza or just to talk, and I think they genuinely like me and know me.

KRYSTAL  I love the diversity. I've never met so many people with different points of view who are willing to voice their beliefs and act on them. I find that so amazing.

LUIS  The best part of Vassar You could just be here and not back to your room. But if you're get involved with an office on ca — you make a difference, and make good friends.

LIZ  The people. Everyone is ju doing — it wasn't like that in my creative, they're very funny, th things and discussing what the

# Academics

**A** If you want to study history, you read a textbook, right? Not exactly. In the early 20th century, Vassar history professor Lucy Maynard Salmon sent her students out to examine buildings and the landscape for clues to the history of the college and the surrounding area. At the beginning of the 21st century, geology professor Brian McAdoo took his students to an 18th-century graveyard and used an array of geophysical tools (such as an electrical resistivity meter and a Cesium-vapor magnetometer) to figure out who was buried there. Times have changed, tools have changed — but the purpose of a Vassar education hasn't changed. It doesn't matter which of Vassar's 46 majors you choose, or which of the 1,000 courses you take. The purpose is to teach you to think outside of "the box," to question assumptions, to use your own powers of observation, to go to the source for answers…to become a kind of private investigator in affairs of the mind.

### LA Consequential

As for the future, Kelley Kawano, class of 2000, says that "the plan is that there is no plan. I used to be the girl with the plan: I wanted to stay in California, go to a UC school, and write. And look where I am now: in New York City, a Vassar grad, and on the other side of the writing coin And I don't regret any of it for a minute. The upshot is that I've pretty

much stopped making plans taking life just as it comes."

Former editor-in-chief o *Quilt*, one of several Vassar journals, Kawano landed a j Random House right out o working for the Media Asse Department web team as a editorial and marketing assi "The real reason I like my j much is that I can wear flip-

-2-

WHAT SHOULD I BRING WITH ME — BESIDES SOCKS AND CDs?

ng a part of Vassar.
just go to class and
t of Vassar — if you
ganization or a sport
nnections, and you

**GELEEN** A camera. I regret now not having taken as many pictures in the beginning, because I want to look back and see how I've changed. So many memorable things happen the first few weeks — definitely bring a camera.

d about what they're
People here are very
thinking about new
about.

**ALEX** Bring an open mind, enthusiasm, and perseverance. There have been times when I have had so much work that I felt overwhelmed. But I persevered, and I overcame those obstacles, and I was like, wow, if I can do this, there's almost nothing I can't do. The work is definitely challenging, but that's a good thing.

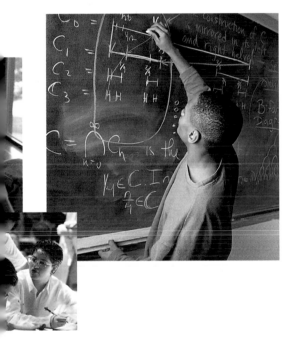

*Different subjects get different type treatments in this booklet (pages 118 – 123): quotes are black sans serif on a solid color, two columns per page;*

*a mini bio is red serif, three columns per page; general information is a larger, blue sans serif in one column following the shape of an initial letter*

work." No, seriously, her "most involving and favorite project" is editing Books@Random, the company's channel with AvantGo, a service that allows subscribers to access channels such as the *New York Times* using palm pilots. She's also on the editorial board of *Bold Type*, Random's online literary magazine. "I got to interview Haven Kimmel, writer of the memoir *A Girl Named Zippy*,

and Julian Gough, author of the novel *Juno & Juliet*. I loved their books, and it was nice to discover that they were funny, cool, smart, interesting people in addition to being great writers."

What did she like most about Vassar? "Its realm of possibility. I was very rarely told that I couldn't do something. When I wanted to prove that *Singin' in the Rain* was an anarchist film, my professor listened."

(continued)
creative firm
Nesnadny + Schwartz
client
Vassar College

Blocks of text,
blocks of color,
photographic blocks,
negative block shapes
all fit together like a puzzle

**Come Together**

The ALANA (African-American,
Latino, Asian, Native American)
Center, a cultural space for students
of color at Vassar, hosts a wide
range of activities and events —
workshops, lectures, faculty
dialogues, and cultural exhibitions,
as well as campus-wide events like
Asian Awareness Week, Indiafest,
Black History Month, Latino Week,
Multicultural Awareness Week,
Kawanzaa, and Diwali.

**From College to Career**

The Office of Career Development offers extensive support both for students
entering the job market after graduation and for students pursuing graduate study.
In addition to a full range of career counseling services, Career Development hosts
a number of special events, including Executive-in-Residence, a program to
demonstrate and strengthen the relationship between the liberal arts and the work-
ing world. This year's exec-in-res was Vassar graduate Paula Madison (above),
president and general manager of KNBC-TV, the first African-American woman to
become general manager at a network-owned station in the top-five market.

(continued)
creative firm
*Nesnadny + Schwartz*
client
Vassar College

- 8 -

## Vassar Firsts

If any one thing proves the value of a Vassar education, it is the pioneering achievements of Vassar graduates. The accomplishments of the community of color figure prominently in the long list of Vassar "firsts". A few examples: Claudia Lynn Thomas, MD, Vassar class of 1971, was the first African-American orthopedic surgeon in the United States. Fritz Friedman, class of 1974, was the first and remains one of the few Asian-American entertainment executives in Hollywood. Physicist Sau Lan Wu (left), class of 1963, and her collaborators discovered gluon, the "stuff" that holds quarks together to form protons and neutrons. Vicki Miles-LaGrange, class of 1974, was the first African-American woman to be sworn in as a United States Attorney…

Sports
eball
asketball
cross country
fencing
field hockey
golf
lacrosse
rowing
rugby
soccer
quash
mming and

## Affinity Groups and Cultural Organizations

African Students Union
Asian Students Alliance
*Asian Quilt* (literary magazine)
Black Student Leadership Network
Black Student Union
Caribbean Students Alliance
Council of Black Seniors
Ebony Theater Ensemble
International Students Association
Korean Students Alliance
Poder Latino
South Asian Students Alliance

## Coed Since 1969

After turning down an offer to merge with Yale University, Vassar opened its doors to men in 1969, with the first fully coeducational class arriving in the fall of 1970. Among that group of pioneers was Richard Roberts (left), now a US federal district judge for the District of Columbia. Roberts graduated cum laude from Vassar in '74, earned a master's from the School for International Training, and a JD from Columbia University Law School. He began his legal career as a trial attorney in the Civil Rights Division of the US Department of Justice.

-9-

# agency for change

At London's St. Luke's Communications, the employee-owners are challenging the corporate establishment. And business couldn't be better.

By Lori Stacy
Photography by Chad Windham

St. Luke's CEO Andy Law presides over an ad agency in constant revolution. He likes it that way.

## andy law is not your typical CEO. Not in a Jack Welch kind of way, or even a Larry Ellison kind of way. Law is a corporate chief who eschews every executive perk, from the big corner office (Law, like the rest of his 137 co-owners, must find a new place to park himself each morning) to the cadre of assistants (I can tell you firsthand, Law makes his guests a mean cup of cappuccino).

In fact, I might have taken it personally when Law escorted me into a storage room in the basement of his ad agency's London headquarters for our interview. But knowing how unusual St. Luke's made sitting in a closet among stacks of boxes feel just right. And considering the hectic pace at which St. Luke's operates, our makeshift meeting room turned out to be the quietest place in the building.

Law, the adopted son of a minister, entered advertising in the late '70s after a brief stint as a commodities trader. He was managing director of the London office of Chiat/Day at a time when Chiat/Day itself was exploring ways to run a company differently. Law was part of a task force charged with determining the ideal advertising agency of the future. He and the others became convinced that businesses — not just ad agencies, but any business — could become more ethical in the way they treated both their customers and their employees. But before they could implement any of their findings, the agency announced its merger with the behemoth Omnicom agency. ▶

05.15.01 | AMERICAN WAY | 79

*Whimsical type treatments include a flipped headline and body copy with very little leading; background photo spans the entire spread*

creative firm
*American Airlines Publishing*
designers
Gilberto Mejia,
Chad Windham
client
American Way Magazine

*"Neon" bars, borrowed from the sign/logo, frame this flyer's headline*

creative firm
**Berry Design, Inc.**
designer
Bob Berry
client
Apple-Rio Management

## SITE AND BUILDING REQUIREMENTS

### Site Specifications
- 1.0 – 1.5 acres depending on cross-access easement opportunities
- 100 parking spaces
- Population requirements: 45,000 within 3-mile radius
- Median household income of $30,000+
- High traffic / high visibility
- Heavy retail and office space backed up with heavy residential
- Preference for free-standing, self-contained site

### Building Design
- Prototype freestanding building is approximately 6,500 square feet
- Includes curbside service/to go facility
- Additional 293 square feet for cooler / freezer
- Exterior features cedar siding, stone and stucco
- Typical construction time is 90 – 120 days
- Warm accent lighting highlights building
- Distinctive neon logo and exterior lighting
- Seating capacity is 198
- Separate dining room and bar areas
- Kitchen designed for high volume and ease of execution

### Decor
- Inviting, lodge-like interior
- Comfortable free-standing tables and booths
- Custom fishing-themed ironwork accents
- Fishing artifacts and gear, including full-size canoe
- 400-gallon saltwater aquarium with exotic tropical fish

These specifications are approximate and are subject to change.

Vibrant colors unite
these pages;
very effective mix of
script, serif, and
italic fonts

*E*xperience the inspiring,
breathtaking natural landmarks
and endless moments of tranquil surroundings.

creative firm
*Bonato Design*
designer
Donna Bonato
client
Savoy Senior Housing Corporation

## Liberty Village offers you...

*an unparalleled lifestyle surrounded by the beauty and amenities of central Virginia, where you can enjoy life as you dreamed, partaking in a host of spiritual, educational, recreational and cultural amenities that are unsurpassed in the nation.*

*Within minutes of Liberty Village, you can tour the scenic Blue Ridge Parkway, hike the spectacular Natural Bridge, feel the power of the five cascades at Crabtree Falls, or canoe on pristine Smith Mountain Lake. Or you might take a leisurely drive to find yourself sunbathing on the beautiful beaches of Virginia and the Atlantic oceanfront.*

Liberty Village is central to many of our nation's most revered historic landmarks. Explore Lynchburg's mansion districts overlooking the James River or take a hike through Jefferson's summer home, Poplar Forest. Appomattox, where our nation was reunited, is a short drive away and the new D-Day Memorial Is In the neighboring town of Bedford. If you prefer a relaxed drive, within one hour, you can visit Jefferson's Monticello in Charlottesville, within two hours, you can visit historic Richmond, and within three hours, you can enjoy Washington D.C. and Fredericksburg.

*No wonder central Virginia is becoming known as retirement heaven!*

*Here, where deep blue seas meet azure skies and painted sands race toward purpled mountains, Rosewood has created an opulent resort. Las Ventanas offers a world of secluded luxury and unmatched service in a setting as warm and soothing as the Mexican sun. Outside, sapphire waters crash against soft white sands and wave-carved monuments of stone. Inside, indigenous art and architecture create an elegant Latin atmosphere that celebrates the essence of this ancient culture.*

**LAS VENTANAS**
· AL PARAISO ·
LOS CABOS, MEXICO
ROSEWOOD HOTELS & RESORTS

LOCATION Nestled between the roaring waves of the Pacific Ocean and the colorful deserts and soaring mountains of Baja California Sur, Las Ventanas is 15 minutes from San Jose del Cabo International Airport.

ACCOMMODATIONS Sixty-one richly appointed accommodations include 28 rooftop terrace suites, 28 ground-floor suites, four one-bedroom luxury suites and a three-bedroom villa. All rooms offer satellite television, CD players and views of a colorful tropical garden or the ocean. Many suites also offer splash pools, fireplaces and telescopes for whale watching. Guests are treated to an in-room tequila welcome, have access to a full video library, and may enjoy nightly entertainment.

MEETING/EVENT FACILITIES Meeting facilities include a 1,680-square-foot conference room capable of hosting up to 90 guests for receptions, 36 guests in a classroom setting or 60 guests for dinner. The conference room may be divided into two rooms. The outdoor Plaza offers a breathtaking view and holds up to 120 guests for a wedding or reception.

RECREATION Home to a remarkable European spa, Las Ventanas offers sought-after restorative treatments and a sophisticated health center. Guests also have access to five golf courses and deep-sea fishing, horseback riding, desert excursions and other activities.

DINING For elegant dining, The Restaurant offers Baja Mediterranean cuisine in a formal setting. The Sea Grill, with its swim-up bar and open-air setting, and The Ceviche Bar both offer a relaxed atmosphere. Guests may also enjoy starlit dinners on their private terraces, or small receptions in the private wine room.

KM 19.5 Carretera Transpeninsular ~ Cabo San Lucas ~ San Jose Del Cabo
Baja California Sur 23400 ~ Mexico ~ Telephone 52.624.144.0300 ~ www.lasventanas.com

creative firm
*David Carter Design Assoc.*
designer
Stephanie Burt
client
Rosewood Hotels & Resorts

*Badrutt's Palace*

ST. MORITZ, SWITZERLAND

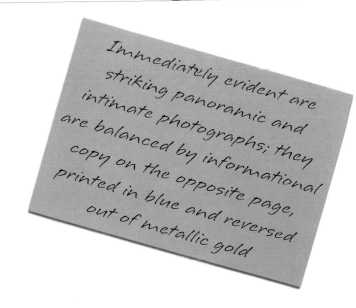

Immediately evident are striking panoramic and intimate photographs; they are balanced by informational copy on the opposite page, printed in blue and reversed out of metallic gold

# THE GALLERY AT FULTON STREET

THREE LEVELS OF OPPORTUNITY IN DOWNTOWN BROOKLYN

creative firm
**Kolano Design**
designer
Cate Sides
client
Thor Equities

Swirls of metallic and black inks, top and bottom borders are continued throughout this brochure; text is reversed out

Border-to-border and side-edge bleeds, architectural drawings are also a theme

## THE GALLERY AT FULTON STREET

MEZZANINE LEVEL

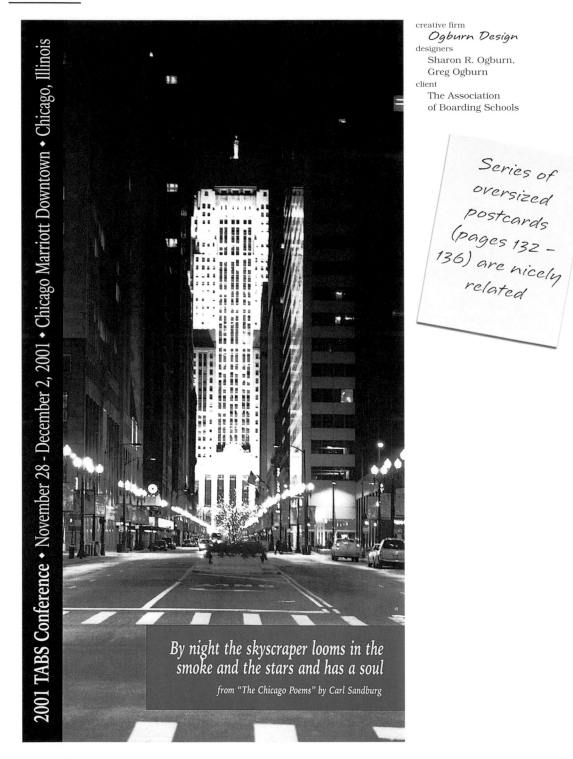

2001 TABS Conference ◆ November 28 - December 2, 2001 ◆ Chicago Marriott Downtown ◆ Chicago, Illinois

*By night the skyscraper looms in the smoke and the stars and has a soul*

*from "The Chicago Poems" by Carl Sandburg*

creative firm
*Ogburn Design*
designers
Sharon R. Ogburn,
Greg Ogburn
client
The Association
of Boarding Schools

Series of oversized postcards (pages 132 – 136) are nicely related

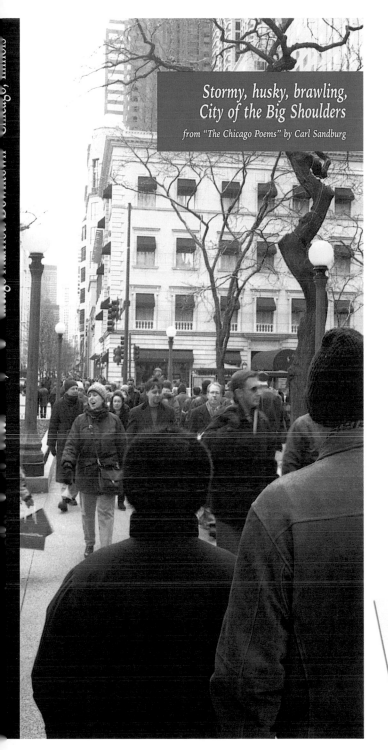

Stormy, husky, brawling,
City of the Big Shoulders

*from "The Chicago Poems" by Carl Sandburg*

Black-and-white
prints are big in
size and subject

Vital information is reversed, white, out of black bar

(continued)
creative firm
*Ogburn Design*
client
The Association
of Boarding Schools

**2001 TABS Conference ◆ November 28** ◆

The fog comes on little cat feet.
It sits looking over harbor and city
on silent haunches and then moves on.

*from "The Chicago Poems" by Carl Sandburg*

ember 2, 2001 ◆ Chicago Marriott Downtown ◆ Chicago, Illinois

Quote from Sandburg's "The Chicago Poems" is reversed out of teal box with one-sided bleed

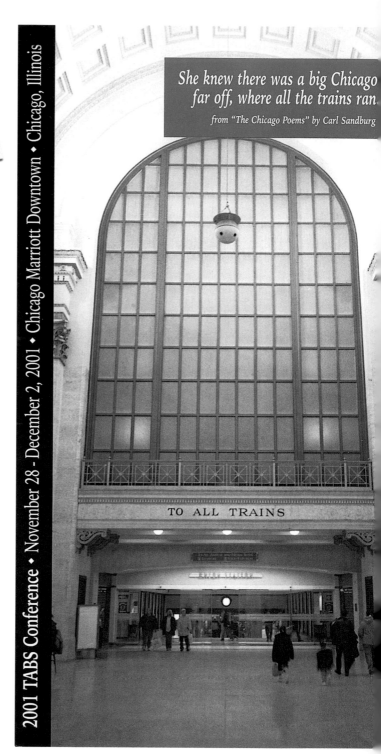

**2001 TABS Conference ◆ November 28 - December 2, 2001 ◆ Chicago Marriott Downtown ◆ Chicago, Illinois**

*She knew there was a big Chicago far off, where all the trains ran.*

*from "The Chicago Poems" by Carl Sandburg*

TO ALL TRAINS

(continued)
creative firm
*Ogburn Design*
client
The Association
of Boarding Schools

## formula for success

**Don't hire us unless...**
*...your formula for success
is the same as ours.*

Our best work and most
successful relationships are
based on shared expectations,
solid communication and
common goals.

### If you want to...     you need to...

| | |
|---|---|
| **Enhance profitability** | **Check egos at the door** |
| | Our program is designed to enhance your profitability, not to support the egos of individuals. The only way to achieve meaningful, measurable results is through a strategic marketing and positioning strategy—which means some business lines, offices and individuals will get more attention than others. |
| **Increase media coverage** | **Answer the calls** |
| | Reporters are like everyone else—they tend to favor people who make them feel valued and important. If you do not return calls or regularly communicate interesting items, you lose credibility and undermine important relationships. |
| **Establish a brand** | **Commit to a sustained effort** |
| **en**™ | Yes, you will get in the news right away. (We put clients into major media an average of 16 times a day.) But the real goal—building top-of-mind awareness with key clients and prospects—takes years. Branding knows no shortcuts. |
| **Penetrate markets** | **Invest in a multifaceted program** |
| | Your strategic communications program will be a powerful business development tool, but it can only go so far alone. Studies prove that only multiple, simultaneous initiatives such as strategic planning, market research, sales training, advertising and strategic communications will influence purchasing decisions. |
| **Support business development** | **Get inside your clients' heads** |
| | Few professionals know the publications their clients read. Give at least as much time to their professional reading as to your own. Keeping up with industry trends lets you speak to the issues that keep your clients up at night—and makes your comments memorable. |
| **Fulfill your firm's expectations** | **Keep us in the loop** |
| | To keep your program on track, your senior management must meet with LSC consultants at least twice a year to discuss short- and long-term goals, changes in the market and client opportunities. If you cannot commit to this level of involvement, you should not begin. |

*Yes!* My company wants a strategic communications program.

_____     _____
*Signature*                    *Date*

creative firm
  *Greenfield/Belser LTD*
designers
  Burkey Belser, Charlyne Fabi,
  Lise Anne Schwartz
client
  Levick Strategic Communications

*Dominated by red, use of gridlines very effectively displays company's information*

# Differentiate

**Focus on the small picture**
Strong practice areas are a platform for business expansion.

R

R

R

R

*You a*
*one a*
*and a*
*the m*

*A bala*
Success
are inte
as many
a little a
some sa
like eat
meat in

# e and shine.

# e and shine.

# e and shine.

# e and shine.

*a car because you've seen it once or read
out it. It takes repetition, consistency
ation of approaches to create the aura of
.*

g communications
concurrent. To say,
some PR this year,
next year, maybe
the year after," is
etables and your
cal years.

**Healthy brand**
Consistent care and feeding help your
message become a brand.

Really nice use
of color
borrows yellow
from the
picture and
prints the
headline
with it;

theme shade of red
(pages 137 –139) is
incorporated into
photographic image
creating a duotone

(continued)
creative firm
*Greenfield/Belser LTD*
client
Levick Strategic Communications

creative firm
  Shigeharu "Smiley" Kato
designer
  Shigeharu "Smiley" Kato
client
  ALL Co., Ltd

Text overlaps artwork, just a little, to create a relationship between the two without obscuring readability

Jealousy rears its ugly head.

*Enjoy our quality responsibly • Visit crownroyal.com*

CROWN ROYAL • IMPORTED IN THE BOTTLE • BLENDED CANADIAN WHISKY • 40% ALCOHOL BY VOLUME (80 PROOF) • ©2001 JOSEPH E. SEAGRAM & SONS, NEW YORK, NY

creative firm
*Grey Worldwide*
designers
Graham Button,
Nira Firestone,
Fred Liedtke,
Tim Mattimore
client
Seagram America

Understated headline is strategically placed, offering a hint to anthropomorphic humor

# I CAN KISS YOUR WHAT?
## a guy's guide to martial arts
### by Chauncey Hollingsworth

**Y**ou want to beef up and kick some ass, so you enlisted at a dojo down the street. A month later, and you're still doing gentle hip movements. What gives? While no art is necessarily better than any other, martial arts can be tedious—if you don't pick one that matches your interests. Are you meditative or competitive? Do you want philosophy attached to your training or is it enough just to kick a heavybag? Matching your temperament with a school of study will go a long way toward creating enthusiasm. With that in mind, here's a quick guide to the disciplines.
Aikido: Aikido is a nonviolent art that uses flow-ing, circular movements to turn your opponent's weight and momentum against him. Study stresses gracefulness, so expect plenty of stretching and some physical exertion. Black belts get to ditch the regular uniform and don a giant black pant-skirt called a hakama.
Capoeira: A Brazilian martial art originally developed by African slaves more than 300 years ago, Capoeira looks like a combination of break dancing and drunken cartwheels. While drums and a bow-shaped instrument called a berimbau provide background music, "players" stand in a circle and wait turns to face off against one another with handstand kicks and

leg-sweeps. Though the kicks are powerful, emphasis is usually on simply touching the opponent.
Hapkido: A hybrid of karate, judo and aikido, this school emphasizes the balance of opposites: passivity against a hard attack, powerful countermoves against soft attacks. Maneuvers consist mainly of large kicks and lots of aikido-style circular movement, while advanced training includes using staffs, canes, nun-chucks and other weapons. The hero in *Billy Jack* used hapkido (he could also have used some acting classes).
Jeet kune do: "Absorb what is useful" is the tenet of this art, developed by Bruce Lee. And, frankly, who knew more about pummeling someone than Bruce Lee? Loosely, JKD encompasses kung fu and Western boxing, but Lee instructed his pupils to learn from every source to develop a ruthlessly efficient nonstyle.
Judo: A Japanese art turned Olympic sport, judo is stylized wrestling using a set of defined movements, throws and holds. Consider losing your beer belly before signing up. Judo's grappling moves and high-intensity practices (including plenty of trips to the mat) are

rough on the a disappoint, bu such move as a Jujitsu: An anc arts that uses range attacks chokes and joi vers are so vic high injury rate to weed out th to create judo. used their Bra years' worth o pionships, so i ing your butt in Kali (also calle ipino art uses and sometime an attacker. A niques are ta use of weapon to disarming a an aim expres the hand and t Karate: One karate is also texts trace its with other Asi of styles to c nese. Chines good match f punch in a sh how to break Kickboxing: M American kic contact karate

**ILLUSTRATION BY DAVID VOIGT**

*Animated mix of illustration and body copy; borders of text areas are reminiscent of Oriental calligraphy*

and long-
es, kicks,
s maneu-
suffered a
actitioners
ous moves
ly of Brazil
vin several
ting Cham-
able of sav-

na): This Fil-
mboo sticks
to decimate
anded tech-
resses the
ntion is paid
ing combat,
ch as "Break

opular arts,
est. Chinese
00 years. As
e are dozens
cluding Japa-
Okinawan. A
nt to throw a
me and learn
d.

a martial art,
ffshoot of full-
sis on compe-
n. Its first na-
al exposure in
U.S. came in
'U, when Joe
s, fresh from
ing with Bruce
, knocked out
Baines to be-
the first heavy-
nt kickboxing champion. Training is a
y aerobic workout heavy on kicks and
work, so expect to sweat.

g fu (also gung fu or wu shu): A catch-
escribing hundreds of different Chi-
e fighting arts that collectively cover
y, strikes, locks and throws. Also
des the study and use of pressure
ts, an effective way to slow down
ger opponent when brute force
't cut it.

te: You mean the French actually have a
tial art? This competition-oriented form of
boxing was named *savate* (pronounced sa-
vat) after a common term for a street
shoe, earning it a reputation as a street-
fighting technique. It might not have
the mystique of an Asian mar-
tial art, but you'll look Paris
fashionable wearing its uni-
form of a tight, sleeveless,
striped one-piece track
suit and shoes with

creative firm

*Playboy Enterprises
International, Inc.*

designers

Tom Staebler, David Voigt
Rob Wilson

client

Playboy Magazine

rubber-reinforced toes.
Tae kwon do: The Korean "art of
kicking and punching" is known for
spectacular legwork. An average
class looks like warm-ups for a
John Woo film. Forget learning
tae kwon do if you can't touch
your toes. The head-high kicks
and roundhouses are recom-
mended only for the relatively lim-
ber. Also a good art for women.
T'ai-chi-ch'uan: Actually a system
of kung fu, t'ai-chi-ch'uan is heavy
on philosophy and slow, "soft"
movements designed to build
health and strength. Still, 80 mil-
lion skinny, elderly Chinese people
can't be wrong. Just don't expect
a few weeks (or even months) of
t'ai-chi-ch'uan to help you pummel
someone in a fistfight. Recom-
mended for the spiritual and med-
itative of any shape or size.
Thai kickboxing (muay thai): Dev-
astating attacks (elbow, leg over
hip kicks, elbows and knees) and
a suck-it-up defense system con-
sisting of shin and forearm blocks
define this brutal art. Sport fight-
ers in Thailand are typically young,
because their effective careers

are so short. Not recommended
for wimps or whiners.
MARTIAL ARTS YOU THOUGHT
WERE BULLSHIT (BUT ARE
QUITE REAL)
Ninjutsu: Supposedly developed
by mountain mystics, "the art of
stealing in" was practiced by se-
cret clans who hired out to war-
lords for assassinations, spying
and other clandestine operations.
Armed with claws, explosives and
throwing stars, ninja rely on dis-
guises and special contraptions.
Masters today concentrate more
on efficient throws and joint locks
than on smoke bombs. Damn.
Monkey style kung fu: Among the
animal variations of kung fu (pray-
ing mantis, white crane, leopard),
monkey style is the goofiest.
Founded by Kou Tze, who created
it while watching monkeys during
an eight-year prison sentence, it
uses a barrelful of unorthodox
hopping, rolling and squatting ma-
neuvers to confuse opponents be-
fore lashing out. Studied in vari-
ous forms, including lost monkey,
tall monkey, wood monkey and

stone monkey.
Drunken Style kung fu: No,
it's not what your buddies
did after they saw *The Ma-
trix*. The drunken forms of
kung fu depend on move-
ments not unlike booze-
soaked stumbling. Oddly,
training is reserved for the
highest levels of various kung
fu styles (drunken monkey,
drunken praying mantis,
etc.). According to the *Origi-
nal Martial Arts Encyclopedia*,
"the Eight Drunken Fairies
set—extremely difficult—was
developed by the famous eagle
claw master Lau-Fat-Mang."
And who hasn't heard of Lau-
Fat-Mang and his eight drunk-
en fairies?
Shao-lin kung fu: Thought by
many to be the birthplace of
kung fu, the Shao-lin temples
housed Buddhist monks who
used the martial arts to protect
themselves from an oppressive
government that eventually
burned down their original tem-
ple. Rebuilt just south of Beijing,
it's now the country's
most renowned kung fu
facility. To avoid another
flameout, trainees are
taught a mantra that in-
cludes "I love my country,
I love my peo-
ple. I love the
Communist
Party of China."
Tae-Bo: Our mis-
take. Tae-Bo is
bullshit.
FINDING A
GOOD SCHOOL
Finding a martial
arts academy
isn't the hard
part. The phone
book lists plenty
of schools, acad-
emies and dojos
that vie for your
tuition money with
such catchphrases
as "Techniques
used in actual cage
matches" and "Your
last big fight was
on a PlayStation and
the only black belts
you own are made of
leather." Unfortunate-
ly, separating the legit
schools from the Hong
Kong hooey can be dif-
ficult. There are no
state certifications and
(concluded on
page 164)

creative firm
**Iconix, Inc.**
designer
Alec Peterhans
client
GM Powertrain

### ■ Improved Performance

While refined operating characteristics were a priority in developing the new Northstar, the overall goal was exceptional performance. The performance targets are best exemplified by the XLR roadster: 0-60 mph acceleration in under six seconds; the quarter mile in less than 14.7 seconds, and a top speed of 155 mph, the industry's voluntary limit for high-performance cars.

In both new Cadillac models, the Northstar delivers a higher output across the entire operating range with targeted output of 315 horsepower (235 kW) @ 6400 rpm and 310 lb-ft (420 Nm) of torque @ 4,400 rpm. In addition to these peak values, new four-cam continuously variable timing has freed the engine from the traditional constraints of fixed-cams that can only provide either high horsepower or high torque.

The Northstar also has an increased 10.5.1 compression ratio; while premium fuel is recommended for maximum performance, it can be operated on regular unleaded fuel.

*2004 Cadillac XLR*

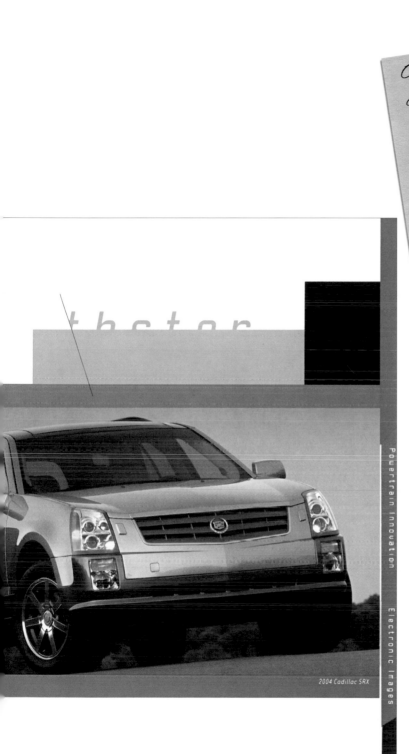

Overlapping effect creates depth and focus; notice letter fragments of product name in the "back"

Powertrain Innovation

Electronic Images

2004 Cadillac SRX

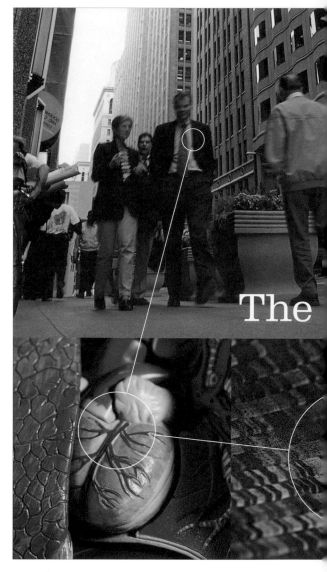

Photographic layout on the left and text layout on the right are bound together by headline which spans the spread, beginning in reversed copy and ending in black

creative firm
**Levine**
designer
Maggie Soudano
client
National Institute on Aging

The

NATIONAL INSTITUTE ON AGING

# ology of Aging

our muscles, bones, heart, brain, and other vital tissues and organs. It is now clear to scientists that each of us is a product of a complex mix of heredity, environment, and lifestyle. Understanding the genetic, molecular, and cellular processes common to aging as well as how these processes may differ in individuals will lead to biological and lifestyle interventions that maintain function and prevent disease.

The past decade of study has moved us away from the idea that any one process or gene is responsible for how we age biologically. "There is no single theory to explain aging," says Dr. Huber Warner, NIA Associate Director, Biology of Aging Program. "It's possible that some age-related changes are genetically programmed while others involve the effects of less predictable activity, such as free radical damage to cells or other insults that seem to occur with age."

Research supported and conducted by the NIA examines many of these fundamental mechanisms of aging — in genes, in the biochemistry of cells, and in critical organs of the body. Scientists expect that the next few years will be particularly prolific for basic research on aging because of the promise of a number of new technologies. From the use of new microarray techniques to measure the activity of thousands of genes at once to refinements in developing new animal models for the study of gene function, "I think the development of technologies for a new generation of research at the genetic and molecular level will bring major breakthroughs in the biological sciences," says Dr. Warner.

Scientists at the NIA's Laboratory of Genetics, for example, have taken a major step forward in the use of new microarray technologies. The laboratory's work is based on the thinking that important genes begin to determine the course of aging at the very start of life. But these studies have lagged because many of the genes active in early life have not been part of gene libraries

"Gee, he sure doesn't look 70." "Oh, she's got to be at least 60." "You're *how* old?"

At one time or another, most of us have formed some opinion about what it is to look or feel a certain age. The truth is, of course, there's no real standard. One 75 year old may be active and healthy, with an almost visible vitality. Another can project a more stereotypical image of someone in his or her mid 70s, perhaps with a few wrinkles and a bit slower in step.

The basis for much of modern research on aging is this notion of heterogeneity, or differences, among individuals. That is, people "age" differently — outwardly, in the appearance of our hair, eyes, and skin, and inside, in

<
First graders dress
as characters from
their fairy tales for
Authors' Tea.

Students in Grade
participate in le
sports throug
after-school pro

# FORSYTH SCHOOL

## HONOR CODE

As a member of the Forsyth School
Community, I will always be **honest,
kind, respectful, responsible,
fair,** and **practice good
sportsmanship.**
I will do my part
to make Forsyth
**a special
place.**

opportunities that Forsyth promotes are praiseworthy
for a school that serves elementary age students,"
noted the U.S. Department of Education Blue Ribbon
Site Visit Report.

### CONFLICT RESOLUTION

An important aspect of getting along well with others
is the ability to resolve conflicts. Forsyth School has
adopted the Eye-to-Eye process that was developed by
the Friends' School of Minnesota. A significant bene-
fit of Eye-to-Eye is that all grade levels use the same
process and language. In each class, time is available
every day for resolution sessions, usually during a
quiet reading time. The children experience the
process as a regular part of the school day, and so,
learn that conflicts are normal, and the skills to settle
them a necessary part of everyday life.

### STUDENT COUNCIL

The Student Council encourages ownership by the
students of school rules and values, and provides
leadership-training opportunities. One of the Student
Council's accomplishments was writing a student
code of behavior, the Honor Code. Another of its tasks
is to oversee and gather data about the Eye-to-Eye
program, from the student point of view.
The Council members will
also discuss matters of
concern to students
-- missing posses-
sions, playground
disputes, good
ideas and sugges-
tions -- and intro-
duce speakers and
groups at assembly. Members
are nominated by teachers, and
criteria for nomination include

good conduct, working to the best of their ability,
responsibility, honesty, kindness, and interest in being
on the council.

### SCHOOL ASSEMBLY

Once a month the School gathers in The Rand Center
for Performing Arts and Athletics for an all-School
Assembly. These assemblies align with the children's
learning and showcase the students' ongoing experi-
ences. Each grade takes responsibility for one assem-
bly, and bases their presentations on class activities
and core values. Over the course of a school year, the
younger students learn what the older students can
do, and look forward to their turn with relish. The
older students reflect with pride on their achieve-
ments, enjoy their longevity
and stature, and through the
presentations of the younger
students, revisit their own
early years through the
songs, rhymes, and
reading of their young
friends. Assembly
develops community
and the students' leadership and
citizenship skills.

Challe
TEAM
Forsyth
health
games
Physic
skills w
gram,
The Se
the ye
T-ball
good s
leader

in a v
towar
challe
tency
can de
those
satisfa
aging
contri
Schoo
Gradu
satisfa
they a

creative firm
  *Berkeley Design LLC*
designer
  Larry Torno
client
  Forsyth School/Phoebe Ruess

ork

ation program promotes
n movement awareness,
skills, and team sports skills.
nares the children with the
olvement in the sports pro-
school activities at Forsyth.
s in 3 league sports during
all, and baseball/softball/
ld athletic skills, promote
ad teamwork, and develop

sful participation in leagues
oifies the School's drive
ren with opportunities for
The general student compe-
everyone who wants to play
table level of expertise and
illed also find their level of
sis is on having fun, encour-
ipate, and honoring the
ember of the team. The
l is a source of pride.
ls, report a high degree of
nstruction at Forsyth because
ams in all the major sports

when they enter secondary school. They continue to
enjoy athletic challenge, and at the same time, make
friends among their teammates at a time when social
matters are of great importance.

**OUTDOOR EDUCATION**

Forsyth's outdoor education program, currently
targeted to students in Grades 5 and 6, with
age-appropriate components for the lower grades,
provides the physical and mental challenges that
become metaphors for what is possible in future
endeavors. Forsyth's outdoor education program
fosters cooperation, positive risk taking and persist-
ence. By facing and overcoming challenges, students
discover their inner resources and develop self-
confidence. In addition to off-campus overnight
expeditions, there is a climbing wall on campus and
the high beam, 30 feet above ground in the gymnasi-
um. A number of Forsyth's faculty are certified out-
door education instructors who leave their classrooms
to lead these outdoor education expeditions.

In Grade 5, students take their first overnight
outdoor education camping trip. They climb the
50-foot Alpine Tower, play team building
games, work on orienteering and map
reading skills, take a solo hike, pre-
pare and cook all their own meals

"What I will remember most about
Forsyth is that I was always
challenged, and when I wasn't
challenged enough, I was able to
challenge myself even more. The
hardest thing I did at Forsyth was
the camping trips and climbing,
but the feeling of accomplishment
made it all worthwhile."

— *Class of 2002 alum*

Monochromatic action
shots mix with other
art to loosely form
a border for
columned type

## Case Study

**Billing study demonstrates reduced hospitalization costs.**

### Situation

Preparing for phase III clinical trials, a company with a new immunosuppressive agent needed to demonstrate the impact of improved immunosuppression on treatment costs.

### Key Issues

- The company believed that better immunosuppression would result in fewer rejection episodes and associated hospitalizations.

- A multicenter U.S. trial provided an opportunity for a comprehensive billing study.

### The Covance Solution

- Select the appropriate approach to demonstrate expected product economic benefits.

- Design a hospital billing study to compare rates of hospitalization, length of stay, and hospitalization costs for each treatment group.

- Integrate billing study into phase III trial without delaying enrollment or distracting site personnel.

- Prepare findings for peer-reviewed scientific meetings and publications.

### Results

Study results documented reduced hospitalization rates and associated costs. This strongly supported our client's overall marketing initiative as well as submission of its Canadian economic dossier. The product was a leader in the immunosuppressive category.

**Capture and convey the value of your product.**

Determining and demonstrating the value of a product or technology in the highly competitive and regulated health care environment requires broad-based knowledge and skill.

Having pioneered the concept of reimbursement planning, Covance Health Economics and Outcomes Services provides a broad spectrum of consulting and support services to the pharmaceutical, biotechnology, medical device, and diagnostic industries.

Over 200 strong, our staff is highly educated, multidisciplinary, and well versed in the complexities of today's medical markets.

Our company is part of Covance, the development services company, with operations in 17 countries and 7,000 employees worldwide.

Because of our corporate reach, we can tap into global resources to deliver the solutions you need to gain and maintain a competitive advantage.

With the depth of our expertise and our unique experience, we offer you what no other firm can: strategic and analytic services that help capture and convey the value of your product to all those who can affect its success.

And the sooner you call us in, the more you can benefit.

**We can help yo**
**of the product l**

Success in the healt
vigilance. From dev
you to make sure th

In a collaborative st
colleagues in other
achieve your comm

You can rely on us
work with you on s

All of which is esse

**Build on a foun**
**intelligently app**

Begin with solid ou
Economics and Ou

Call 240/632-3000

Squares are found consistently in this brochure,

**obstacles at any stage**

lace demands planning and constant
gh post-launch, we work with
surprises.

rk closely with you and your
facilitate communication and
als.

utcomes support you need, and to
le aspects of your program.

roduct to achieve its highest potential.

**tcomes data,**

ents from Covance Health
.

square portraits,
spare mosaics,
lines formed by
square dots

creative firm
  *Martin Schaffer, Inc.*
designer
  Steve Cohn
client
  Covance

*Wonderful illustrations used with condensed sans serif type reflect a verticalness also found in narrow columns of copy*

creative firm
**Lebowitz/Gould/Design, Inc.**
designers
Sue Gould, Trisia Tomanell
client
The Marx Hotel & Conference Center

## WELCOME TO THE MARX

The current news in Syracuse is

The Marx Hotel & Conference

Center, a fresh new downtown

hotel offering deluxe lodging, a

state-of-the-art conference center,

exciting dining, and an impressive

20th floor venue ideal for

hosting memorable social and

business events.

### NEW IN SYRACUSE

Located on Genesee Street facing Syracuse University, The Marx is within close proximity of the OnCenter, four major medical centers, the Carrier Dome, DestiNY USA, and many of Syracuse's business locations and most popular leisure activities.

A $22 million redevelopment is transforming The Marx into a hotel that is custom designed to serve the unique needs of the Syracuse community. It will give Syracuse 280 new downtown hotel rooms and Horizons, the 3,500-square-foot banquet space on the hotel's 20th floor. First quarter 2003 will see the launch of Redfield's — an American-style bistro, the Library Lounge and The Conference Center at The Marx.

### DINING AND RELAXING

An intimate 60-seat Library Lounge serves beverages and light fare, while Redfield's — a striking two-story American bistro — seats 110 for breakfast, lunch and dinner. Seasonal al fresco dining will be available. For in-room dining, the hotel offers a full Room Service menu.

### AMENITIES

Other Marx services and amenities include a fully outfitted Executive Business Center, a Fitness Center with individual video and Internet access, a 300-space adjacent parking garage and complimentary local transportation.

think big-brand insight,
powerful design
implementation.

think new.

anthem group

think:
anthem group.
global thinking
regional insight
local service

www.anthemgroup.com

908 850 62...

sulting
nding and design
nding and design
sulting + implementation

creative firm
*Anthem Group*
designers
Barbara Krause,
Patti Soldavini,
Cavon Galati
client
Anthem Group

"Hands-on" information:
circles of vellum-like
plastic, printed in muted
colors, pivot for artistic
effect or clarity in reading

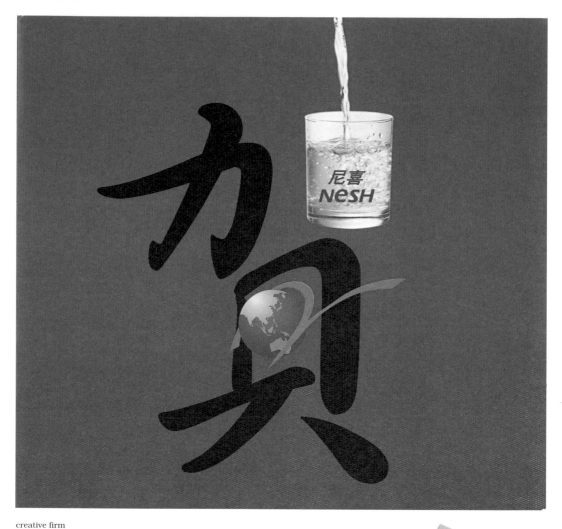

creative firm
### *Fixgo Advertising (M) SDN BHD*
designers
FGA Creative Team
client
Nesh Marketing SDN BHD

Water image "pours" from off the page; overlapping images create depth

*Strongly contrasting colors produce an eyecatching cover*

creative firm
**University Communications**
designers
Mary C. Dillon, Mark Krumel
client
Undergraduate Admissions

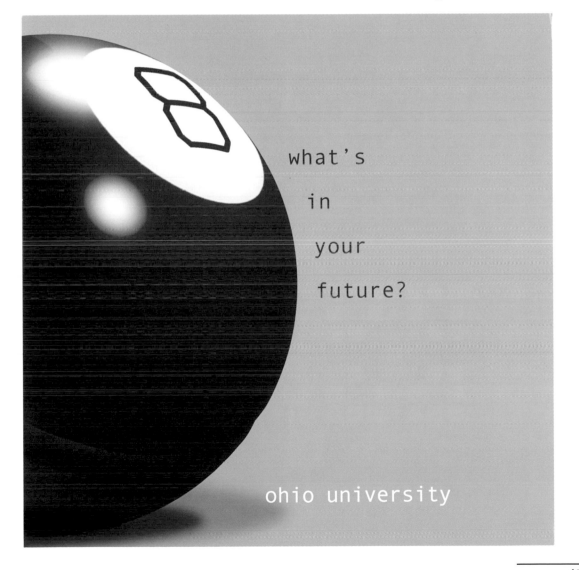

what's

in

your

future?

ohio university

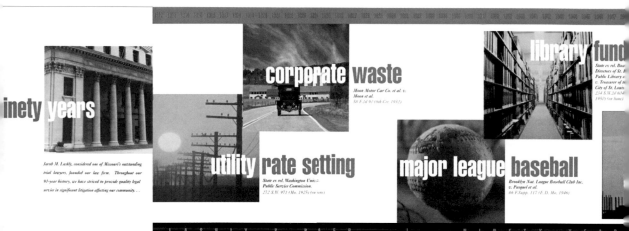

creative firm
*Grizzell & Co.*
designer
John Grizzell
client
Lashly & Baer

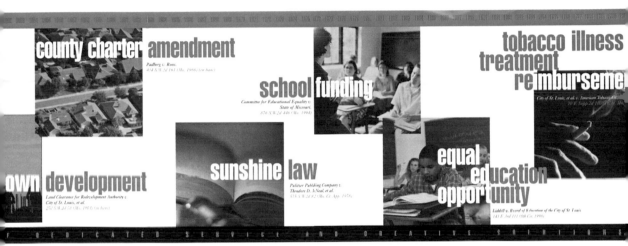

Accordion-fold pamphlet unfolds to reveal a timeline printed in metallic and black inks

NBR | AR 01

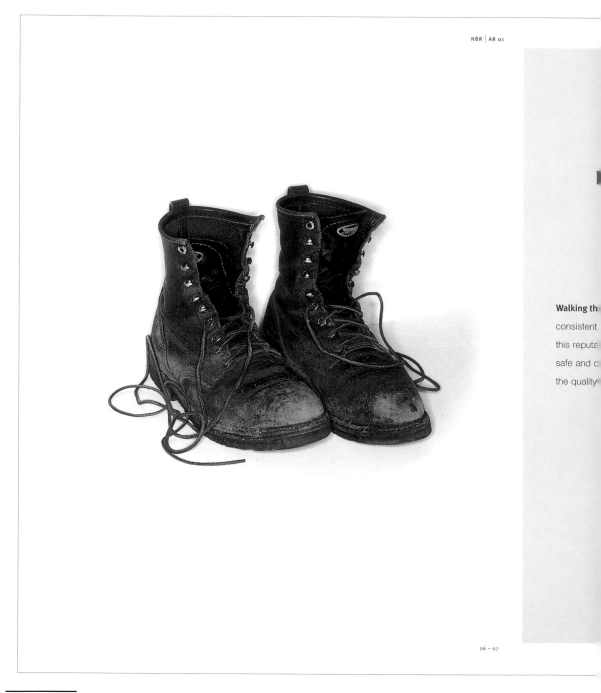

**Walking th**

consistent

this reputa

safe and c

the quality

06 – 07

Single images, whether art or text, are accentuated by solitude

**bility**

...ad of talking the talk – A company is deemed to be reliable when it
...exceeds the expectations of its constituencies. Nabors has developed
...vering superior returns over the long term for investors, by providing a
...working environment for employees, and by consistently improving
...ces we provide to our customers.

creative firm
**Savage Design Group**
designers
Dahlia Salazar, Matthew Ryf,
Terry Vine, Irma Burns, Bill Wright,
Barbara Weeke, Page International
client
Nabors Industries, Inc.

Text is either reversed out of black or printed in pale yellow;

right page is doubled vellum, which creates a denser opacity than a single sheet

PT HM Sampoerna Tbk. | annual report 2001

## THE SAMPOERNA FOUNDATION

THE SAMPOERNA
FOUNDATION WAS
ESTABLISHED WITH
A COMMITMENT TO
ENSURE THAT THE BEST
AND BRIGHTEST OF
INDONESIA'S YOUNG
PEOPLE HAVE ACCESS
TO HIGHER EDUCATIONAL
OPPORTUNITIES,
IRRESPECTIVE OF
THEIR ECONOMIC
CIRCUMSTANCES.

THE ESTABLISHMENT
OF THE SAMPOERNA FOUNDATI
WAS UNDERTAKEN AGAINST
THE BACKDROP OF INDONESIA
DIFFICULT ECONOMIC
SITUATION AND DETERIORATIO
IN EDUCATIONAL ACCESS FOR
MANY YOUNG PEOPLE.

creative firm
**Epigram Pte Ltd**
designers
Ranee Goh, Edmund Wee,
Frank Pinckers
client
PT HM Sampoerna Tbk.

# COMPETENCY

EDUCATION IS A
CRITICAL PRECURSOR
FOR AN INCREASINGLY
SOPHISTICATED
WORKFORCE THAT
WILL BE ABLE TO
PARTICIPATE IN THE
GLOBAL ECONOMY
AND SHARE IN
THE BENEFITS OF
REGIONAL PROSPERITY,
DEVELOPING OUR HUMAN
RESOURCES WILL
PROVIDE THE BEST
OPPORTUNITY FOR
INDONESIA'S
CONTINUING NATIONAL
DEVELOPMENT, SOCIAL
STABILITY AND
ECONOMIC GROWTH.

## LAST ISSUE WE ASKED...

your opinion about homework. Do you think you get the right amount of homework, too little or too much?

Illustration by edward tamez

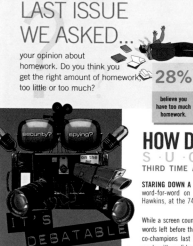

**28%** believe you have too much homework.

**62%** think you don't get enough homework.

**10%** are unsure or couldn't make up your mind.

### You said ...

"Homework is the way that we can learn and study. You can learn a lot with homework"

"Teachers at my school give just the right amount. I manage my time well so I have enough time to do everything"

"Some homework is important, but the homework that is 'busy work' is not right"

"Sometimes we have a lot of homework, but sometimes it is light. My teachers usually get together and manage the lo"

"I get too much homework. When I get home, my back hurts from carrying so many books in my backpa"

"I get too much homework. I think the teachers should communicate with each other so it is not so ba"

"We have six hours of school each day and other activities; we don't need to be spending another two to three hours doing homework."

---

**security? spying?**

**ON THE AIR**

**IT'S DEBATABLE**

Would you mind your picture being taken when you weren't aware of it? What if someone took your picture and compared it to a database of people wanted by the police? Casinos and banks currently do this as a routine part of business. Recently a town in Florida installed a camera system in its streets downtown. After the Sept. 11 tragedy in New York City, it might become more common. But is it a good or bad thing?

**WHAT'S YOUR OPINION?**
Do you think the screening process is something necessary to keep people safe? Or do you think it might be an invasion of privacy? Call and give us your opinion. (800) 845-0501.

**WHAT'S YOUR OPINION?**
Call and give us your opinion.
**(800) 845-0501**

*Do you have a subject that you'd like to know more about? Are you wondering what your fellow readers think about a certain topic? If you would like to survey fellow classmates or friends on a topic for U-TURN, let us know. We want to hear your ideas.*

---

## HOW DO **YOU** SPELL SUCCESS?

S·U·C·C·E·D·A·N·E·U·M

### THIRD TIME A CHARM FOR NATIONAL SPELLING BEE WINNER

**STARING DOWN A SWARM OF NATIONAL MEDIA AND TV CAMERAS**, Sean Conley dueled word-for-word on stage during five rapid-fire rounds with another finalist, Kristin Hawkins, at the 74th Annual Scripps Howard National Spelling Bee in Washington, D.C.

While a screen counted down the number of words left before the two would be declared co-champions last May, Kristin spelled her words with confidence and speed. Sean was his usual methodical self. Then she slipped on "resipiscence," and he held steady through "gallimaufry" before nailing the $10,000 word, "succedaneum," and leaving 247 competitors behind in a cloud of dictionary dust.

Sean drilled his way through 16 rounds of tongue twisters before claiming his trophy and feasting on the thrill of victory at age 13. One year earlier Sean tasted the agony of defeat when he stumbled over "apotropaic" and fell to second place.

#### HERE'S THE DRILL
The young USAA member and resident of Shakopee, Minn., seems destined for success; he learned to read at 2, has written two computer video games and completed three semesters of college-level courses in Spanish and computer programming. So was his championship win a cakewalk? Not unless six years of memorizing words is your idea of fun and games.

Home-schooled until he was 12, Sean competed in his first spelling bee at age 8. Winning "the gold" became his goal, and daily word study and drills were his challenge as he prepared for and competed in three national competitions.

Yet he credits his win this year to a combination of luck and skill. "There is skill

involved," he admits, "but even as a top competitor you can get a word you don't know — and if you don't guess correctly, then someone else will win. You can't learn or memorize all the words in the dictionary."

#### CAN YOU SPELL S-T-R-E-S-S?
Sean's chance to win the golden prize got higher with each round, and although he remained a model of composure, the pressure was on.

"On stage with everyone getting amazingly tough words and dropping out in earlier rounds, I really had to concentrate," he says. His advice to others?

- Tune out the people watching.
- Get as many clues about the word as you can by asking questions.
- Take your time and don't spell as fast as you can just to get off the stage.

#### THE PAYOFF
Sean says the gain from his long-term commitment is worth the effort: a $10,000 prize; a press conference and live interviews with national media; a brief chat with President Bush at the White House; and great times touring Washington three years in a row.

Now retired from the stage, when Sean needs to take a break from studying he plays computer games. Next up: advancing to 10th grade in public school and a calculus course at the University of Minnesota.

---

## U-TALK!

**READER PROFILE**

Sean Conley (right) accepts the winner's trophy at the 74th Annual Scripps Howard National Spelling Bee.

Sean and his family (lower right) meet with President Bush at the White House after Sean's championship win.

**ROUND 16** Succedaneum: One that succeeds to the place of another.

**ROUND 15** Gallimaufry: Hodgepodge.

**ROUND 14** Irenicism: Conducive to peace or reconciliation.

**ROUND 13** Aleatoric: Improvisatory or random in character.

# JONATHAN BOULDEN'S
# U-SURVEY ON STRESS

**JONATHAN BOULDEN** put on his "reporter hat" for U-TURN in his hometown of Owings, Md., talking with friends and schoolmates about stress and stress-busters. Jonathan, 16, asked a group of teen-agers about the type of things or situations that cause them to feel stressed — and how they deal with stress. Here's what they told him:

**Benjamin Lyons,** 13, named more than one stress-producer. "People telling me to do something I already know to do" ranked first, followed by, "Teammates giving advice when they don't know what they're talking about," and finally, "People (especially short people) calling me short." Benjamin's solution to stress is to "go out and buy junk food — or play soccer."

Sometimes after a tough day at school, **Wayne Schonthaler,** 16, comes home and his younger brother, Robbie, annoys him. When that happens, he goes into his room and plays music, "like Newsboys or DC Talk."

For **John Hollidge,** 13, a source of stress is "people yelling at me"; also, "Latin class (it makes me feel like I don't know anything)." John listens to music to relax.

Math causes stress for **Zach Cook,** 15. And whenever Zach's 14-year-old brother annoys him, he says, "I ignore him; it works really well."

**Derric Stotts,** 14, lists school, homework, teachers and "unnecessary work of any kind" as his sources of stress. To reduce stress, he says, "I go to gymnastics (team workout), or I talk on the phone."

Schoolwork is a stressor for **Julie Herndon,** 14. To handle it, she likes to "plan ahead (so I can get it all done)."

**Janet Schonthaler,** 13, claims schoolwork makes her stressed — but to feel better, she says, "I call my friends — or talk to them on IM."

According to **Elizabeth Goulart,** 13, having her brother, Joey, "sick with mono for the past seven months" has been stressful. It helps her to "listen to Pachelbel's 'Canon in D' over and over and over again."

Singing in front of large groups of people and being asked to do "a million things at once" produce stress for **Dana N.,** 14. It helps her to "have a good cry and write a letter to God about everything that's bothering me." Then her letter becomes a prayer.

**Caroline Boulden,** 13, feels stress when she has "to do things I don't want to do." To feel better, she lies on her bed and reads.

And U-TURN's intrepid reporter, **Jonathan,** says his biggest stress is "not being ready — for classes, for my weekly piano lesson, for gymnastics meets." His solution is to "plan out my week so I can accomplish everything." He also writes songs or poetry to relax.

(our man on the street.)

creative firm
**Toolbox Studios, Inc.**
designers
Paul Soupiset, Linda Helton,
Brian White, Allie Vallery
client
USAA

This spread is the first "unfolding" of a single sheet that opens three times from 10" x 13" to a final 20" x 52"

Giant math
problems link
these two pages,
even though they
are printed in
different colors
and fonts

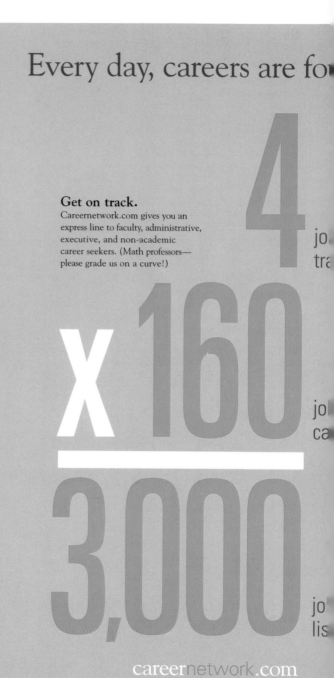

# Every day, careers are fo

**Get on track.**
Careernetwork.com gives you an
express line to faculty, administrative,
executive, and non-academic
career seekers. (Math professors—
please grade us on a curve!)

4

x160

3,000

jo
tra

jo
ca

jo
lis

careernetwork.com

creative firm
*Greenfield/Belser LTD*
designers
Burkey Belser, Robyn McKenzie,
Charlyne Fabi, Danielle Cantor
client
Chronicle of Higher Education

in

Every day, careers are improved by

**Inside intelligence.**
Find the editorial strength of
*The Chronicle of Higher Education*
and expert advice on career
building, CV writing, and other
topics, only at careernetwork.com.

5 feature
article links

8 monthly
columnists

48 online
resource links

33 editorial topics

2 salary surveys

careernetwork.com

es

creative firm
*Selling Power*
designers
Tarver Harris,
Stéphan Daigle
client
Selling Power Magazine

*Primitive-style illustration weaves in and out of headline, while forming a margin edge for body copy*

# THE SEA OF CHANGE

### How to chart a steady course through changing tides and stormy seas

By Joan Leotta
Illustrations by
Stéphan Daigle

TAKE A LOOK at your desk calendar and see where you were professionally exactly one year ago. Then ask yourself what were the biggest internal and external changes that affected you during the past 12 months. Was it the economic slowdown or the dot-com crash? Did you face labor shortages or job cuts?

While your situation now may be dramatically different than it was a year ago, the changes themselves are not the most important consideration. Rather, how you deal with transitions and innovations, as well as the aftermath of change, are equally if not more significant – and certainly a challenge for any sales manager. While sales forces are widely and rightly touted as the engines of change, sales managers keep the ship on the right course at the right speed and steer it clear of potential hazards ahead.

How do they do it? *Selling Power* spoke with sales managers to better understand how they navigate the sea of change.

What asset or characteristic is most valuable when dealing with change? For Shelly Withers at Magnolia Graphics in Starkville, MS, the answer is commitment. Not only has her commitment been essential to the success of new projects or policies, but it also has inspired the same commitment in her sales staff. When Magnolia Graphics recently opened a telesales unit, Withers moved from a long-held position managing direct-sales staff to the newly created position of vice president, telesales. First, she had to elicit a level of commitment from her former staff that would allow them to accept a new manager and help the entire firm adjust to the concept of telesales. At the same time, she had to work to get the new unit up and running – in an operation that prints directories in 46 states. The result? The success of the new unit and the acceptance of the new manager are reflected in the great sales figures. According to Withers, careful handling of the selection of her successor and paving the way for the transition were important, but commitment was the key. "Always lead from the front and do better than you expect the people under you to do," she says.

In order to be able to act immediately to changing situations, having the right attitude can make all the difference. Jeff Hunt, vice president of marketing for OpenAir.com, a Boston-based, Web-native professional-services automation company, recently managed the company's shift to new contact management software. The entire management team saw the change as a positive step forward. "We were confident that the change would result in the better management of the prospect pipeline," he explains, "and would result in a better closing rate for all of the sales team."

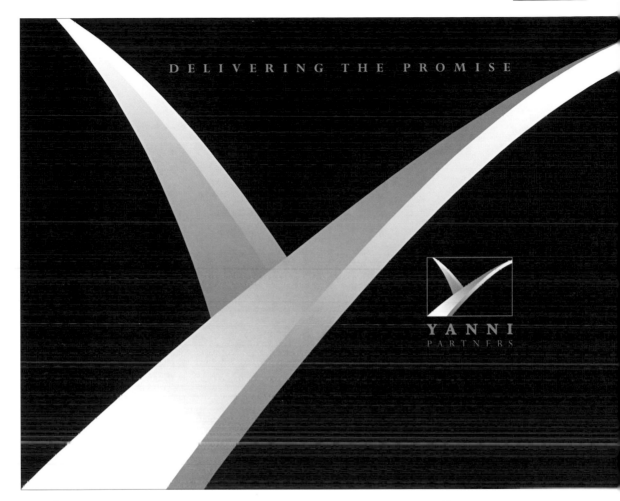

DELIVERING THE PROMISE

YANNI
PARTNERS

creative firm
**Adam, Filippo & Associates**
designers
Robert Adam, Martin Perez
client
Yanni Partners

Initial symbol from logo is enlarged and printed with a three-sided bleed

Initial symbol (pages 167 – 169) is printed in enlarged and segmented form on each page;

YANNI PARTNERS
■ ■ ■
DELIVERING THE PROMISE

"WE ARE ONE OF THE ORIGINAL FIRMS IN THE INVESTMENT CONSULTING INDUSTRY AND ARE PROUD THAT MANY OF OUR ORIGINAL CLIENTS REMAIN WITH US TODAY.. THEY'RE PUTTING THEIR RETIREMENT SECURITY - THEIR VERY FUTURE - IN OUR HANDS, AND WE TAKE THAT VERY SERIOUSLY. IT'S OUR DUTY TO GET IT RIGHT."

YANNI PARTNERS IS A NATIONAL FIRM OFFERING CUSTOMIZED SERVICE

YANNI PARTNERS OFFERS A SINGULAR CONCENTRATION: INVESTMENT CONSULTING. AS PIONEERS IN THE INVESTMENT CONSULTING INDUSTRY, WE OFFER THE UNIQUE BENEFIT OF MAKING INDEPENDENT DECISIONS BECAUSE WE HAVE NO PRODUCT AFFILIATION. WE FUNCTION WITHOUT BIAS OR COMPROMISE AND MAINTAIN ABSOLUTE OBJECTIVITY. BECAUSE WE ARE NOT A DIVISION OF A BANK, BROKERAGE, ACTUARIAL, BENEFITS OR ACCOUNTING FIRM, WE ARE 100% COMMITTED TO PROVIDING INVESTMENT CONSULTING. THAT FOCUS SERVES OUR CLIENTS WELL.

THREE

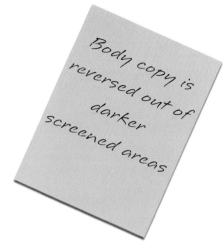

Body copy is reversed out of darker screened areas

(continued)
creative firm
**Adam, Filippo & Associates**
client
Yanni Partners

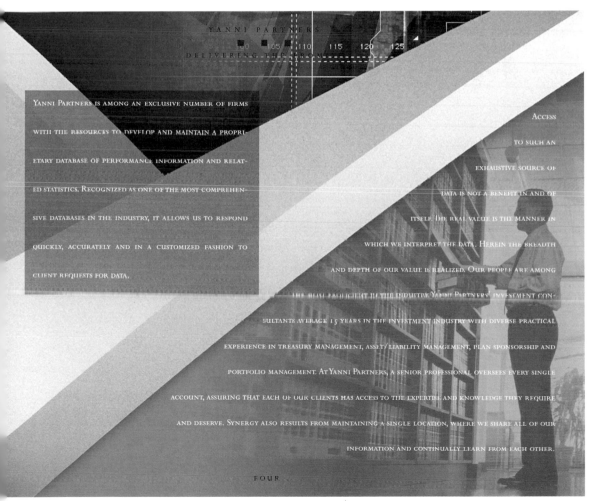

YANNI PARTNERS

DELIVERING THE

YANNI PARTNERS IS AMONG AN EXCLUSIVE NUMBER OF FIRMS WITH THE RESOURCES TO DEVELOP AND MAINTAIN A PROPRIETARY DATABASE OF PERFORMANCE INFORMATION AND RELATED STATISTICS. RECOGNIZED AS ONE OF THE MOST COMPREHENSIVE DATABASES IN THE INDUSTRY, IT ALLOWS US TO RESPOND QUICKLY, ACCURATELY AND IN A CUSTOMIZED FASHION TO CLIENT REQUESTS FOR DATA.

ACCESS TO SUCH AN EXHAUSTIVE SOURCE OF DATA IS NOT A BENEFIT IN AND OF ITSELF. THE REAL VALUE IS THE MANNER IN WHICH WE INTERPRET THE DATA. HEREIN THE BREADTH AND DEPTH OF OUR VALUE IS REALIZED. OUR PEOPLE ARE AMONG THE MOST PROFICIENT IN THE INDUSTRY. YANNI PARTNERS' INVESTMENT CONSULTANTS AVERAGE 15 YEARS IN THE INVESTMENT INDUSTRY WITH DIVERSE PRACTICAL EXPERIENCE IN TREASURY MANAGEMENT, ASSET/LIABILITY MANAGEMENT, PLAN SPONSORSHIP AND PORTFOLIO MANAGEMENT. AT YANNI PARTNERS, A SENIOR PROFESSIONAL OVERSEES EVERY SINGLE ACCOUNT, ASSURING THAT EACH OF OUR CLIENTS HAS ACCESS TO THE EXPERTISE AND KNOWLEDGE THEY REQUIRE AND DESERVE. SYNERGY ALSO RESULTS FROM MAINTAINING A SINGLE LOCATION, WHERE WE SHARE ALL OF OUR INFORMATION AND CONTINUALLY LEARN FROM EACH OTHER.

FOUR

Arlene Arzola–Kloch

Federal Bureau of Investigation | Class of '92

AT

"Performing helped me to develop self-confidence, poise, and discipline. It made me fearless. What I learned at American and in music theatre gave me the tools to survive and thrive in the real world."

two

ART OF **learning**

A criminal justice major aspiring to a career with the FBI becomes a key performer in music theatre. A physics professor plays double bass with a chamber group and helps design and teach a course in multimedia design. A composer and music teacher immerses himself in computer technology.

People are multidimensional. That fact lies at the heart of the liberal arts approach to education, designed to create a whole, balanced, and fully educated person.

That focus has drawn many students to American University who want to pursue a career in law or business or medicine, but also want the chance to use their talents at painting, acting, or music.

One such student is Arlene Arzola-Kloch. "I always knew I wanted to work for the FBI, and I also knew that singing was part of who I am. I didn't want to give that up." Arzola-Kloch turned down the chance to attend a military service academy to come to American University. She wanted a school with a strong program in criminal justice where she could also continue to pursue her love of singing, develop her talents in a superior music program, and get an all-around excellent education. "I found all of those things at American."

Today, as a supervisory language specialist with the FBI's San Diego Field Office, a mother, and a wife, Arzola-Kloch is still singing—with a law enforcement band and at special community events. She openly credits her experience at American University for the richness and quality of her life. "In my work, self-confidence is crucial, and performing gave me that. I'm a success today because of what I learned at American University. There's no doubt about it."

three

creative firm
**Grafik**
designers
**Michelle Mar,
Lynn Umemoto**
client
**American University**

Specific divisions of ad start with the fun info in natural colors;

vertical, dotted line guides the eye downward to a darker band that has all the stuff you "need" to know

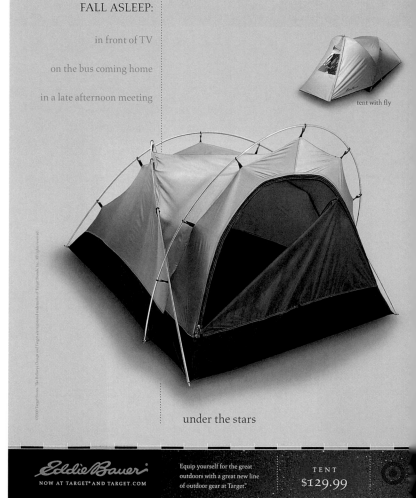

FALL ASLEEP:

in front of TV

on the bus coming home

in a late afternoon meeting

under the stars

tent with fly

Eddie Bauer
NOW AT TARGET® AND TARGET.COM

Equip yourself for the great outdoors with a great new line of outdoor gear at Target®

TENT
$129.99

creative firm
  *Design Guys*
designers
  Steven Sikora,
  Wendy Bonnstetter
client
  Target Stores

creative firm
**Advantage Ltd.**
designer
Susan Tang-Petersen
client
Bermuda Festival

## Ladysmith Black Mambazo

"... such close harmonies and subtle nuances that they sounded like one deep, rich, resonant and proud voice."
NEIL STRAUSS, NEW YORK TIMES

Ladysmith Black Mambazo has come to represent the traditional culture of South Africa, more than any other group of performers in recent memory. Considered a national treasure of the new South Africa, in part because they embody traditions suppressed in the old South Africa, its members are regarded as South Africa's cultural emissaries around the world. At the invitation of Nelson Mandela they performed for the Queen and other members of the Royal Family at the Royal Albert Hall in London; they have performed for the Pope in Rome, at two Nobel Peace Prize Ceremonies, at the 1996 Olympic Games and at the South African Presidential inaugurations

Excellent use of color— layout tones are taken from the photographs, relating all elements as one entity

*Colors are continued throughout this booklet (pages 173 – 175); shots of performances and artists liven up and specialize what could have been just-another-calendar*

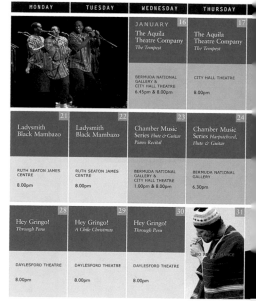

What's on at the Festival

| MONDAY | TUESDAY | WEDNESDAY | THURSDAY |
| --- | --- | --- | --- |
| | | JANUARY 16<br>The Aquila<br>Theatre Company<br>*The Tempest*<br><br>BERMUDA NATIONAL<br>GALLERY &<br>CITY HALL THEATRE<br>6.45pm & 8.00pm | 17<br>The Aquila<br>Theatre Company<br>*The Tempest*<br><br>CITY HALL THEATRE<br><br>8.00pm |
| 21<br>Ladysmith<br>Black Mambazo<br><br>RUTH SEATON JAMES<br>CENTRE<br><br>8.00pm | 22<br>Ladysmith<br>Black Mambazo<br><br>RUTH SEATON JAMES<br>CENTRE<br><br>8.00pm | 23<br>Chamber Music<br>Series *Flute & Guitar*<br>*Piano Recital*<br><br>BERMUDA NATIONAL<br>GALLERY &<br>CITY HALL THEATRE<br>1.00pm & 8.00pm | 24<br>Chamber Music<br>Series *Harpsichord,*<br>*Flute & Guitar*<br><br>BERMUDA NATIONAL<br>GALLERY<br><br>6.30pm |
| 28<br>Hey Gringo!<br>*Through Peru*<br><br>DAYLESFORD THEATRE<br><br>8.00pm | 29<br>Hey Gringo!<br>*A Chile Christmas*<br><br>DAYLESFORD THEATRE<br><br>8.00pm | 30<br>Hey Gringo!<br>*Through Peru*<br><br>DAYLESFORD THEATRE<br><br>8.00pm | 31<br><br>NO PERFORMANCE |

(continued)
creative firm
**Advantage Ltd.**
client
Bermuda Festival

(20)

| SATURDAY | SUNDAY | | MONDAY | TUESDAY | WEDNESDAY | THURSDAY | FRIDAY | SATURDAY | SUNDAY |
|---|---|---|---|---|---|---|---|---|---|
| **8** The Aquila Theatre Company *Wrath of Achilles* <br><br> BERMUDA NATIONAL GALLERY & CITY HALL THEATRE 6.45pm & 8.00pm | **19**  **20** | |  | | | | **FEBRUARY 1** Monty Alexander *America* <br><br> RUTH SEATON JAMES CENTRE 8.00pm | **2** Monty Alexander *Goin' Yard* <br><br> RUTH SEATON JAMES CENTRE 8.00pm | **3** NO PERFORMANCE |
| **5** Chamber Music Series *Flute & Piano* <br><br> CITY HALL THEATRE 8.00pm | **26** **27** NO PERFORMANCE | | **4** American Ballet Theatre *Studio Company* <br><br> RUTH SEATON JAMES CENTRE 8.00pm | **5** American Ballet Theatre *Studio Company* <br><br> RUTH SEATON JAMES CENTRE 8.00pm | **6** An Evening of Orchestral Music <br><br> CITY HALL THEATRE 8.00pm | **7** An Evening of Orchestral Music <br><br> CITY HALL THEATRE 8.00pm | **8** The Black Dyke Band <br><br> THE FAIRMONT SOUTHAMPTON PRINCESS HOTEL 8.15pm | **9** The Black Dyke Band <br><br> THE FAIRMONT SOUTHAMPTON PRINCESS HOTEL 8.15pm | **10** NO PERFORMANCE |
| | | | **11** Joshua Rifkin plays Ragas Tangos and Waltzes <br><br> CITY HALL THEATRE 8.00pm | **12** The Bach Ensemble <br><br> CITY HALL THEATRE 8.00pm | **13** The Bach Ensemble <br><br> CITY HALL THEATRE 8.00pm | **14** The New Shanghai Circus <br><br> RUTH SEATON JAMES CENTRE 8.00pm | **15** The New Shanghai Circus <br><br> RUTH SEATON JAMES CENTRE 8.00pm | **16** The New Shanghai Circus <br><br> RUTH SEATON JAMES CENTRE 3.00pm matinee 8.00pm | **17** The New Shanghai Circus <br><br> RUTH SEATON JAMES CENTRE 3.00pm matinee |
| | | | **18** NO PERFORMANCE | **19** NO PERFORMANCE | **20** NO PERFORMANCE | **21** Donald Byrd/ The Group <br><br> RUTH SEATON JAMES CENTRE 8.00pm | **22** Donald Byrd/ The Group <br><br> RUTH SEATON JAMES CENTRE 8.00pm | **23** Donald Byrd/ The Group <br><br> RUTH SEATON JAMES CENTRE 8.00pm | **24** NO PERFORMANCE |
| | | | **25** ART a play by Yasmina Reza <br><br> CITY HALL THEATRE 8.00pm | **26** ART a play by Yasmina Reza <br><br> CITY HALL THEATRE 8.00pm | **27** ART a play by Yasmina Reza <br><br> CITY HALL THEATRE 8.00pm | **28** ART a play by Yasmina Reza <br><br> CITY HALL THEATRE 8.00pm | **MARCH 1** ART a play by Yasmina Reza <br><br> CITY HALL THEATRE 8.00pm | **2** ART a play by Yasmina Reza <br><br> CITY HALL THEATRE 8.00pm | |

*Please note that doors will close 5 minutes before the start of the performance and there will be no late admission until the interval.*

creative firm
*Leo Burnett Company Ltd.*
designers
Judy John, Josh Rachlis,
Kelly Zette, Sean Davison, Anne Peck
client
Woodbine Entertainment Group

*Short, clever copy
is often best left
to stand alone*

# VOTED WORST
## PICK UP BAR.

★ PEOPLE COME HERE TO BET. PERIOD. ★

**Champions**™
OFF-TRACK WAGERING

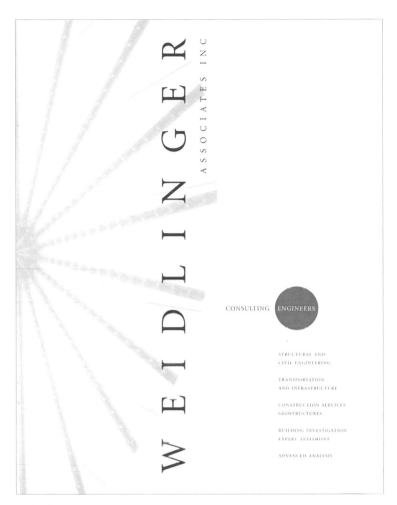

creative firm
**Nassar Design**
designers
Nelida Nassar,
Margarita Enconienda
client
Weidlinger Associates, Inc.

*Type is in all caps on this cover; name of firm runs vertical on top of a screened photograph*

INVENTING
STRUCTURE

CONSTR

Chein Stadium Fabric Roof Analysis

Leighton House Tower

Douglas Securities Headquarters

One Financial Center

St. Francis de Sales Church

Franklin Park Zoo Tropical Forest Pavilion

World Bank Headquarters

Minneapolis Conservatory

US Embassy at Nairobi

WAI WEIDLINGER ASSOCIATES INC
CONSULTING ENGINEERS

(continued)
creative firm
*Nassar Design*
client
Weidlinger Associates, Inc.

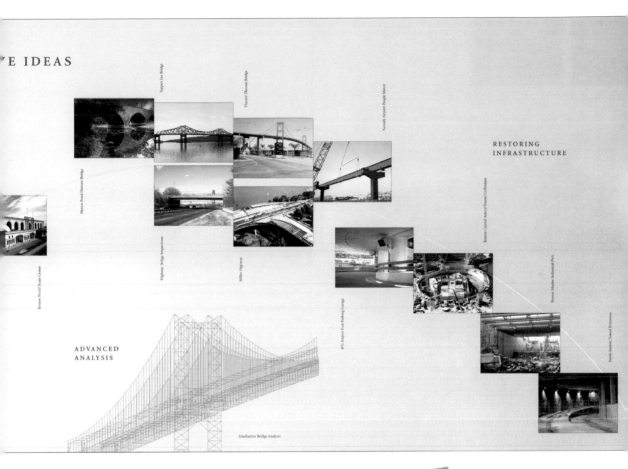

E IDEAS

RESTORING
INFRASTRUCTURE

ADVANCED
ANALYSIS

Photo examples of the firm's work are displayed in building-block fashion on the four-page, center spread of this brochure (pages 177 –179);

headlines, architectural drawings, and connective, arched line are printed in the same blue from the cover

## HUMMINGBIRD CENTRE
### FOR THE PERFORMING ARTS

BALCONY

MEZZANINE

ORCHESTRA

STAGE

## * EARLY-BIRDS SAVE MORE!

If you're planning on only ordering 3 operas this
consider ordering at least one more by April 2, 2

### 2002 / 2003 SCHEDULE

| | TUES SERIES 7 pm | WED SERIES 8 pm | THURS SERIES 8 pm | FRI SERIES 8 pm | SAT SERIES 8 pm |
|---|---|---|---|---|---|
| **FALL SEASON 2002** | | | | | |
| | | | 26 Sept Queen | 27 Sept Oedipus | |
| | 1 Oct Oedipus | 2 Oct Queen | 3 Oct Oedipus | | 5 Oct Queen |
| | 8 Oct Queen | 9 Oct Oedipus | | 11 Oct Queen | 12 Oct Oedipus |

| | TUES SERIES 7 pm | WED SERIES 8 pm | THURS SERIES 8 pm | FRI SERIES 8 pm | SAT SERIES 8 pm |
|---|---|---|---|---|---|
| **WINTER SEASON 2003** | | | | | |
| | | | | 24 Jan Ball | 25 Jan Jenůfa |
| | 28 Jan Ball | 29 Jan Jenůfa | 30 Jan Ball | 31 Jan Jenůfa | |
| | 4 Feb Jenůfa | 5 Feb Ball | 6 Feb Jenůfa | | 8 Feb Ball |

| | TUES SERIES 7 pm | WED SERIES 8 pm | THURS SERIES 8 pm | FRI SERIES 8 pm | SAT SERIES 8 pm |
|---|---|---|---|---|---|
| **SPRING SEASON 2003** | | | | | |
| | | | | 28 Mar Butterfly | |
| | 1 Apr Italian | 2 Apr Butterfly | | 4 Apr Italian | 5 Apr Butterfly |
| | 8 Apr Butterfly | 9 Apr Italian | 10 Apr Butterfly | | 12 Apr Italian |
| | 15 Apr Butterfly ADDED PERFORMANCE | 17 Apr Italian | | | 19 Apr Butterfly ADDED PERFORMANCE |
| | | Passover | | | |

| | TUES 7 pm | WED | THURS 8 pm | FRI 8 pm | SAT |
|---|---|---|---|---|---|
| **COC ENSEMBLE STUDIO PRODUCTION 2002** | | | | | |
| | 3 Dec Turn | | 5 Dec Turn | 6 Dec Turn | |

## SUBSCRIPTION PRICES

### ADULT

| SECTION | same day, same seats FULL 6 OPERA SERIES | EARLY-BIRD 4 OPERAS** | 4 OPERAS | 3 OPERAS |
|---|---|---|---|---|
| 1 | 796 | n/a | n/a | n/a |
| 2 · 9 | 580 | n/a | n/a | n/a |
| 3 · 10 | 472 | 330 | 342 | 262 |
| 4 · 5 | 430 | 290 | 302 | 235 |
| 6 · 11 | 298 | 206 | 218 | 169 |
| 7 · 12 | 238 | 166 | 178 | 139 |
| 8 · 13 | 160 | 114 | 126 | 100 |

*Your choice of days, different seats*

### SENIOR (65+ proof of age required)

| SECTION | | | | |
|---|---|---|---|---|
| 1 | 766 | n/a | n/a | n/a |
| 2 · 9 | 544 | n/a | n/a | n/a |
| 3 · 10 | 436 | 306 | 318 | 244 |
| 4 · 5 | 376 | 266 | 282 | 220 |
| 6 · 11 | 238 | 174 | 190 | 151 |
| 7 · 12 | 184 | 142 | 154 | 121 |
| 8 · 13 | 148 | 106 | 118 | 97 |

### YOUNG PEOPLE* (17 & under, proof of age required)

| SECTION | | | | |
|---|---|---|---|---|
| 1 | 310 | n/a | n/a | n/a |
| 2 · 9 | 250 | n/a | n/a | n/a |
| 3 · 10 | 190 | 130 | 130 | 100 |
| 4 · 5 | 190 | 130 | 130 | 100 |
| 6 · 11 | 130 | 90 | 90 | 70 |
| 7 · 12 | 130 | 90 | 90 | 70 |
| 8 · 13 | 100 | 70 | 70 | 55 |

GST and a handling charge are included in all prices.
*must be accompanied by an adult.
**purchased by April 2, 2002.

21

creative firm
## The Riordon Design Group Inc.
designers
Tim Warnock, Dan Wheaton,
Ric Riordon
client
The Canadian Opera Company

## 2002/2003 Season CD Track List

**Track 1**
Canadian Opera Company
4:40
**Das Rheingold:** *Rheintöchtergesang (Rheinmaidens'*
*song)* from the complete EMI CLASSICS recording.
Symphonie-Orchester des Bayerischen Rundfunks,
Bernard Haitink, conductor; featuring Julie Kaufmann
as Woglinde, Silvia Herman as Wellgunde, Susan
Quittmeyer as Flosshilde and Theo Adam as Alberich
℗1989 EMI Records Ltd.

**Track 2**
The Queen of Spades
3:08
*Uzh polnoch blizitsya (Midnight is already nearing)*
from the EMI CLASSICS recording. Slavonic Opera
Arias featuring Lucia Popp, soprano Münchner
Rundfunkorchester, Stefan Soltesz, conductor
℗1988 EMI Records Ltd.

**Track 3**
Oedipus Rex with Symphony of Psalms
4:13
Excerpts from *Nonn' erubeskita, reges (Are you not*
*ashamed, O princes); Kaedit nos pestis (The plague is*
*killing us)*; and *Gloria* from the complete EMI CLASSICS
recording featuring Marjana Lipovšek as Jocasta
and The London Philharmonic Choir, The London
Philharmonic, Franz Welser-Möst, conductor
℗1993 EMI Records Ltd.

**Track 4**
A Masked Ball
3:57
*Eri tu che macchiavi quell'anima...O dolcezze perdute! O*
*memorie (You it was who stained that soul... O sweet-*
*ness lost; O memory)* from the complete EMI CLASSICS
recording featuring Piero Cappuccilli as Renato, New
Philharmonia Orchestra, Riccardo Muti, conductor
℗1975 EMI Records Ltd.

**Track 5**
Jenůfa
4:02
*Co chvilla...co chvilla (Presently...presently)* from the
complete EMI CLASSICS recording featuring Nadezda
Kniplová as Kostelnička Buryja, Orchestra of the
National Theatre, Prague, Bohumil Gregor, conductor
℗1970 EMI Records Ltd.

**Track 6**
Madama Butterfly
3:31
*Quanto cielo! (What an expanse of sky!)* from the
complete EMI CLASSICS recording featuring Renata
Scotto as Butterfly, Rolando Panerai as Sharpless
and the Chorus of the Teatro dell'Opera di Roma,
Orchestra of the Teatro dell'Opera di Roma, Sir John
Barbirolli, conductor ℗1966 EMI Records Ltd.

**Track 7**
The Italian Girl in Algiers
3:03
*Overture* from the VIRGIN CLASSICS recording Rossini
Overtures, The London Classical Players, Roger
Norrington, conductor ℗1991 EMI Records Ltd.

CD edited and mixed by John Smithbower,
Airwaves Audio Inc.

PHOTOGRAPHIC AND ARTISTIC CREDITS:

Cover: Illustration by Riordon Design Group Inc.,
from a photograph by Michael Cooper (Jennie Ford
in COC's **Oedipus Rex**, 1997). Pages 1 & 2, photo of
Richard Bradshaw by Johnnie Eisen. Pages 3 & 4,
main image: Vitali Taraschenko; inset: Susan Chilcott
and Emma Selway, both images from **The Queen of**
**Spades**, (Welsh National Opera, 2000), photos by
Donald Cooper. Pages 5 & 6, inset: Michael Schade,
both images from **Oedipus Rex**, (COC, 1997), photos
by Michael Cooper. Pages 7 & 8: **A Masked Ball**,
(Dallas Opera, 1998), photos: George Landis. Pages
9 & 10, main image: Gwynne Geyer, Judith Forst and
Quade Winter; inset: Judith Forst, (COC's Jenůfa,
1996), photos: Michael Cooper. Pages 11 &12, main
image: Yoko Watanabe and Marcello Giordani, inset:
Yoko Watanabe and Stephanie Applin (COC's **Madama**
**Butterfly**, 1990), photos: Michael Cooper.

22

*Back cover opens to*
*reveal a three-page*
*spread which shows*
*seating and*
*schedule*

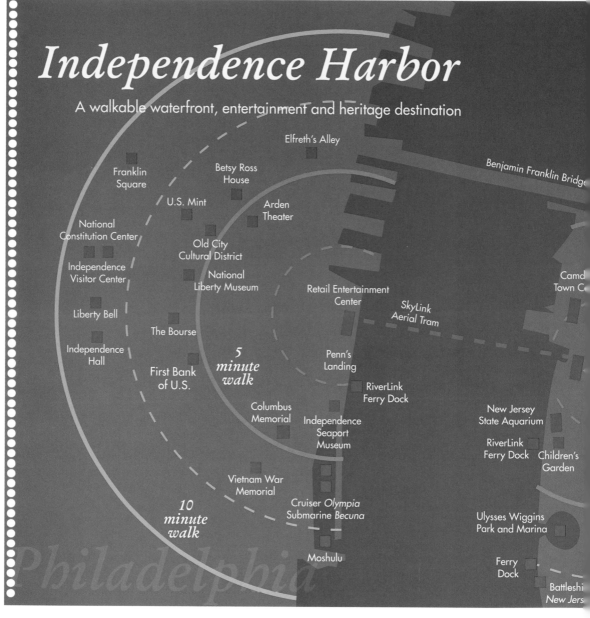

# Independence Harbor

A walkable waterfront, entertainment and heritage destination

Elfreth's Alley

Benjamin Franklin Bridge

Betsy Ross House

Franklin Square

U.S. Mint

Arden Theater

National Constitution Center

Old City Cultural District

Independence Visitor Center

National Liberty Museum

Retail Entertainment Center

SkyLink Aerial Tram

Camd Town C

Liberty Bell

The Bourse

*5 minute walk*

Penn's Landing

RiverLink Ferry Dock

Independence Hall

First Bank of U.S.

New Jersey State Aquarium

Columbus Memorial

Independence Seaport Museum

RiverLink Ferry Dock   Children's Garden

Vietnam War Memorial

*10 minute walk*

Cruiser *Olympia*
Submarine *Becuna*

Ulysses Wiggins Park and Marina

*Philadelphia*

Moshulu

Ferry Dock

Battleshi
New Jers

creative firm
*ID8 Studio/RTKL*
designers
Phil Engelke, Jill Popowich,
Molly Miller
client
DRPA

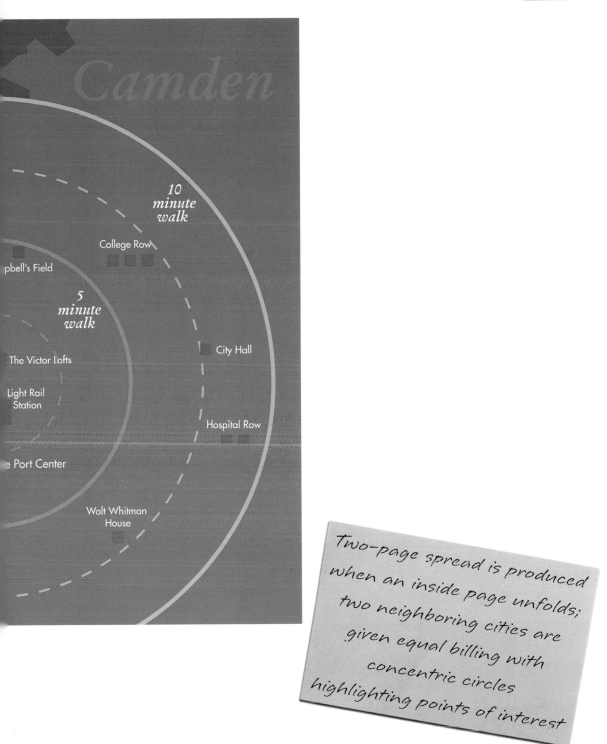

Camden

10
minute
walk

College Row

pbell's Field

5
minute
walk

The Victor Lofts

City Hall

Light Rail
Station

Hospital Row

e Port Center

Walt Whitman
House

Two-page spread is produced when an inside page unfolds; two neighboring cities are given equal billing with concentric circles highlighting points of interest

Same mechanics as its sister spread (pages 182 – 183), but the artwork differs giving the viewer an additional perspective

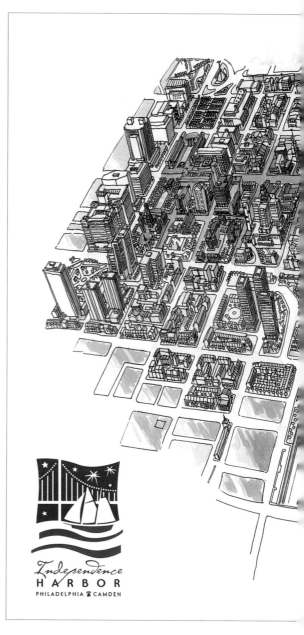

(continued)
creative firm
*ID8 Studio/RTKL*
client
DRPA

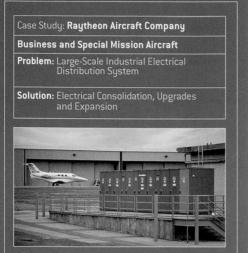

Case Study: **Raytheon Aircraft Company**

**Business and Special Mission Aircraft**

**Problem:** Large-Scale Industrial Electrical
Distribution System

**Solution:** Electrical Consolidation, Upgrades
and Expansion

## *Premier Power*

For a company known for developing powerful innovations
like the King Air, Hawker Horizon and the Premier I – winner of
*Flying* magazine's Editor's Choice Award – overloaded and

outdated electrical systems
simply wouldn't do.

Prior to 1992 the facility
suffered from unexplained
interruptions and
disturbances in electrical
power. Out-of-date substations
had no spare capacity and no room for expansion. The quickly
growing aviation plant needed increased power capabilities,
yesterday. And without any downtime.

**The solution? The experts called in the experts.**

Working closely with Raytheon Aircraft plant engineering
and the local utility, Morrow Engineering re-engineered the
entire power distribution system for increased reliability and
capacity, consolidated multiple services into two underground
primary selective utility circuits, redistributed loads and
reconnected the electrical services to 18 buildings – all with
no loss of production during installation.

Morrow increased capacity by engineering new substations
and increased the utilization of electrical power by
completing a power distribution monitoring system that
monitors more than 100 different points.

For more than ten years Raytheon Aircraft has continued to
rely on Morrow Engineering to provide it with a steady supply
of Premier Power.

## Precision Under Pressure

When it is time to create, upgrade or modify either a
complex automated processing system or an electrical
distribution system, who should you call? Who do you trust
to instill the highest level of quality? Who do you trust to
deliver solutions within budget demands? What engineering
company can perform with exacting precision under the
most stringent constraints of time? What kind of company
can integrate the demands of the job at hand today, and the
needs you'll face tomorrow?

**Morrow Engineering, Inc.**

By specializing in
automated processing,
programming and power
systems — and with the
unique ability to
integrate automation and
power — Morrow is the
name to trust. Morrow
Engineering has built a
remarkable track record
for safe, innovative
solutions, leading its
competitors throughout the land. By remaining flexible and
demanding only the best from its engineers and maintaining
ruthless standards of quality, Morrow Engineering is well
qualified to lead your company to greater productivity,
efficiency and quality, today and into tomorrow.

**Make the connection with Morrow Engineering today.**

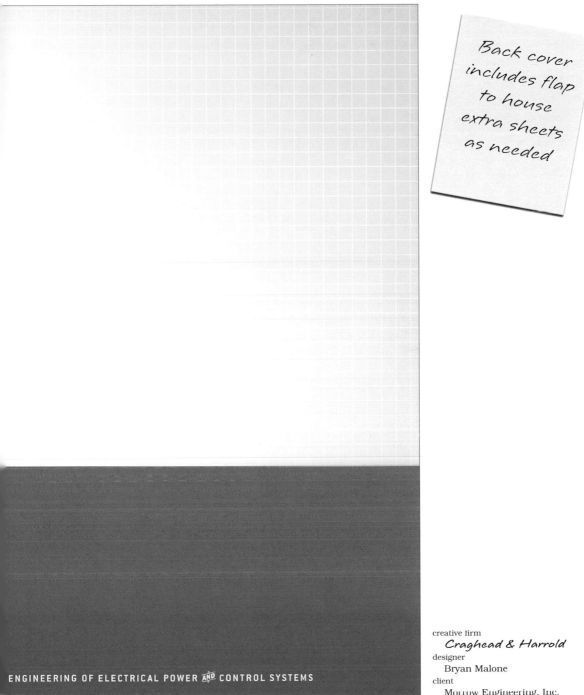

Back cover
includes flap
to house
extra sheets
as needed

ENGINEERING OF ELECTRICAL POWER **AND** CONTROL SYSTEMS

creative firm
**Craghead & Harrold**
designer
Bryan Malone
client
Morrow Engineering, Inc.

>> First Check® your path to
# Wellness

**First Check #1 National Brand**

■ FDA 510(k) Cleared State-of-the-Art Tests

■ Dedicated Experienced Management Team

■ Diagnostic tests across multiple disciplines

**Spectrum Analytics, Inc.**

■ EIA and GC/MS On-Site Testing

■ R&D in Areas of Diagnostic and Toxicology

■ Synthesis of Reagents for Drugs of Abuse Testing

**Diverse Distribution Channels**

■ Professional

■ Retail Consumer

■ International

■ E-commerce

*First Check® – When the need to know...is now!*

Consistent color usage maintains visual integrity until the very last page

creative firm
**Vince Rini Design**
designer
Vince Rini
client
Worldwide Medical Corp.

## SOLUTIONS START HERE

Halloran & Sage LLP delivers a **team-based service approach.** Our attorneys are organized into teams that regularly practice in specific areas. This approach enables us to stay on the leading edge of developments in our practice areas and thereby maximize our contributions and minimize your costs.

Halloran & Sage LLP can assist you with **full legal representation, handling transactions, advising, counseling, planning, litigating and resolving disputes,** in the following areas:

- Administrative and Regulatory Law
- Appellate Law and Advocacy
- Banking, Finance, Bankruptcy and Creditors' Rights
- Business Law
- Civil and Tort Law
- Civil Rights and Governmental Tort Liability
- Commercial Law
- Construction Law
- Criminal Law
- Education Law
- Employee Benefits
- Energy and Telecommunications
- Environmental and Land Use Law
- Estate, Trust and Probate Law
- Fidelity and Surety Law
- Governmental Relations and Lobbying

- Health Care and Disability Law
- Information Technology, including Year 2000
- Insurance Coverage/Bad Faith
- Intellectual Property
- Labor and Employment
- Municipal Law and Liability
- Products Liability and Risk Management
- Professional Liability/Malpractice
- Property Insurance
- Real Estate
- Religious Institution Law
- Securities
- Tax Law
- Trade Regulation and Antitrust
- Trucking and Transportation
- Workers' Compensation

2

Our experienced **business** attorneys are "hands-on." We will work closely with you to fully understand your business and enable you to meet its needs and achieve its goals.

Halloran & Sage LLP's **governmental relations and lobbying** group is engaged when an issue requires access to the state legislature. Through the years, we have developed working relationships with local, state and federal elected officials and administrators.

Halloran & Sage LLP has one of the most active **litigation** practices in Connecticut. Our litigation expertise is widely recognized by the courts, clients and colleagues alike.

*With attorneys admitted to practice in Connecticut, New York, Massachusetts and Rhode Island, and three offices strategically located throughout Connecticut, we possess the experience and depth to handle whatever legal challenges are presented.*

**Technology** plays a key role in our practice and supports our operational flexibility, efficiency and client service. We can communicate electronically with clients, the courts and opponents around the block or around the world.

**Visit us at** **http://www.halloran-sage.com**

3

Photography is accentuated with white frames and black borders; important text is prioritized by changing the font and putting it in boxes

creative firm
*Leverage MarCom Group*
designer
Heather Patrick
client
Halloran & Sage

creative firm
**atomz interactive**
designers
Patrick Lee,
Vivi Chang
client
MCI WorldCom Pte Ltd

Negative images, printed in vivid colors, make an attention-getting display

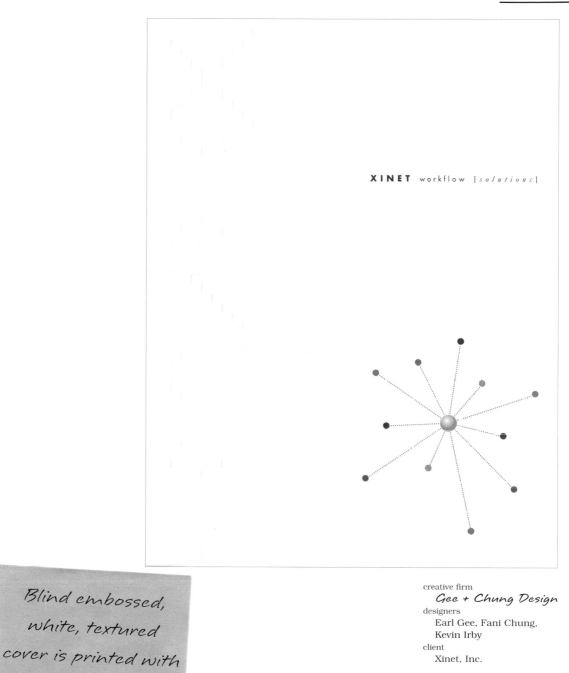

XINET workflow [*solutions*]

creative firm
**Gee + Chung Design**
designers
Earl Gee, Fani Chung,
Kevin Irby
client
Xinet, Inc.

Blind embossed,
white, textured
cover is printed with
only one ink; color
dots are printed
behind die cuts

# Expanding your business: now and in the future. Different industries discover product benefits in different ways.

**FULLPRESS, WEBNATIVE & WEBNATIVE VENTURE: INNOVATIVE SOLUTIONS FOR COMPETITIVE MARKETS**

XINET'S SCALABLE SOLUTIONS GROW WITH YOUR BUSINESS, SPEEDING LOCAL AND REMOTE PRODUCTION — ACROSS THE OFFICE AND AROUND THE WORLD.

*FullPress®* server software alleviates the bottlenecks that businesses encounter when they work with large image files. With FullPress at the center of the workflow, managing file-sharing, minimizing network traffic, and sending output to any device on the network, sites can speed production, reduce costs and increase output.

Adding *WebNative*™ to the FullPress workflow extends services over the Internet, giving customers, staff and collaborative partners instant access to digital assets. In addition to the advantages of centralized multi-site asset sharing, WebNative also streamlines many production activities, such as re-purposing, proofing,

archiving and restoring. WebNative is an incredibly versatile system that can be used for corporate brand management, as well as creating new Web-enabled production workflows.

Xinet's *WebNative*™ *Venture* combines all of the functionality and ease-of-use of WebNative with an enterprise-strength SQL database—for even faster searching, organizing, and categorizing of data—creating an asset-management system that's completely and automatically integrated into each site's existing FullPress workflow.

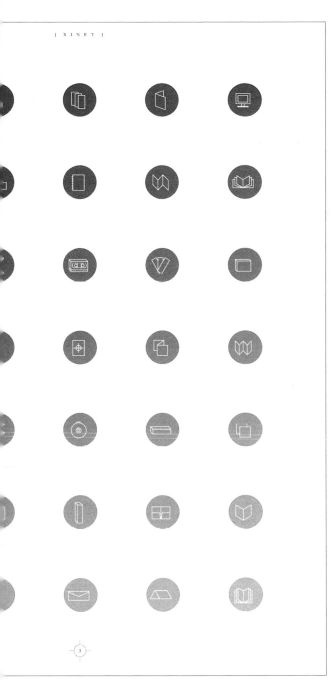

[ XINET ]

(continued)
creative firm
*Gee + Chung Design*
client
Xinet, Inc.

Interesting balance is achieved between an all copy layout and all symbol layout, white being the common color;

slight gradations behind the text indicate light; modern icons are housed behind die-cut circles, a treatment also found on the cover (page 193)

creative firm
**Design Coup**
designers
Michael Higgins,
George Farkas
client
Function Engineering

# CINEMA DISPLAY

Users of flat panel displays must set the viewing angle for best results. In line with its easy-to-use design approach, Apple Computer sought a method for users to quickly adjust the Cinema Display without using locking buttons or levers to secure the support.

Function Engineering designed an articulated support foot that uses a unique slip clutch to hold the display position. The innovative mechanism provides single-hand adjustment of the monitor's tilt.

INDUSTRIAL DESIGN BY
APPLE COMPUTER, INC.

*f(x)*   *Apple Computer, Inc.*

Short, but wide, pages make good use of their shape (the very product has been imitated!); two-color layout incorporates pure white to add a third color

Every day, the pile gets higher: brochures and viewbooks from some of the best colleges and universities in the country. But you're not afraid of heights. You're "up there" in your class. You've gotten a lot of feedback over the past twelve years that says you've got a brain and you know how to use it.

We're up there, too. Vassar is consistently ranked among *the top one percent* of colleges and universities in the country and has been a frontrunner in higher education for nearly a century and a half.

So we're both good—better than good. We're both among the best. The question is: are we right for each other? Or more to the point: *are we right for you?*

Only you can answer that question. What we can do is tell you what sets Vassar apart from the other colleges on your "maybe" list.

First things first. We're a college, not a university. That sets us apart from about half of the schools in the top one percent. Some people prefer big. Some people prefer anonymity. If that's for you, then we probably aren't.

But it's more than a question of size. It's also about your economics professor knowing what position you play on the soccer team. It's about actually getting to *use* the inductively coupled plasma atomic emission spectroscope—instead of watching a graduate student demonstrate it. It's about getting close enough to a Rembrandt etching to smell the paper.

Finally, it's also about what happens to people when they come here, what they *become*. English professor Gretchen Gerzina put it like this: "Vassar students are more willing to leap in and get involved. They're more original and less tentative. There are more independent thinkers here than any other place I've taught."

Two-time Academy-Award winner Meryl Streep, class of 1971: "I say to people, Vassar is where I became who I am, where I found my character—where I found my *self.*"

Vassar student Shaka King '01: "My mother—she's a writer—asked me if it was the air up here, because I've changed."

Vassar is transformative. If you're ready for that—ready to be challenged intellectually; ready to connect with other people who have as much going on in their heads as you do; ready to figure out who you are and what you want—then Vassar probably is your kind of place.

You might want to make sure we're at the top of that pile.

**Location, Location**
An hour and a half on the train and you're in Grand Central terminal, in the heart of Manhattan, headed for the Museum of Modern Art, Comedy Central, or the half-price ticket booth in Times Square. A 20-minute drive in the other direction and you're rock climbing in the Shawangunks or rowing on the Hudson River or brunching at the Beekman Arms, the oldest inn in the U.S.

**Celebrated Faculty**
They're distinguished scholars and artists. They win big awards—Guggenheims, NSF research grants, and major artistic commissions. But they're also master teachers. As one sophomore put it, "They really, really love their jobs." Student-faculty ratio, 9:1.

**Connected**
The entire Vassar community—including every student room—is networked via fiber-optics and connected around the clock to the Internet and the World Wide Web.

**Summer Science**
The Undergraduate Research Summer Institute annually gives about 50 students in the natural sciences an opportunity to work one-on-one with faculty mentors on significant, publishable research—and to get paid for it.

**Dollars and Sense**
Exclusive of federal and state aid, Vassar awards about $18 million annually among highly selective liberal arts colleges. About 55% of Vassar students rece[...]

creative firm
*Nesnadny + Schwartz*
designers
Mark Schwartz, Joyce Nesnadny,
Michelle Moehler, Cindy Lowrey,
Stacie Ross, Keith Pishnery
client
Vassar College

ng the 13,500 works of art in the Vassar collection are 9,000 prints and drawings—Rembrandts, Dürers, ...ndays, any student can go into the Frances Lehman Loeb Art Center and ask for any print or drawing in collection, and it will be brought to the seminar room where he or she can examine it closely.

**Star Gazing**
Did you know that "Friends" star Lisa Kudrow is a Vassar alumna? And Oscar winner Meryl Streep. And Jon Tenney in *You Can Count on Me*, and Catherine Kellner in *Shaft* and *Pearl Harbor*, and...

**If You've Got It, Flaunt It**
Recent accolades: named "College of the Year" by *TIME* magazine and the Princeton Review in *The Best College for You*; "one of the new lives" by the *Wall Street Journal*; one of the top colleges for African-American students by *Black Enterprise* magazine; and one of the nine "hottest" schools by the *Newsweek/Kaplan How to Get into College Guide*.

**Never a Dull Moment**
Every year, about 1,650 campus-wide events are listed on the Vassar calendar—everything from the Vassar Cross Country Invitational to stand-up by Adam Sandler to a Branford Marsalis concert to a lecture by Spike Lee to a Film League screening of Hitchcock's *Vertigo*.

**When They Play, They Play Hard**
Recently: both women's volleyball and men's soccer earned N.C.A.A. post-season berths and advanced to the second round; women's rugby won the Metropolitan New York Conference title for the third consecutive year; men's cross country runner Troy Hull won the Upstate Collegiate Athletic Association Championship; and women's tennis earned a number 10 ranking in the 150-team N.C.A.A. Division III East Region.

**The Lay of the Land**
1,014 acres, maintained as an arboretum with more than 200 species of trees; the Vassar Farm, an ecological preserve adjacent to the main campus with nine miles of jogging and hiking trails; a 10-acre area and sailing facility on the Hudson River; a nine-hole golf course...

**The Play's the Thing**
There are three venues for dramatic productions on campus— a proscenium theater in the new Center for Drama and Film and two "black box" theaters, the Hallie Flanagan Davis Powerhouse Theater and the Susan Stein Shiva Theater.

college in the forefront in financial aid available ...d to first-year students in 2001 was over $21,000.

---

*Unassuming leaflet unfolds to over 36" wide, chockful of action shots of college life— who WOULDN'T want to go to school THERE?*

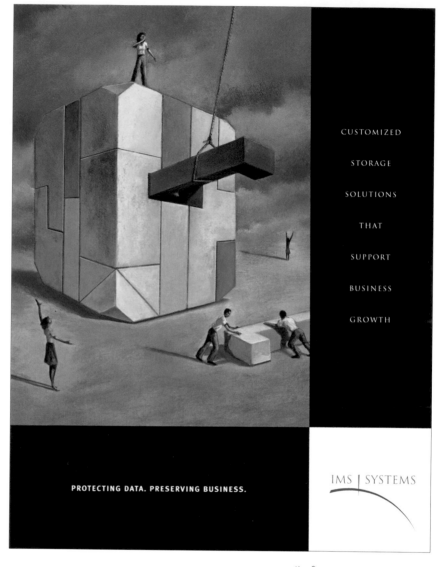

CUSTOMIZED

STORAGE

SOLUTIONS

THAT

SUPPORT

BUSINESS

GROWTH

**PROTECTING DATA. PRESERVING BUSINESS.**

IMS | SYSTEMS

creative firm
*Phoenix Creative Group*
designer
Kathy Byers
client
IMS Systems

Nice primary-color illustration dominates the cover, surrounded by blocks of black and white; last page of folder uses the same style of art and reversed headline

## THE COMPLETE COMBINATION OF
# SERVICES AND
# SUPPORT.

Because we specialize in storage solutions, IMS Systems is uniquely positioned to provide the most extensive array of products and services while maintaining a level of technical support and training that is second to none. Our commitment to service is one of the distinct advantages we offer over other, less specialized integrators. Instead of attempting to sell you a particular product line or a level of sophistication that is beyond your needs, IMS Systems takes pride in designing the best possible storage solution for you, with:

- Technical phone support
- Installation and consulting services
- State-of-the-Art Solutions Lab
- State-of the-Art  Demo Center
- State-of-the-Art Training Center
- Storage Management Software

**Data storage is a business necessity. IMS Systems can turn yours into a business advantage.**
Every day, you strive to gain new knowledge and develop new competitive advantages that will distinguish your business from your competition. So why trust your most valued asset to an outdated or pre-designed system to safeguard and manage it?

IMS Systems will provide a customized solution that specifically fits your company's needs and leverages your unique strengths. Our combination of experience, technical expertise and commitment to service will help you get the most return from your company's biggest overall investment–your information.

creative firm
*Phoenix Creative Group*
designer
Kathy Byers
client
IMS Systems

IMS SYSTEMS

# THE STORAGE SOLUTIONS
# ARCHITE

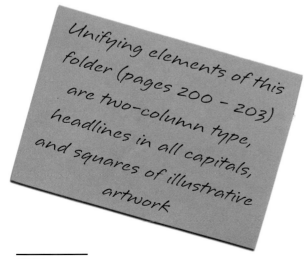

Integrated Mass Storage (IMS)
Systems is a full-service integrator
of Information Technology (IT) data
storage solutions. We combine the
industry's leading hardware and
software tools with a comprehensive
level of technical expertise, allowing
us to provide custom storage systems
that are precisely engineered for
our clients.

Since 1991, IMS Systems has been
designing, installing and supporting
mass data storage systems for companies
of all sizes across all imaginable
platforms and network environments.
We offer a full range of storage solutions
that includes storage area networks
(SANs), network attached storage (NAS),
departmental and enterprise backup and
recovery, high availability (HA) clustering,
data replication, comprehensive

Unifying elements of this
folder (pages 200 – 203)
are two-column type,
headlines in all capitals,
and squares of illustrative
artwork

## INFORMATION IS THE
# LIFEBLOOD
### OF BUSINESS.

t, monitoring and reporting
chial storage management
nore. By combining a
oduct offering with an
commitment to service
, we provide a fully
solution that is based
ur clients' current and
ess needs.

we design IT storage
keep your data secure
le at all times. Because
you spend worrying
curity and availability of
, the more time you can
rving your customers—and
business.

When stored as data, information is the single most indispensable asset of any company, from multinational corporations that stretch across the globe to local organizations with a single office and a handful of employees. Regardless of the industry, information is the one thing that no business can live without—even for a short period of time.

At IMS Systems, our sole business purpose is to ensure that your information remains secure and accessible, without interruption, for the life of your company.

## WHEN INFORMATION IS
# LOST,
### SO IS YOUR BUSINESS.

Information systems are not unlike cogs in an elaborate machine. They rely on one another to continue functioning properly, and when one cog slips, the entire mechanism is affected—often with disastrous, if not irreversible, results.

IMS Systems designs storage solutions that protect your data and ensure its availability every time you need it. Our solutions provide the most efficient and practical architecture for your business, helping to keep "the machine" in perfect working order.

**Don't just protect your information.
Benefit from it.**

Disaster recovery is a critical function of our business. But at IMS Systems, we believe in designing storage solutions that enable users to get to the information they need, when they need it. Because being able to use your information efficiently is every bit as important to your business as protecting it. And we would rather work with you to prevent disasters from happening than meet you after the fact.

Solid-to-white gradation in bottom corner is reproduced in product shot;

similar treatment in top corner deletes color altogether; gray text is printed in italic fonts, both serif and sans serif

STRONG
# Branding

creative firm
**Design North, Inc.**
designers
Design North Staff

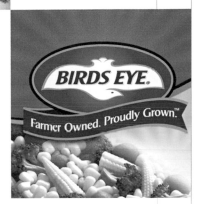

*Our goal is to move companies from
good branding, to owning a desired brand.
We feel this can only happen when you have
a coordinated team of specialists working on
your brand. No one on our team does it all,
but together we do it all well.*

Branding takes equal parts creative inspiration and marketing savvy.
That's why we not only have an award-winning design team with
heavy brand expertise, but also a top flight marketing staff that
specializes in brand development. Many of our account strategists
come from world class marketers like Nike, Miller Brewing, Nestle
and Snap-on. They're experienced at helping you analyze your
market, identify your target, and discover what motivates them.
Then our design team can take those critical insights and create the
kind of eye-catching brandmarks, packaging, POS, and promotional
materials that appeal to consumers on an emotional level. When
design harmonizes with lifestyle in that manner, your product is
elevated to the vaunted class of a desired brand.

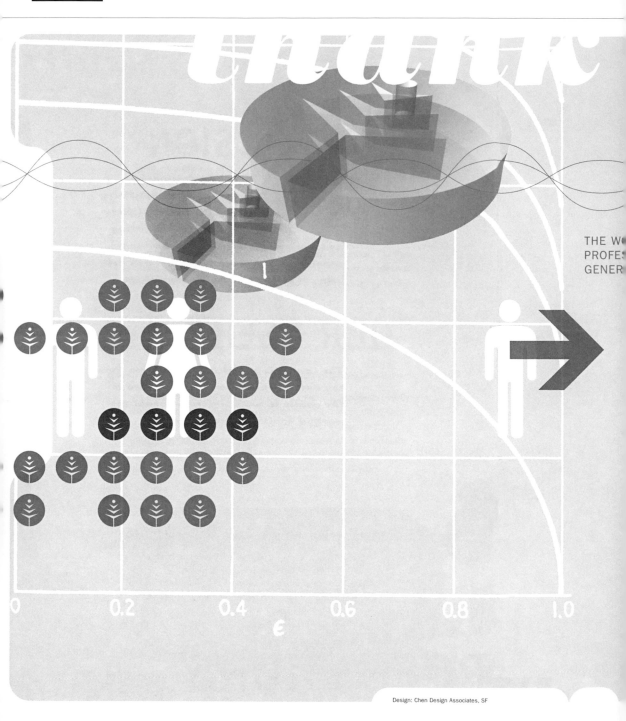

Design: Chen Design Associates, SF

Two-color layout
makes full use
of value range
to produce
dimensionality and
movement

THE CENTER FOR THE HEALTH
IS MADE POSSIBLE BY THE
AND SUPPORT OF ITS FUNDERS:

oundation
ia HealthCare Foundation
ia Policy Research Center
ia Office of Statewide Health Planning
d Development
ia Wellness Foundation
tion for National and Community Service
nstitute
Resource Services Administration
Macy, Jr. Foundation
Fund for Medical Education
Institute for Dental and
niofacial Research
Institute for Health
fornia Endowment
ene Fuld Health Trust, HSBC, Trustee
Charitable Trusts
ert Wood Johnson Foundation
ty of California Office of the President
au of Health Professions
au of Primary Health Care

*thank you*

creative firm
**Chen Design Associates**
designers
Max Spector, Josh Chen
client
UCSF Center for
the Health Professions

All visuals move rightward in this layout; wire textures produce great background imagery; slate blue from the product is reproduced in headlines

This simple customer service philosophy has driven the efforts of Archer/American wire for over

# leading wire fabricating

60 years. Passed along for three generations through the Svabek family, it has been the catalyst for our evolution into one of the leading wire fabricating companies in the world.

In suc you qu

creative firm
**dawn design**
designer
Dawn Peccatiello
client
Archer/American Wire

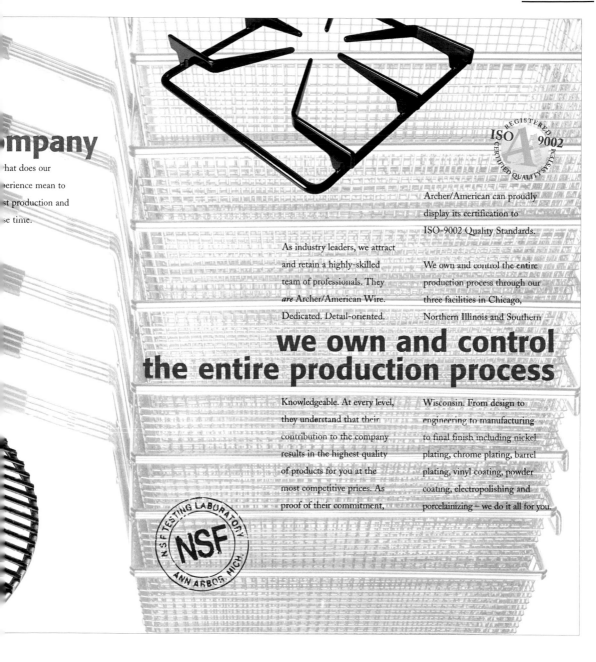

...mpany

...hat does our
...erience mean to
...st production and
...se time.

ISO 9002 — REGISTERED CERTIFIED QUALITY SYSTEM

Archer/American can proudly
display its certification to
ISO-9002 Quality Standards.

As industry leaders, we attract
and retain a highly-skilled
team of professionals. They
*are* Archer/American Wire.
Dedicated. Detail-oriented.

We own and control the entire
production process through our
three facilities in Chicago,
Northern Illinois and Southern

# we own and control the entire production process

Knowledgeable. At every level,
they understand that their
contribution to the company
results in the highest quality
of products for you at the
most competitive prices. As
proof of their commitment,

Wisconsin. From design to
engineering to manufacturing
to final finish including nickel
plating, chrome plating, barrel
plating, vinyl coating, powder
coating, electropolishing and
porcelainizing – we do it all for you.

NSF TESTING LABORATORY — NSF — ANN ARBOR, MICH.

creative firm
*D,L,V, BBDO*
designers
Gianpietro Vigorelli
client
Studio Universal Italy

10

**The Value That We Bring
To You As Our Customer**

"When you select Liebert, you're not
just buying a product — you're buying
a company. We are in it with you for the
long haul. It's this ability to add ongoing
value to your purchase that is your
return on investment.

In the systems protection business, it's
when you need someone to count on that
you find out whether you've made the right
choice. Liebert customers — many of them
with us for over three decades — already
know how good their decision was. Their
Liebert equipment has been providing the
highest level of protection for critical
information systems and key processes
year after year.

Our ultimate goal is to provide the products
and services that will allow our customers
to have the confidence that their critical
systems will always be there when needed.
*That is the Liebert experience.*"

Strength and R
Em
Pow
The

The Liebert Experience

What The
Liebert Difference
Really Means
To You

*President*
Bob Bauer

**Liebert**®
KEEPING BUSINESS IN BUSINESS®

11

**ources**

**Network**
**hances**
**rt Experience**

Wherever Your Needs Extend, We Can Help

As an Emerson Network Power company, Liebert is uniquely
positioned to join with other Emerson divisions to offer
complete power solutions.

Emerson Network Power has the technology expertise,
global reach, and breadth of products and services to build
and support your entire power network. Emerson Network
Power is a leader in the design, manufacturing, installation
and maintenance of power and connectivity solutions
for power dependent businesses.

From the grid to the chip, Emerson Network Power is
keeping mission-critical equipment up and running in a
rapidly changing, "always-on" economy.

**EMERSON**
**Network Power**

Silver metallic
headlines, copy
that spans the
spread, spot
varnished figures,
and yellow color
boxes all join to
turn these two
layouts into one

creative firm
*Mlicki Inc.*
designers
Ron Mlicki, John Randle
client
Liebert Corporation

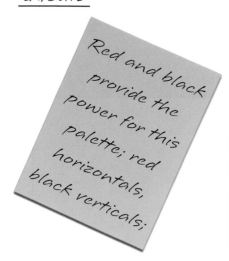

Red and black provide the power for this palette; red horizontals, black verticals;

# PEÑOLES AT A GLANCE

### MINING AND EXPLORATION

**Proven and probable reserves (at operating units) (000):**
- Gold: 3,397.2 ounces
- Silver: 406,140.1 ounces
- Lead: 794.2 metric tons
- Zinc: 3,101.3 metric tons

**Main exploration projects:**
**Mexico**
- Milpillas: copper (2005) US$180.0 million; advanced exploration and start-up of feasibility study
- Mezcala: gold; exploration at reduced rate
- Pinos Altos: gold; exploration at reduced rate

**International**
- Argentina: gold and copper; continuous exploration
- Peru: polymetallic; continuous exploration

**Key mines:**
- Fresnillo: richest silver mine in the world
- La Ciénega: richest gold mine in Mexico
- La Herradura: largest gold mine in Mexico
- Naica: largest lead producer in Mexico
- Francisco I. Madero: largest zinc producer in Mexico

### METALS

**Main operations and annual capacity:**
- Lead smelter: 180,000 metric tons/lead bullion
- Lead-silver refinery: 80 million oz/silver; 1,200,000 oz/gold; 180,000 metric tons/lead; 2,000 metric tons/bismuth
- Electrolytic refinery: 220,000 metric tons/zinc
- Alloys: 130,000 metric tons/zinc; 50,000 metric tons/lead
- Other: sulfuric acid, liquid sulfur dioxide, and metal sulfates

**Key facility:**
- Met-Mex: fourth largest metallurgical complex and largest refined silver and metallic bismuth producer worldwide

### INORGANIC CHEMICALS

**Key facilities and annual capacity:**
- Química del Rey: 620,000 metric tons/sodium sulfate; 100,000 metric tons/magnesium oxide; 30,000 metric tons/magnesium world's largest sodium sulfate plant
- Magnelec: 5,000 metric tons/electrofused magnesium oxide
- Fertirey: 250,000 metric tons/ammonium sulfate

2

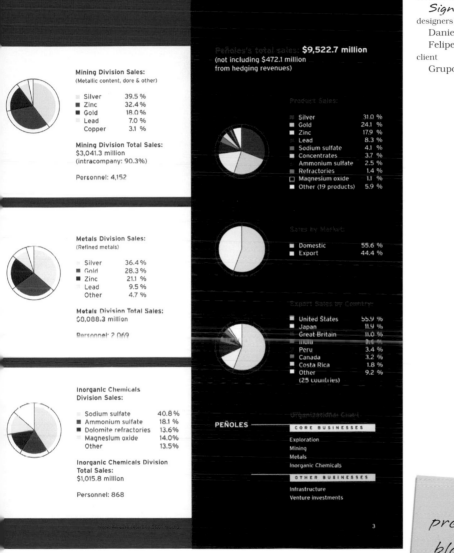

creative firm
*Signi Design*
designers
Daniel Castelao,
Felipe Salas
client
Grupo Peñoles

**Mining Division Sales:**
(Metallic content, dore & other)

| | |
|---|---|
| Silver | 39.5 % |
| Zinc | 32.4% |
| Gold | 18.0 % |
| Lead | 7.0 % |
| Copper | 3.1 % |

**Mining Division Total Sales:**
$3,041.3 million
(intracompany: 90.3%)

Personnel: 4,152

**Metals Division Sales:**
(Refined metals)

| | |
|---|---|
| Silver | 36.4% |
| Gold | 28.3% |
| Zinc | 21.1 % |
| Lead | 9.5 % |
| Other | 4.7 % |

**Metals Division Total Sales:**
$6,088.3 million

Personnel: 2,069

**Inorganic Chemicals Division Sales:**

| | |
|---|---|
| Sodium sulfate | 40.8% |
| Ammonium sulfate | 18.1 % |
| Dolomite refractories | 13.6% |
| Magnesium oxide | 14.0% |
| Other | 13.5% |

**Inorganic Chemicals Division Total Sales:**
$1,015.8 million

Personnel: 868

Peñoles's total sales: **$9,522.7 million**
(not including $472.1 million
from hedging revenues)

Product Sales:

| | |
|---|---|
| Silver | 31.0 % |
| Gold | 24.1 % |
| Zinc | 17.9 % |
| Lead | 8.3 % |
| Sodium sulfate | 4.1 % |
| Concentrates | 3.7 % |
| Ammonium sulfate | 2.5 % |
| Refractories | 1.4 % |
| Magnesium oxide | 1.1 % |
| Other (19 products) | 5.9 % |

Sales by Market:

| | |
|---|---|
| Domestic | 55.6 % |
| Export | 44.4 % |

Export Sales by Country:

| | |
|---|---|
| United States | 55.9 % |
| Japan | 11.9 % |
| Great Britain | 11.0 % |
| India | 0.6 % |
| Peru | 3.4 % |
| Canada | 3.2 % |
| Costa Rica | 1.8 % |
| Other (25 countries) | 9.2 % |

Organizational Chart

PEÑOLES —

**CORE BUSINESSES**
Exploration
Mining
Metals
Inorganic Chemicals

**OTHER BUSINESSES**
Infrastructure
Venture investments

3

*statistics are presented in three blocks within the pages boundaries, spiking center*

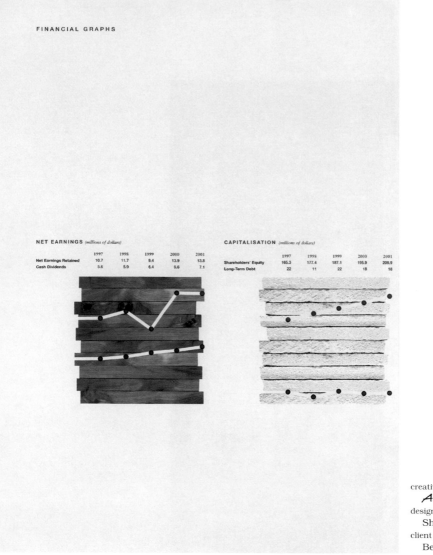

FINANCIAL GRAPHS

**NET EARNINGS** *(millions of dollars)*

|  | 1997 | 1998 | 1999 | 2000 | 2001 |
|---|---|---|---|---|---|
| Net Earnings Retained | 10.7 | 11.7 | 9.4 | 13.9 | 13.8 |
| Cash Dividends | 5.6 | 5.9 | 6.4 | 6.6 | 7.1 |

**CAPITALISATION** *(millions of dollars)*

|  | 1997 | 1998 | 1999 | 2000 | 2001 |
|---|---|---|---|---|---|
| Shareholders' Equity | 165.3 | 177.4 | 187.1 | 195.9 | 209.9 |
| Long-Term Debt | 22 | 11 | 22 | 18 | 18 |

creative firm
*Advantage Ltd.*
designer
Sheild Semos
client
Belco Holdings Limited

TO THE SHAREHOLDERS

2001 was a year characterised by the ever-evolving process of change, and one in which we made significant progress in defining the platform for change throughout our organisation. Building on our successes in 2000, we moved several steps closer to creating a more streamlined and process-centred organisation during 2001.

Our goal is the same as it has always been. We want to be the best: the best employer, the best-managed company in Bermuda, the best customer service provider. Although this position could be considered by some to be over-ambitious, we are determined to succeed and reap measurable results from the changes we make.

Throughout 2001, we remained vigorous in our pursuit of this goal, continuing the process of becoming a more effective, more productive, more sensitive and ultimately more successful organisation by changing the way we do business and embracing accountability, innovation, and flexibility as key elements of change.

Our results in 2001 reflect the organisation's focus on performance. Net earnings were $20.9 million, up 2.3 percent from 2000, which itself was a strong year. Earnings per share were up 2 percent to $4.55. The dividend paid to shareholders was also up 7.7 percent to $1.54 from $1.43.

All three of BELCO Holdings Limited's (Holdings) operating subsidiaries – Bermuda Electric Light Company Limited (BELCO), Bermuda Gas & Utility Company Limited and BELCO Energy Services Company Limited (BESCO) – performed well in 2001. BELCO earnings rose 3 percent to $19.8 million with kilowatt hour sales up 3.5 percent. Bermuda Gas earnings were up 12.5 percent over 2000, and while BESCO's earnings were down from 2000, operating revenue increased 20.6 percent.

Our most significant accomplishment in 2001 was our ability to define precisely the strategic direction we will follow over the next five years. This process has involved much analysis, discussion, and planning on what it means to be the best, and how we need to change the way we do business in order to get there. More specifically, we focused on the rapidly increasing expectation levels of all our stakeholders and the less certain market environment in which we are now operating.

**Other key accomplishments during the year were:**

❖ In addition to a number of group and department initiatives, five corporate strategic initiatives were identified for 2002 which fit squarely with our desire to change the way we do business. They relate to operational effectiveness, customer service, performance management, leadership development, and corporate relationships.

❖ In keeping with these strategic initiatives, the remodeling of the Human Resources department got underway. Changes are being made to both the physical office space at our Head Office and in the Training Centre, as well as to the roles and responsibilities of the HR team.

**INVESTMENT IN PROPERTY, PLANT AND EQUIPMENT – NET** *(millions of dollars)*

| 1997 | 1998 | 1999 | 2000 | 2001 |
|------|------|------|------|------|
| 16.1 | 25.1 | 36.7 | 22.3 | 16.1 |

3

BELCO HOLDINGS LIMITED 2001 ANNUAL REPORT

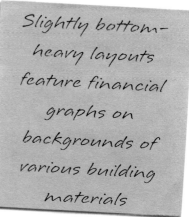

*Slightly bottom-heavy layouts feature financial graphs on backgrounds of various building materials*

Nice trilogy of pictures: aerial shot of the golf course, take-it-as-you-play-it photo, and close-up of an azalea bloom seen on the green; quote from famous golfer is set on torn-paper image dimensionalized by shadow effect

# 13 Azalea

| Par 5 | 510 Yards | 2001 Field Average: 4.740 | 2001 Difficulty Rating: 1 |

"In my opinion this 13th hole is one of the finest holes for competitive play I have ever seen. The player is first tempted to dare the creek on his tee shot by playing in close to the corner, because if he attains this position he has not only shortened the hole but obtained a more level lie for his second shot. Driving out to the right not only increases the length of the second, but encounters an annoying sidehill lie. The second shot as well entails a momentous decision whether or not to try for the green. A player who dares the creek on either his first or second shot may very easily encounter a 6 or 7 at this hole. Yet the reward of successful, bold play is most enticing."

—*Bob Jones*

Players used to hit a 4-wood second shot to reach the 13th green. These days, it often takes no more than a 6-iron. By acquiring a small portion of land from the adjacent Augusta Country Club last summer, Augusta National was able to build a new tournament tee to lengthen the hole 25 yards. Most players will have to use a driver to get around the corner and into position to reach the green in two. An accurate second shot with a longer iron will be crucial for a chance to make an eagle or birdie.

| HOW THE HOLE PLAYED IN 2001 | | | | | |
|---|---|---|---|---|---|
| Eagles: 10 | Birdies: 109 | Pars: 116 | Bogeys: 32 | Double Bogeys: 6 | Other |

88

creative firm
**OrangeSeed Design**
designers
Damien Wolf, Dale Mustful,
Doug Hoover
client
West Group

Everything in this spread seems to "cross the line": individual elements within a painting that is itself divided in two, headline crossing two boxes' mutual margin

creative firm
**Peterson + Company**
designers
Dorit Suffness,
Nicholas Wilton
client
University of Texas at Dallas
School of Management

WHAT A
DIFFERENCE
A YEAR MAKES

Although finding a job has gotten harder
lately, here are some strategies for remaining
a hot prospect in a cold economy.

BY HELEN BOND

True complementary colors produce an eye-popping effect as the color edges seem to vibrate

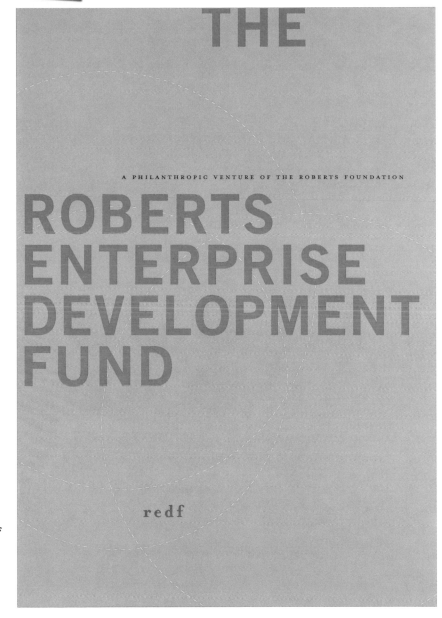

THE

A PHILANTHROPIC VENTURE OF THE ROBERTS FOUNDATION

ROBERTS
ENTERPRISE
DEVELOPMENT
FUND

redf

creative firm
**Chen
Design Associates**
designers
Max Spector, Leon Yu,
Josh Chen
client
Roberts Enterprise
Development Fund

Using a venture
techniques des
work with its no
businesses with
to provide trans
for over 600 ho

In fulfilling its c
philanthropic co
on learnings fro
resources on th
and convening i

Blue and orange from the cover (page 221) reappear on this spread;

circles are balanced by horizontal lines of numbers, which reflect the horizontal text lines on the facing page

approach to philanthropy, REDF applies
create value in the for profit sector to its
un enterprises. REDF helps the twenty
rtfolio grow toward sustainability in order
nd permanent employment opportunities
nd very low-income individuals each year.

ssion, REDF engages the nonprofit and
in dialogue by publishing research based
rk in the nonprofit sector, providing
ww.redf.org, participating in public forums,
e gatherings of practitioners and investors.

(continued)
creative firm
*Chen Design Associates*
client
Roberts Enterprise Development Fund

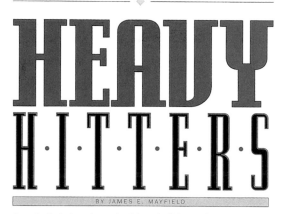

# HEAVY
# H·I·T·T·E·R·S

BY JAMES E. MAYFIELD

America's beloved sport of baseball has taken some hits over the years — but none as hard as those delivered by the guys who actually step up to the plate. Here's a roster of some of the big swingers we expect will smack it out of the nation's ballparks this season.

44 | AMERICAN WAY | 04.01.02

Barry Bonds

creative firm
*American Airlines Publishing*
designer
Gilberto Mejia,
Betsy Semple
client
American Way Magazine

Lively layout results from a few, but well-selected elements: very bold, strongly-colored headline, and action shot photography

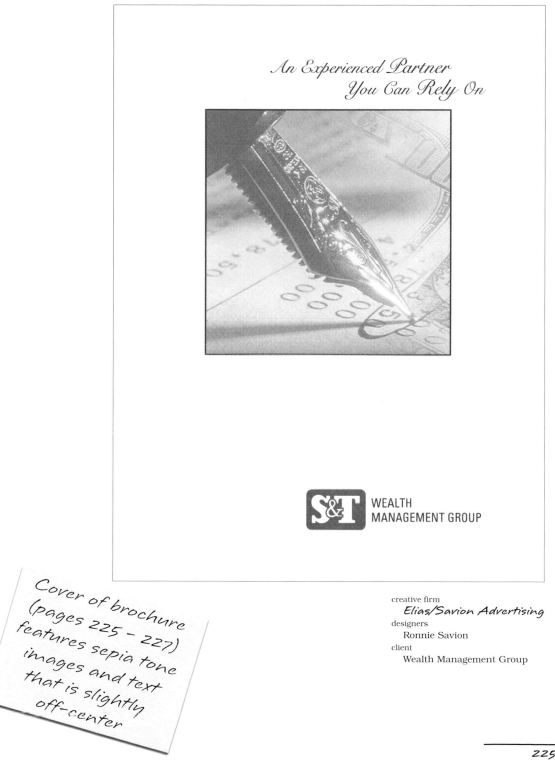

*An Experienced Partner
You Can Rely On*

**S&T** WEALTH
MANAGEMENT GROUP

creative firm
*Elias/Savion Advertising*
designers
Ronnie Savion
client
Wealth Management Group

Cover of brochure
(pages 225 – 227)
features sepia tone
images and text
that is slightly
off-center

*Warm photos play beautifully against parchment overlay*

With a century of trust and professionalism that marks the history of S&T Wealth Management Group, you can be assured that you are in the hands of a team that prides itself on outstanding perform- ance … year after year.

When you invest with S&T Wealth Management Group, your assets are man- aged by a sophisticated

# Rely On Us

team of senior level managers, analysts, planners and advisors who represent the pinnacle of their profession. More than seventy percent of our team either holds professional designations or graduate level degrees.

dedication to serve products and servic

In short, S&T Wea is a corps of elite p to winning for you

— 8 —

(continued)
creative firm
*Elias/Savion Advertising*
client
Wealth Management Group

**TEAM**

alth Management
eam is comprised
tified Financial
Chartered Finan-
alysts, Certified
d Financial Advi-
tified Retirement
Professionals, and
Securities Oper-
ofessionals.

bottom line is a
organized by
pline, but united
the unwavering
ith the best tools,
try has to offer.

nent Group
dedicated

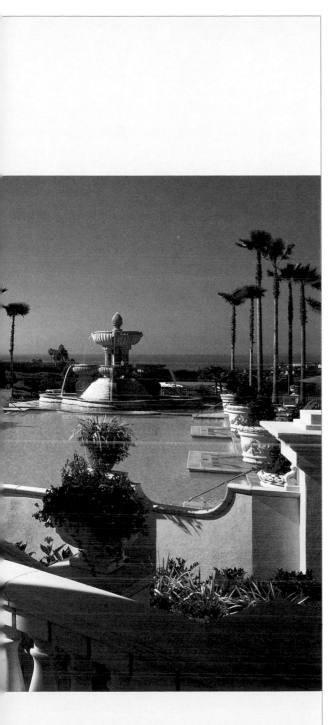

Sometimes words are too insufficient a conveyance— with a picture like this, why clutter up the scenery with them?

creative firm
   **David Carter Design Assoc.**
designers
   Donna Aldridge, Mike Wilson
client
   St. Regis Monarch Beach

Rolling greens and fairways, set against a breathtaking backdrop of sea

and sky, make the day both challenging and exhilarating. For a more restful

pursuit, cast your cares to the tranquil waters and soothing caresses

of Spa Gaucin, dedicated to your personal relaxation and rejuvenation.

(continued)
creative firm
   **David Carter Design Assoc.**
client
   St. Regis Monarch Beach

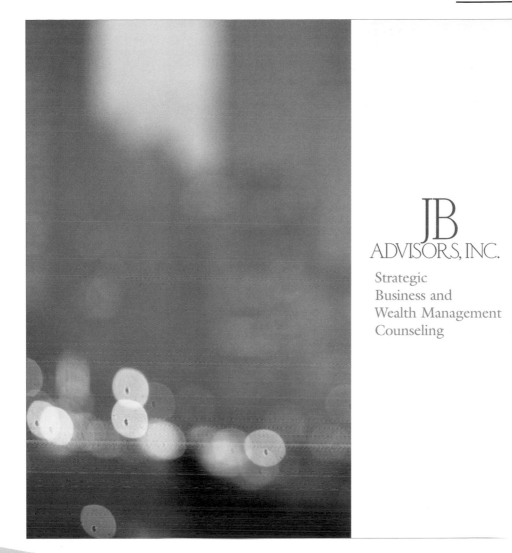

JB
ADVISORS, INC.
Strategic
Business and
Wealth Management
Counseling

creative firm
*Erwin Lefkowitz & Associates*
client
JB Advisors, Inc.

*Soft colors are reiterated in soft focus; gradient bar on right displays text in somewhat stronger values*

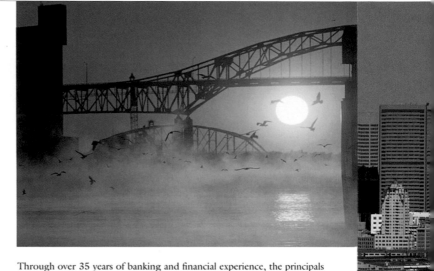

**JB**

Corporate
Representation

Through over 35 years of banking and financial experience, the principals

of JB Advisors, Inc. have been involved in transactions such as:

* Advising retail chain on capitalization plan and private
  equity investment

* Arranging mortgage financing for office and warehouse space
  for large electronic distributor

* Helping apparel firm focus on sales productivity and inventory
  management

* Financing licensing deal with soft goods manufacturer

Our geographic areas of expertise are in the U.S., Europe,

Latin America and the Middle East.

Th

yea

Repeated from the cover (page 231), layouts use cream-colored bars on outer edge; interior of page has color pics bleeding off top, and text below

Real Estate
Investment
Advice

...ny contacts in the real estate industry, as well as many

...state financing experience, JB Advisors, Inc. provides

...a broad array of real estate related products including:

* Equity Investments

* Syndications

* Commercial/Residential Mortgage Financing

* Sales and Leasing

(continued)
creative firm
*Erwin Lefkowitz
& Associates*
client
JB Advisors, Inc.

creative firm
**_Lightspeed Commercial Arts_**
designers
Michael Hamers
client
New West Mezzanine Fund

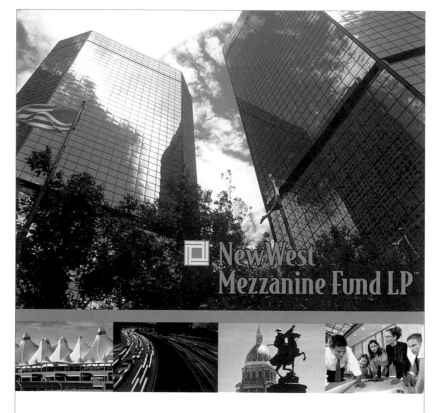

A private
investment fund
dedicated to providing
longer-term mezzanine capital
to smaller, growing companies
throughout the Rocky Mountain Region

# Applications for Mezzanine Capital

■ Mezzanine capital is medium-risk, medium-return capital designed to meet the requirements of growing businesses for flexible, cost-effective, fixed-rate, long-term, subordinated capital.

*Traditional growth capital fundings
for established companies*

~

*Leveraged acquisitions or buyouts
of smaller businesses*

■ Mezzanine capital can be structured to complement a company's existing relationships with senior lenders while minimizing equity dilution.

*Buildups and consolidations of
multiple business units*

~

*Earlier stage opportunities
with proven management teams*

■ Mezzanine capital addresses the needs of companies that have exhausted the resources of friends, family and angel investors but do not fit a traditional venture model or cannot justify the high costs of additional equity capital.

*Senior lending facilities
for earlier stage companies*

~

*Investments in plant and equipment*

■ Mezzanine capital can be customized to meet the needs of both privately owned and publicly held small businesses in diverse circumstances.

*Growth capital for smaller
publicly-held companies*

~

*Management buyouts and ownership successions*

~

*Recapitalizations and going private transactions*

platform
for winning

*More formal layout on the left relates well to a freer-form layout on the right through the use of consistent palette, type treatments, and color boxes*

applying sound
principles

# Principles

The investment professionals at
have significant experience in finan
and building smaller businesses. —
*a team to leverage our experienc*
*resources to craft financings that h*
*create long-term value."*

David L. Henry
*Managing General Partner*

Mr. Henry's professional experience
transactional and managerial responsi
ment and merchant banking, meza
mergers & acquisitions, commercia
venture capital. He has lived in Colo
years and has devoted his career to co
for emerging and middle-market co
greater Rocky Mountain region. He co
stone Capital™ and launched the New
Fund™ in 1998. David received a B.S.
cum laude, from Princeton Universi
degree in finance from Harvard Unive

# Financing Parameters

NewWest works closely with owners and management of each company to customize the transaction structure to address the unique requirements of both privately-owned and publicly-held businesses. Deal terms and covenants are designed to encourage growth and the creation of long-term value.

■ **Preferred Financing Size**
NewWest generally invests between $500,000 and $3,000,000 in each portfolio company. NewWest also maintains close relationships with a variety of other debt and equity financing sources and can structure and lead larger financings. NewWest prefers to be a lead investor but will co-invest with other professionally managed funds.

■ **Focus Sectors**
Focus sectors include manufacturing, distribution, retailing and services.

■ **Focus Industries**
NewWest finances both low-tech and high-tech companies including businesses involving information technologies, medical products, healthcare, computer software and hardware, telecommunications and business-to-business products.

■ **Location**
The Fund prefers to work with companies having operations in the Rocky Mountain Region.

■ **Stage of Development**
NewWest focuses on investments in later stage growth and development companies having established products or services.

■ **Financing Term**
Investment terms range from 1 to 7 years.

■ **Financing Structure**
The Fund's investments are typically structured as subordinated debt with warrants or other equity participation. The Fund will also consider investments in the form of convertible debentures, senior or secured debt and convertible preferred stock.

■ **Financing Inquiry Prerequisites**
NewWest welcomes financing inquiries from all sources. Interested parties are requested to provide a business or operating plan and audited financial statements. NewWest is committed to providing timely and thoughtful responses to all financing inquiries. All financing inquiries are held strictly confidential.

■ **Due Diligence Requirements**
Following preliminary agreement on the basic structure and terms of a proposed investment NewWest conducts an in-depth due diligence review of the company's history, financial results, business or operating plans, owners, management, products, technology, customers, operations, and use of proceeds. References and background checks are also required.

■ **Transaction Schedule and Closings**
The Fund's Principals normally can complete their due diligence investigation and structure, document and close an investment within 45 to 60 days.

forging
creative
partner

This spread is plainly from the same brochure on pages 234 & 235; double columns, small photos, colors, and fonts all reappear in similar format

Chet N. Winter
*General Partner*

Mr. Winter has more than 30 years experience as a senior executive with small to medium-sized companies and has diverse financial, operating and venture investing experience in a wide range of industries. He has lived in Colorado for over 25 years and has served as an investor, owner, consultant, senior executive, operating manager and venture capitalist. He co-founded Touchstone Capital™ in 1998. Chet received a B.A. degree in Economics and a M.S. degree in Industrial Relations and Economics from the University of Colorado.

Daniel K. Arenberg
*Principal*

Mr. Arenberg has significant operational and financial experience as an entrepreneur, and investment management experience as an investor. Mr. Arenberg formerly served as Vice President of Portfolio Management at IdeaSpring™, LLC, a private venture capital fund head-quartered in Colorado. He co-founded and served as Vice President of Finance & Operations, Board Member and In-House Counsel, for IntraEAR®, Inc., a Colorado-based medical device company which was sold to Durect Corporation™ (DRRX). Dan received a B.A. and M.B.A. degree from the University of Colorado and received a law degree from the Catholic University of America, Columbus School of Law, Washington, DC.

(continued)
creative firm
*Lightspeed Commercial Arts*
client
New West Mezzanine Fund

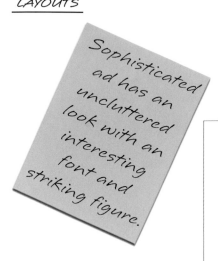

Sophisticated ad has an uncluttered look with an interesting font and striking figure.

"Oh honey,
whatever
you pick out
I'll love."

DO YOU SPEAK
CHERRY CREEK?

creative firm
*Ellen Bruss Design*
designers
Ellen Bruss, Charles Carpenter
client
Cherry Creek Shopping Center

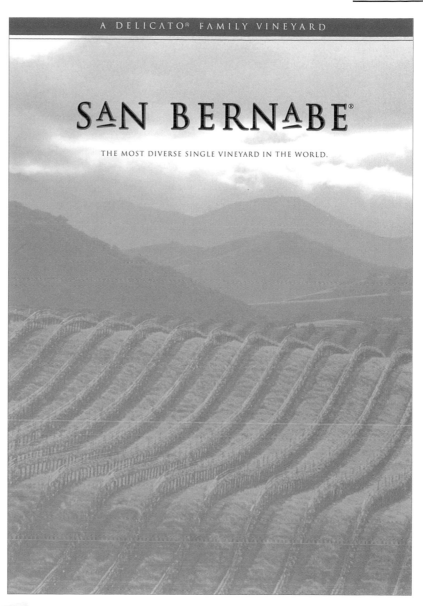

A DELICATO® FAMILY VINEYARD

# SAN BERNABE®

THE MOST DIVERSE SINGLE VINEYARD IN THE WORLD.

*Earthy, olive tones in a monochromatic photo make a good background for the title in black and gold*

creative firm
**Marcia Herrman Design**
designer
Marcia Herrmann
client
Delicato Family Vineyard

SAN BERN⌐

Located towards the southern end of the Salinas Valley, the San Bernabe is one of the oldest and most spectacular vineyard properties in the Monterey growing region. It is a winemaker's dream – the most diverse single vineyard property in the wine world. Purchased by the Indelicato Family in 1988, the vineyard is a major source of fruit for Delicato's Monterra and the exclusive source for the winery's Encore and Delicato Monterey Vine Select brands. San Bernabe Vineyard is also a significant source of fruit for many other California wineries. Twenty one different grape varieties are grown here.

San Bernabe is a recognized leader in Monterey grape growing. The vineyard property encompasses 12,640 total acres (5,118 hectares) of approximately 5,500 (2,227 hectares) are planted. The planted acreage is divided into more than 130 distinct blocks. Each block is farmed separately with the goal of maximizing quality.

The average annual temperature makes the San Bernabe slightly cooler than the southern Napa Valley. However, daily temperature variation during the growing season is much greater - a 50°F difference between daytime high and nighttime low is common! The result is deeply colored wines that retain their acidity.

San Bernabe viticulturists have identified twenty-two distinct mesoclimates on the property. Mesoclimate is a term applied that describes the unique condition that effects each vineyard block, e.g. hillside slopes.

Much of the San Bernabe's soil is unique. It is the remnant of ancient Aeolian sand dunes. (The word Aeolian is derived from the Greek god of wind). This soil type is rarely found in such a broad, uninterrupted expanse. Sixty five percent of all the soils in the vineyard are of the Aeolian type. The San Bernabe contains forty eight percent of all such soil found in the Monterey county! These well – drained sandy soils permit the viticulturist to take control of the vine early in the growing season and to guide the vine into producing the highest quality fruit.

Delicato Monterey Winery was built on the San Bernabe in 1988. It vinifies grapes from the San Bernabe as well as from independent growers throughout the Monterey appellation who supply grapes to Delicato.

(continued)
creative firm
*Marcia Herrman Design*
client
    Delicato Family Vineyard

*Very important color scheme is continued through entire brochure (pages 239 –241)*

CALIFORNIA

Lodi
ancisco
onterey
Paso Robles

Los Angeles

— Adobe Ruin

- Signature Vineyard Blocks

nted
locks

vineyard in the world

| Location/Station | Maximum (°F) | Minimum (°F) | Variation (°F) | JMT (°F) * |
|---|---|---|---|---|
| Salinas | 65.0 | 47.2 | 17.7 | 59.9 |
| Gonzales | 70.3 | 46.0 | 24.3 | 64.3 |
| Arroyo Seco | 71.6 | 45.8 | 25.8 | 65.5 |
| **San Bernabe** | **73.5** | **43.8** | **29.7** | **67.8** |
| Napa (Napa Valley) | 69.8 | 43.3 | 26.5 | 65.0 |
| Oakville (Napa Valley) | 72.3 | 44.7 | 27.6 | 68.3 |
| St. Helena (Napa Valley) | 73.5 | 46.7 | 26.8 | 71.6 |

### AVERAGE ANNUAL TEMPERATURE VARIATION

Temperature variation is a key factor in determining the wine quality potential of a vineyard. This is especially true for red grape varieties. Low nighttime temperatures help retain color and acidity while warm daytime temperatures enable grapes to retain full flavor and ripeness. From the average annual temperature standpoint, San Bernabe is similar to St. Helena and Oakville in the Napa Valley, both areas famous for growing world-class red grapes. However, average temperature variation is greater than any of the three Napa locations. One reason San Bernabe red wines are so deeply colored and retain their acid so well.

### JULY MEAN TEMPERATURE (JMT) *

The unique, cooling winds that quench the heat nearly every afternoon make degree-day comparisons misleading. The San Bernabe averages about 3389° days, making it a Region III. However, the "July Mean Temperature," or JMT - the 24 hour average temperature of a given location in July - makes San Bernabe warmer than most other locations in the Monterey AVA, and more like a locale between Napa and Oakville.

### MONTEREY WINES OF DISTINCTION

San Bernabe Vineyard serves as a select wine grape source for many highly esteemed premier California wineries. San Bernabe is also the home of Delicato and Monterra flagship wines:

**Delicato Monterey**
Vine Select: hand crafted, artisan wines representing the highest expression of San Bernabe Vineyard

**Encore by Monterra:** proprietary, innovative blends capturing the essence of San Bernabe Vineyard

**Monterra:** fruit-forward wines with balance, intensity and crisp acidity, capturing the essence of Monterey

*Text, chart, map, and color photos all combine to tell this vineyard's story*

creative firm
*Funk/Levis & Associates*
designers
David Funk, Lada Korol
client
Sony/eBridge

Overlapping, shadowed images play from this ad's headline to the city skyline

Intimate, full-
page picture
strikes a balance
between portrait
and action shot

creative firm
**The Graphic Expression**
designers
Steve Ferrari,
Kurt Finkbeiner
client
Kessler Rehabilitation Corporation

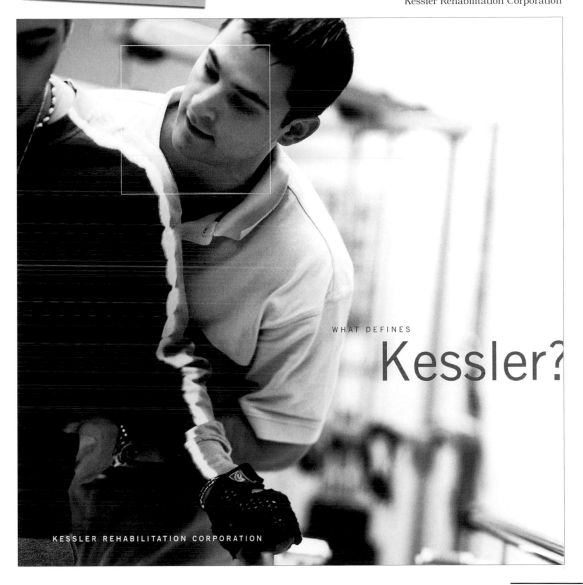

WHAT DEFINES

## Kessler?

KESSLER REHABILITATION CORPORATION

(continued)

creative firm
*The Graphic Expression*

client
Kessier Rehabilitation Corporation

› Kessler's comprehensive inpatient, outpatient and onsite programs for individuals with physical disabilities and functional limitations do not simply set the standards for rehabilitation; we raise that bar to new heights every day.

A full range of

# specialized
TREATMENT PROGRAMS

Notice how the white hairline box creates immediate emphasis on each layout of this brochure

(pages 243 – 248)

A business
# model
DESIGNED FOR GROWTH

Having built a solid clinical and organizational framework, Kessler is strategically positioned to extend our reach . . . explore new opportunities with like-minded providers . . . and expand our national presence.

Lowercase letters serve to display each topical headline; brief explanatory paragraph offers details

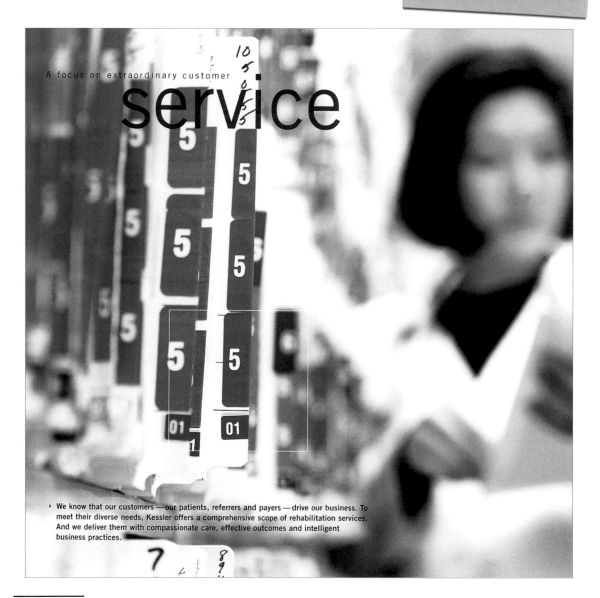

A focus on extraordinary customer

service

▸ We know that our customers—our patients, referrers and payers—drive our business. To meet their diverse needs, Kessler offers a comprehensive scope of rehabilitation services. And we deliver them with compassionate care, effective outcomes and intelligent business practices.

A state-of-the-art

# technology

PLATFORM TO SUPPORT OPERATIONS

▸ Although physical rehabilitation is more high-touch than high-tech, Kessler recognizes the critical demand for the accurate and efficient exchange of information. The advanced platform from which we operate is custom-designed to meet the data communication needs and enhance the capabilities of people throughout the organization.

(continued)
creative firm
*The Graphic Expression*
client
Kessier Rehabilitation Corporation

Design: The Graphic Expression, Inc., NYC, www.tgenyc.com

(continued)
creative firm
**The Graphic Expression**
client
Kessier Rehabilitation Corporation

Hairline box becomes the center of attention when it displays a portrait inside a field of black

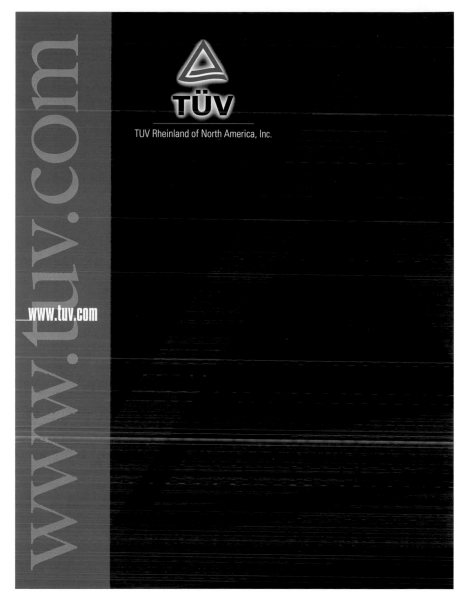

TUV Rheinland of North America, Inc.

www.tuv.com

*Ethereal effects include white glow behind logo, and logo in matte varnish on black background*

creative firm
**Leverage MarCom Group**
designers
Heather Patrick,
Peter Howland
client
TUV Rheinland of North America

SAFETY

PRESSURE

MATERIALS

MACHINERY

FIELD EVALUATION

MEDICAL

TELECOM

EMC

QUALITY

AUTOMOTIVE

# Comprehensive
# Medical
# D

**TUV Rheinland of North America can test and provide certification for all electro-medical and laboratory devices for the U.S., EU and other markets through the following certifications.**

## Our Services Include:

- cTUVus Mark (UL 2601, United States & Canada)
- CE Marking (European Union)
  - MDD Compliance
  - IVDD Compliance
- EN46001 / ISO 13485 Certification
- FDA 510(k) Review
- T-Mark / Test Reports (all applicable standards)

### MDD

The Medical Device Directive (MDD) 93/42/EEC, which became mandatory in June 1998, applies to medical devices, including an instrument, apparatus, appliance or other article to be used for human beings for the purpose of:

- Diagnosis, prevention, monitoring treatment or alleviation of disease
- Diagnosis, monitoring, treatment or alleviation of or compensation for any injury or handicap
- Investigation, replacement or modification of the anatomy of a physiological process
- Control of conception

Local Service, Global Reach

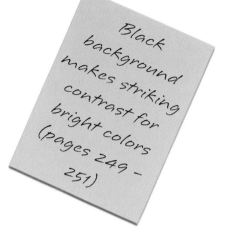

Black background makes striking contrast for bright colors (pages 249 – 251)

IVDD

Recently, the Official Journal of the European Communities published the In Vitro Diagnostic Directive (IVDD) 98/79/EC. The IVDD covers the entire spectrum of in vitro diagnostic medical devices and all corresponding accessories. Achieving IVDD certification was possible as of June 7, 2000. According to Article 22 of the IVDD, the transition period for CE Marking must be complete by December 2003. After this date, CE Marking of in vitro diagnostic medical devices will be mandatory. TUV Rheinland of North America, Inc. is accredited to perform certification for CE Marking of in vitro medical devices as outlined in the IVDD.

The term 510(k) is a reference to the U.S. Federal Food, Drug and Cosmetics Act section 510(k), otherwise known as "Premarket Notification." The information required in a 510(k) submission can be found in the Code of Federal Regulations, Title 21, Part 807, Subpart E. During a 510(k) review, the submission will be reviewed to see whether the medical device is "substantially equivalent" to a device already legally marketed in the U.S. The FDA has designated TUV Rheinland of North America, Inc. as an "Accredited Person" for Third-Party Review of 510(k) submissions of certain eligible devices. This Third-Party Review status often means faster review of 510(k) submissions and quicker market clearance for the manufacturer.

CE 0197

evice
△ Services
TÜV

Single Source for Testing, Registration and Certification. Visit us at www.tuv.com, or call 1-TUV-WRLD-WID. 9

(continued)
creative firm
   *Leverage MarCom Group*
client
   TUV Rheinland of North America

251

creative firm
**The Zimmerman Agency**
designers
Damon Williams, Kevin Rhodes,
Mark Washburn, Eddie Snyder,
David Hautzig
client
The Muse Hotel

Similar tones make the viewer stop and look—for the message, for the photo; the name then jumps black off white

**WHY DON'T SHEEP SHRINK WHEN IT RAINS?**

There are a lot of great restaurants in New York. And one of them happens to be right downstairs.

**{ AND OTHER THOUGHTS YOU'LL HAVE TIME TO PONDER WHILE AT OUR HOTEL.}**

Here's a thought. Considering the comfort of our featherbeds, you may want a wake up call.

YOU SHOULDN'T HAVE TO PUT MUCH THOUGHT INTO STAYING AT THE MUSE. CHECKING IN, RELAXING AND EVEN CONDUCTING BUSINESS IS A BREEZE. YOU'LL BE A CELL PHONE'S THROW FROM TIMES SQUARE. THE BEDS ARE SINFULLY COMFORTABLE. AND THE STAFF CAN GET YOU ANYTHING YOU DESIRE. SO YOU CAN RELAX, AND LET YOUR MIND WANDER. IT'S REALLY QUITE LIBERATING.

*the* Muse *a hotel*

1 877 NYC MUSE OR THEMUSEHOTEL.COM

MIS MOS?

**MOS BURGER**®

◤**B2**

creative firm
*Planet Ads & Design P/L*
designers
Noburu Tominaga,
Michelle Lauridsen
client
Mos Burger

There must be something interesting happening just off the bottom of this ad, with the arrow pointing down and the head popping up...

Really good play
between image
and body copy
as figure actually
pulls the text left

Terry Vavra, president of Marketing Metrics, a consulting firm that designs retention programs.

Just Ha
to what

creative firm
**Selling Power**
designers
Tarver Harris,
Jeff Weiner
client
Selling Power Magazine

CONSIDER THIS sales adage: "It's at least five times more expensive to win a new customer than to keep a current customer." That's according to Terry Vavra, president of Marketing Metrics, a consulting firm that designs retention programs, and author, with Timothy Keiningham, of *The Customer Delight Principle* (McGraw-Hill, 2001). "Sears, Roebuck and Company recently claimed it was 12 times more expensive for them to win a new customer than to keep one of their current customers." You don't have to be a mathematical genius to understand what the numbers are saying. Salespeople light a fire to close the deal but often forget to keep fanning the flames. The result? Those accounts can turn to ashes. Today, good customer service isn't enough. You have to make your customers look for you – and choose you – time after time. While customer retention may not be rocket science, you can't just ignore it and expect to make quota every quarter.

According to the Business Research Lab, an online marketing research company specializing in customer and employee satisfaction and retention (www.busreslab.com), a customer retention program consists of three main elements: a focus on satisfying current customers, a means of measuring why customers leave, and a planned effort to prevent customers from leaving once they express a desire to do so.

"At Pfizer, customer retention is not a result of what you do, it is part of what you do every day," says sales manager Paul Casanova. Pfizer should know. The pharmaceutical giant, producer of the popular drugs Norvasc for blood pressure and Lipitor for cholesterol management, recently entered into an agreement to purchase Warner Lambert, making it the number one pharmaceutical company in the U.S. and number two in the world. Customer retention plays a huge part in this success. "Customer retention is a focal point for our reps every day. It's taught from day one," says Casanova.

Just how much can customer retention help a company? More than most people realize. Bain & Company reports that gains in retention transfer to much larger gains in profit. For example, in the insurance industry raising your customer retention levels by 5 percent gives you a 60 percent profit jump. In banking, you get a 40 percent profit jump.

A survey of banks in the United Kingdom reported that a 5 percent increase in customer retention paid off with a gain of 85 percent in deposit profits and a 75 percent rise in credit card profits.

According to Ted Kinni, co-author of the book *1,001 Ways to Keep Customers Coming Back: Wow Ideas That Make Customers Happy and Increase Your Bottom Line* (Prima Communications, 1999) and co-founder of The Business Reader, a business-to-business bookseller, "There's a finite number of customers for every business, and once you've been through them, it can get tough. That's why it pays to retain."

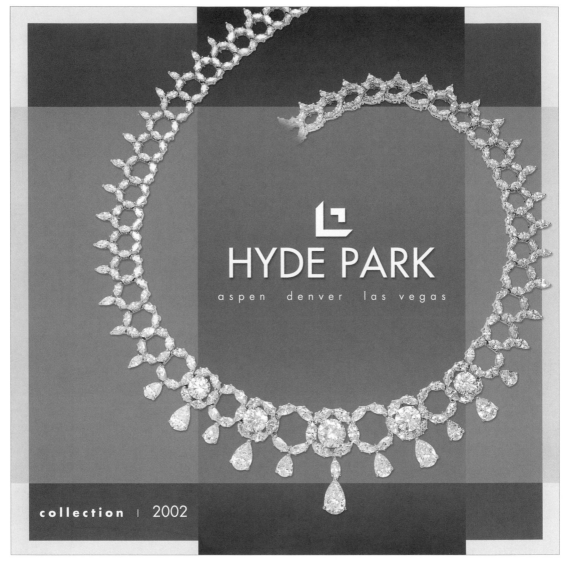

HYDE PARK

aspen   denver   las vegas

collection | 2002

creative firm
*Ellen Bruss Design*
designers
Ellen Bruss, Charles Carpenter,
Greg Christman
client
Hyde Park

White text is reversed out of wonderfully warm, metallic inks, but the products are what immediately engage the eye (pages 256 – 259)

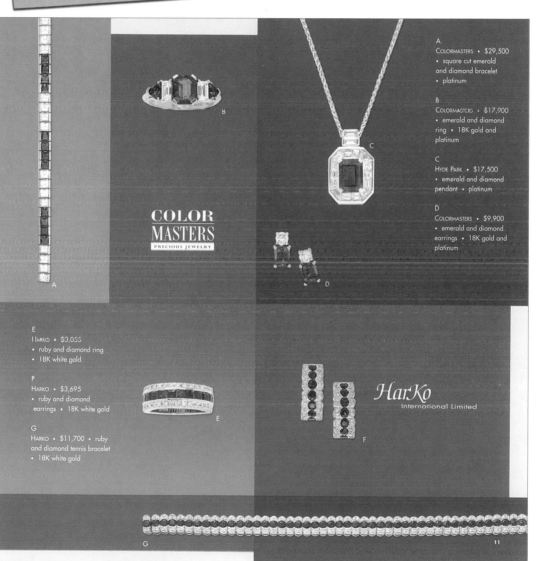

A
COLORMASTERS • $29,500
• square cut emerald
and diamond bracelet
• platinum

B
COLORMASTERS • $17,900
• emerald and diamond
ring • 18K gold and
platinum

C
HYDE PARK • $17,500
• emerald and diamond
pendant • platinum

D
COLORMASTERS • $9,900
• emerald and diamond
earrings • 18K gold and
platinum

**COLOR MASTERS**
PRECIOUS JEWELRY

E
HARKO • $3,055
• ruby and diamond ring
• 18K white gold

F
HARKO • $3,695
• ruby and diamond
earrings • 18K white gold

G
HARKO • $11,700 • ruby
and diamond tennis bracelet
• 18K white gold

*HarKo*
International Limited

11

A
TAG HEUER • $2,300
Men's polished stainless
steel • Targa Florio
Chronograph • black dial

B
TAG HEUER • $1,995
stainless steel Formula One
• digital chronograph
• black dial

C
TAG HEUER • $2,600
Ladies mini Alter Ego •
polished stainless steel •
translucent blue dial with
diamonds around crystal

TAGHeuer
SWISS MADE SINCE 1860

A
CHARRIOL •
• Flamme E
• 18K whit
diamonds

CHARRIOL
COLVMBVS C

B
$3,950 •
• 18K whit
diamonds

C
$3,390 • •
• diamond
bracelet •

D
$2,490 • •
bezel • blu
• white ror
available in
lizard strap

(continued)
creative firm
   *Ellen Bruss Design*
client
   Hyde Park

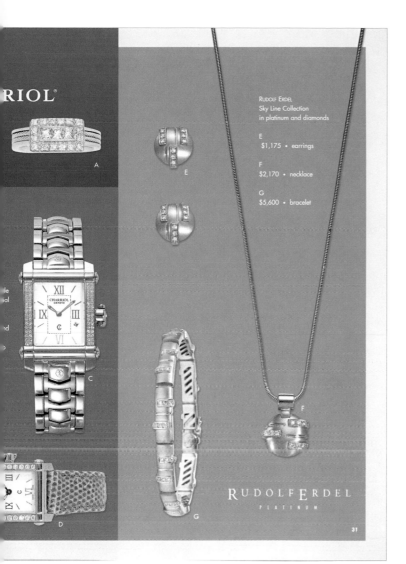

RUDOLF ERDEL
Sky Line Collection
in platinum and diamonds

E
$1,175 • earrings

F
$2,170 • necklace

G
$5,600 • bracelet

RUDOLF ERDEL
PLATINUM

31

*It's not just the layout; even the products are color-coordinated in this catalog's individual and overall designs*

## With SB Capital Group,
### *There's Always Another Option.*

### The ABC Company Story

A respected brand for nearly 40 years, ABC Company sells and manufactures apparel under its own label, owns 300 stores, and distributes their products through five warehouses located in the United States and Canada.

THE PROBLEM > ABC has fallen on hard times. Revenues and stock prices are in freefall. Now, ABC needs to assess its situation, raise cash, and obtain an asset-based loan to turn the company around.

THE BUSINESS-AS-USUAL SOLUTION > Working on its own or with a traditional asset recovery company, ABC leverages its assets creating short-term cash availability but long-term vulnerability and settles for the cash it can raise in the shortest time. Opportunities are missed. ABC fails to achieve long-term financial stability.

THE SB CAPITAL GROUP SOLUTION > Appraise the full value of all ABC assets. Consider the opportunities that a wider range of options can offer. Put together an integrated plan of asset value maximization that generates greater cash, profits and long-term strength — from a smarter disposition of assets, innovative distribution channels, creative restructurings, and unexpected opportunities revealed by SB Capital Group.

## SB Capital Group Helps
### *ABC Company Find a New Strategy.*

### Unique Distribution Channels >

SB Capital Group buys inventory coming from the supply chain and sells it through the firm's distribution channels. Result: ABC maximizes value of inventory; merchandise is sold within 120 days while controlling distribution and protecting the integrity of branded merchandise.

### Full-Valuation Appraisal >

SB Capital Group's experienced and professional staff obtains an accurate appraisal of all of the company's leveragable assets enabling them to obtain an asset-based loan. Result: ABC gains accurate data to plan its asset value maximization strategy and is closer to gaining access to capital.

### Sale Leaseback and Lease Disposition >

ABC determines that 50 leased stores must be closed and lease terminations and assignments are arranged for these stores. SB Capital Group identifies underlying value in another 18 owned stores. They purchase them and lease them back to ABC at favorable terms. Result: Money is saved by mitigating outstanding lease obligations and more cash is available for ongoing operations.

creative firm
*Grafik*
designers
Rodolfo Castro,
Johnny Vitorovich,
Judy Kirpich
client
SB Capital

> OPPORTUNITY RISING

## Liquidation and Acquisition >

SB Capital Group surveys all of the 300 stores and
the company determines that 50 stores will need to be
closed. Inventory is purchased at a guaranteed price, and
SB Capital Group assumes management and operations of
the stores, paying all of the associated operating expenses.
Not only do they liquidate the inventory, they also purchase
the rights to the intellectual property for a brand name
that no longer fits in with the company's go-forth strategy.
Result: ABC receives immediate capital infusion at an
attractive cost.

## Receivables Into Cash >

ABC has extensive accounts receivable.
SB Capital Group buys them and converts
them into cash. Result: ABC receives
immediate capital, avoids collection time,
expense and risk.

## Auctions >

ABC must dispose of two of its warehouses and 50 stores to
raise needed cash. SB Capital Group provides complete auction
services to sell manufacturing equipment, store fixtures and
hardware. Result: ABC raises more cash faster than it could
have on its own.

Now, ABC is Again
a Company *With a Future*.

*Page folds out for a
four-page spread,
good for creating
emphasis and
including large art*

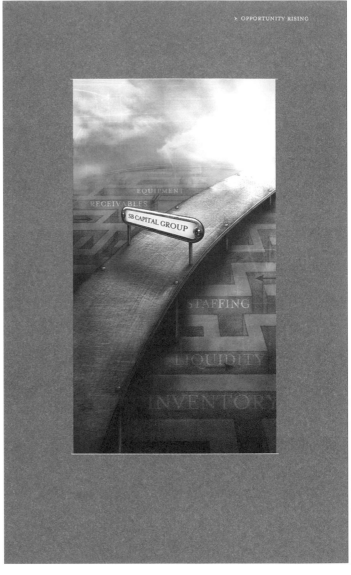

> OPPORTUNITY RISING

EQUIPMENT

RECEIVABLES

SB CAPITAL GROUP

STAFFING

LIQUIDITY

INVENTORY

(continued)
creative firm
*Grafik*
client
SB Capital

Less-involved palette on this brochure's cover (pages 260 - 262), but illustrative qualities remain

Breaking boundaries, photo slides under the border to bleed off right edge

creative firm
*Phoenix Creative Group*

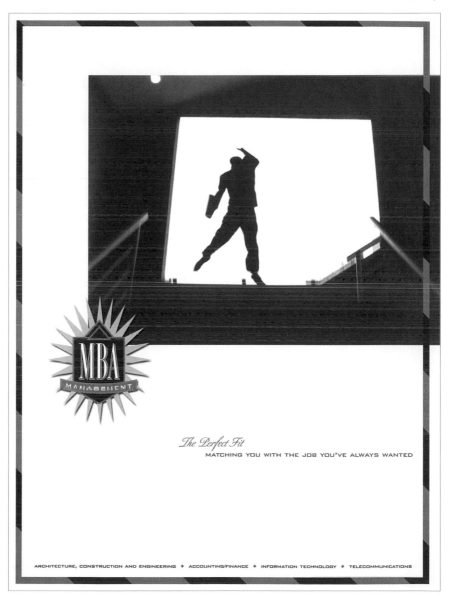

creative firm
*Phoenix Creative Group*

IT TAKES TWO TO MAKE A PERFECT FIT.

### INDUSTRY SPECIALIZATION
*Candidate benefits:*
- Thorough knowledge of some of the largest and fastest-growing fields
- Inside track to the hottest companies
- Established reputation throughout our key industries

*Client benefits:*
- Deep pool of contacts and prospects
- Dedicated understanding of the industries we serve

### INTENSIVE RECRUITMENT PROCESS
*Candidate benefits:*
- Insider's understanding of the jobs, people and culture of the companies we represent
- Qualified job leads, with no dead-end opportunities

*Client benefits:*
- Greater understanding of each prospect that brings only serious contenders to the table

### RESULTS-FOCUSED COMPENSATION
*Candidate benefits:*
- Recruitment services free to all candidates

*Client benefits:*
- Clients pay only for results
- Retainer services available for ongoing service
- Extremely flexible fee structures (including stock option payments) possible

IT TAKES ONE TO KN

### PRACTICE AREAS

**Architecture, Constru**
ACE is divided into fo

*Architecture*

*Construction*

*Civil Engineering*

*Transportation En*

**Accounting/Finance**

**Information Technole**

**Telecommunications**

As you may have guessed, MBA Management is not your average recruiting firm. We don't bombard our client companies with dozens of resumes for each position. By the same token, we don't inundate candidates with scores of job opportunities that may or may not suit them. We do our homework to help ensure that qualified candidates are matched with qualified job leads. Because it's only when both parties are happy that the relationship can be called a perfect fit. And it's only then that we consider ourselves successful.

Much of MBA Management's long-term success can be attributed to our ability to serve companies and candidates equally well.

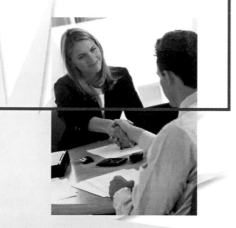

WE DO OUR **HOMEWORK** TO HELP ENSURE THAT QUALIFIED     CANDIDATES ARE MATCH

Cream, sage, gold, and taupe are repeated in this publication's design (pages 263 – 265)

ng the hottest companies–and
tanding what they are looking
best accomplished by a team of
ionals who know an industry
and out. That's precisely why
Management targets a small,
used, group of businesses. Our
zed practice areas are staffed
xperts in some of the most exciting
crative fields available. And they
where today's best opportunities
den.

| | **TYPICAL POSITIONS** |
|---|---|
| **ngineering** gments: | |
| | Architects, designers, program managers, mechanical engineers, electrical engineers, CAD technicians, and many more. |
| | Project managers, estimators, superintendents, technical support staff and project executives. |
| | Project managers, engineers, designers, office/branch managers, surveyors and CAD technicians. |
| | Project engineers and project managers, branch managers, vice presidents, division managers, business developers and presidents. |
| | Accountants, accounting managers, controllers, auditors, financial/business analysts, CFOs, planning managers, payroll supervisors, etc. |
| | Network engineers, programmers, database administrators, MIS directors, etc. |
| | Telecommunications and network engineers specializing in transmission, cellular, RF, network center HW/SW, satellite communications, etc. |

QUALIFIED JOB LEADS.

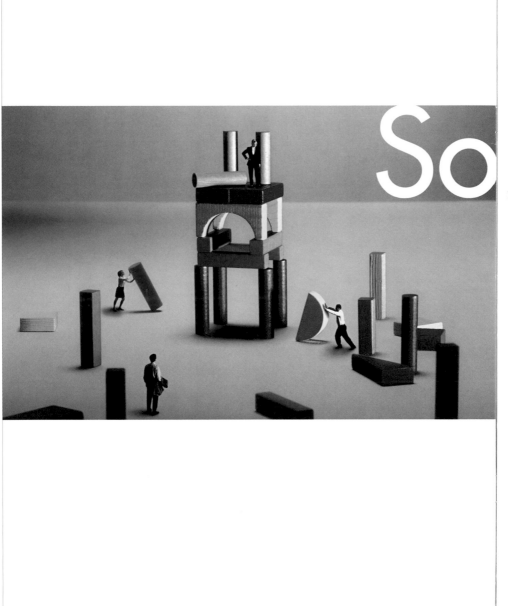

So

you've decided to b

Large brochure (pages 266 – 271) accentuates artwork with a contrast of white space

...lding, add an addition or expand your space.

*Who* should you get involved in the process? An architect? Designer? Contractor? Consultant? Accountant? All of the above?

*What* do you want to accomplish? What's your vision for the building, and what do you want it to do for your business?

*Where* do you start — and finish? What's the process?

*When* does it need to be completed? Are there important milestones to hit along the way?

*Why* are you building in the first place? How do you see this project helping you achieve your business goals?

*How* will this building affect your people? Your brand image? Your cash flow? What do you want it to say about your company?

Tough questions. And increasingly, the right answers aren't available from traditional thinking.

We think there's a better way to manage capital building projects. A seamless way to visualize and achieve your objectives

We're *OneSphere*. Seamless.

creative firm
  *Miller Brooks, Inc.*
designers
  Don Henre,
  Joanne Johnson
client
  OneSphere

If the text is
important, just use
a little and it will
gain priority

(continued)
creative firm
*Miller Brooks, Inc.*
client
OneSphere

I'll see it......when I believe it.

Making the most out of building projects

takes a broader vision — a belief

that anything can be accomplished.

The rewards are seen in the results.

By understanding your objectives

and exploring all the opportunities available,

we're able to accomplish your goals

with outstanding results.

We see it.

Because we believe it.

That's *what* we do.

(continued)
creative firm
*Miller Brooks, Inc.*
client
OneSphere

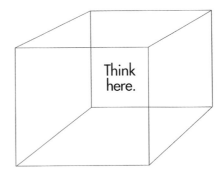

Red "head"line
stands out against a
primarily black-
and-white color
scheme

When you think about building projects, it's easy to be constrained by bricks and mortar. By old methods and assumptions. Don't be.

Instead, think lean. Think about non-traditional solutions that are:
• Functional — for your people, your business processes and your customers.
• Efficient — making better use of materials, space and resources.
• Cost-Effective — getting more from your budget.
• Fast — coordinating action through pulling and continuous flow.

That's lean thinking. That's *where* we are.

Delivering creative capital projects that fit well within your parameters. We accomplish this through our systemic view that explores every aspect of a project and our proprietary Capital Project Management System (CPMS) that controls the entire process.

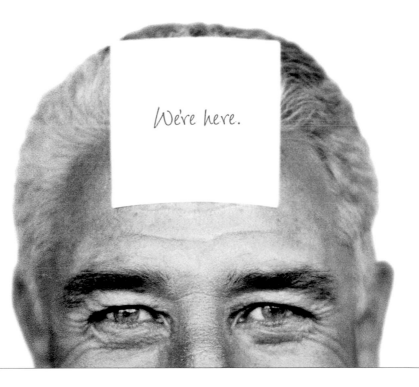

We're here.

# INDEX